THE KING
OF BANGKOK

Essays from the authors can be found on the book's webpage:
https://utorontopress.com/9781487508869/the-king-of-bangkok/

THE KING
OF BANGKOK

CLAUDIO SOPRANZETTI
SARA FABBRI
CHIARA NATALUCCI

UNIVERSITY OF TORONTO PRESS

Toronto Buffalo London

English translation and appendices © University of Toronto Press 2021
Toronto Buffalo London
utorontopress.com

Il Re di Bangkok
© add editore, 2019
All rights reserved

ISBN 978-1-4875-0886-9 (cloth) ISBN 978-1-4875-3916-0 (EPUB)
ISBN 978-1-4875-2641-2 (paper) ISBN 978-1-4875-3915-3 (PDF)

Library and Archives Canada Cataloguing in Publication

Title: The king of Bangkok / Claudio Sopranzetti, Sara Fabbri, Chiara Natalucci.
Other titles: Re di Bangkok. English
Names: Sopranzetti, Claudio, author. | Fabbri, Sara, artist. | Natalucci, Chiara, author.
Description: Series statement: EthnoGRAPHIC | Translation of: Il re di Bangkok.
Identifiers: Canadiana (print) 20210227060 | Canadiana (ebook) 20210227095 |
ISBN 9781487526412 (softcover) | ISBN 0781487508869 (hardcover) |
ISBN 9781487539160 (EPUB) | ISBN 9781487539153 (PDF)
Subjects: LCSH: Thailand – History – 1945– – Comic books, strips, etc. |
LCGFT: Graphic novels. | LCGFT: Historical comics.
Classification: LCC PN6767.S67 R413 2021 | DDC 741.5/945 – dc23

We welcome comments and suggestions regarding any aspect of our publications – please feel free to contact us at news@utorontopress.com or visit us at utorontopress.com.

Every effort has been made to contact copyright holders; in the event of an error or omission, please notify the publisher.

University of Toronto Press acknowledges the financial assistance to its publishing program of the Canada Council for the Arts and the Ontario Arts Council, an agency of the Government of Ontario.

Canada Council Conseil des Arts
for the Arts du Canada

ONTARIO ARTS COUNCIL
CONSEIL DES ARTS DE L'ONTARIO
an Ontario government agency
un organisme du gouvernement de l'Ontario

Funded by the Financé par le
Government gouvernement
of Canada du Canada

To all victims of political violence,
those who continue to live with scars,
and those who paid the ultimate price.

CONTENTS

FOREWORD

In this time when access to information about events anywhere on the globe is always at our fingertips, getting beyond the surface and making meaningful connections to the real human lives impacted by these events is increasingly important. Through a dizzying and masterful demonstration of the comics form, Claudio Sopranzetti, Sara Fabbri, and Chiara Natalucci have created in *The King of Bangkok* an engrossing and necessary account. Fabbri's hauntingly beautiful drawings bring these characters to life, as Sopranzetti and Natalucci immerse readers in the daily lives of ordinary people caught up in extraordinary events on a national scale. Though the characters are created from composite accounts, Sopranzetti has meticulously crafted their identities through exhaustive research to offer an intimate exploration of powerfully real human lives. It is truly a collaborative effort – the different perspectives and skills of each author woven seamlessly together to elevate their overall command of the art form. Comics, in their hands, are a sophisticated vehicle to transport the reader and allow us to bear witness alongside the lives chronicled here – as we come to know these characters' motivations, their choices, their struggles, and their times of joy.

To create this immersive experience, the authors take full advantage of the affordances comics offer to present meaning on the page. Fabbri's drawings are expressive and full of life – deftly conveying characters' happier moments and the pain they endure. Fluid yet deliberate, the very lines that make up her characters and the disparate locations we visit over the course of the book serve to add another voice to this story beyond the written narration. This effect is amplified by her evocative use of color. Wielding a palette at times lush and vibrant while elsewhere drained almost entirely of life, color becomes another character – a fully developed presence or soundtrack that infuses the scenes with emotion and a psychological dimension. At the same time, Fabbri also uses color to help ground and situate the reader in the

different periods in the characters' lives, as this sweeping tale moves back and forth across large swaths of time.

Finally, much should be noted about the compositions. Fabbri is constantly inventive, always employing the architecture of the pages to serve the storytelling. Panels are squared off and hard-edged in one sequence, while more organic and amorphous in another. At times the layout is broken into numerous panels to capture specific beats of the narration, that sequence of events, and then she opens things up, making use of the very space of the page to get at a deeper level of characters' experience. As a whole, this work glides from the representative to the metaphorical and occasionally into wonderfully surreal drawings, bringing access not just to characters' actions but to their internal state. By paying such attention to every element at their disposal, the authors have orchestrated an entirely engaging reading experience and one that will long linger.

The King of Bangkok is a remarkable journey. Through Sopranzetti, Fabbri, and Natalucci's deliberate guidance, we can breathe in the very humanness of the lives at the center of this story. It will most certainly leave you richer for the experience.

Nick Sousanis
Author of *Unflattening* and associate professor of Comics Studies
at San Francisco State University

PREFACE

The story narrated here is based on real events. This account is grounded in hundreds of hours of interviews and ten years of anthropological research in Thailand, filtered through three pairs of eyes and hands.

The characters are composites and the product of narrative fiction. Every detail of their lives is real, yet none of them correspond in their totality to an existing person.

The social, economic, and historical context in which the characters move summarizes the most significant events in the last 50 years of Thai history, without any claim to exhaustiveness. Some events have been omitted and condensed to make the narration more fluid.

However, the reconstruction of locations, clothes, architecture, and graphic material is fully realistic. Every frame is based on a photographic and cine-matographic archive that the authors put together during a 2015 residency in Thailand. It is composed of more than 5,000 items from the National Library of Thailand, the Thai Film Archive, and some private collections.

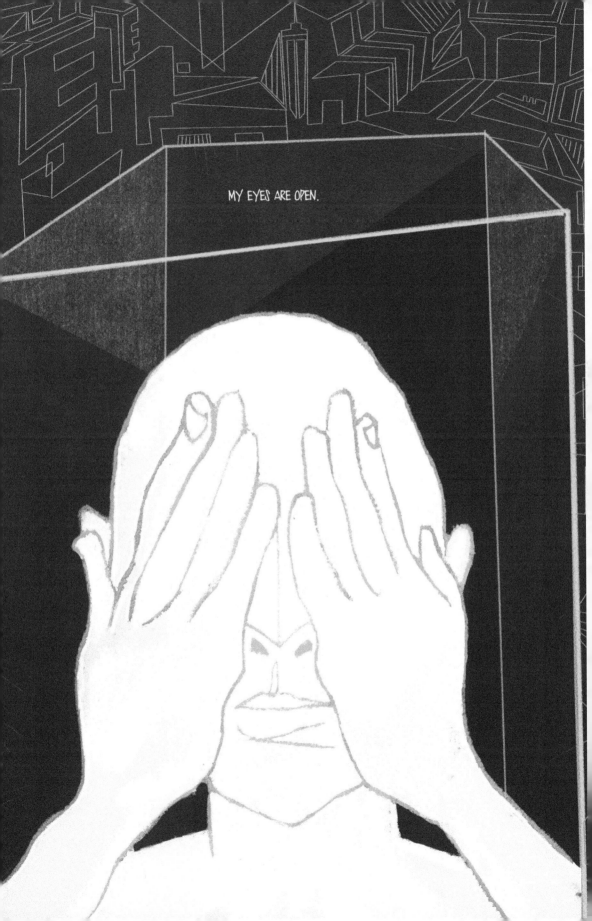

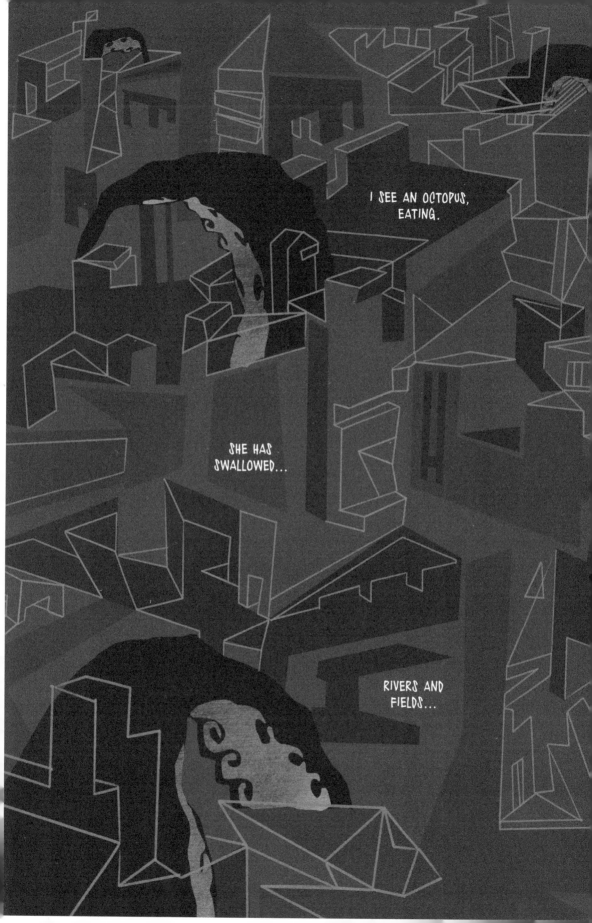

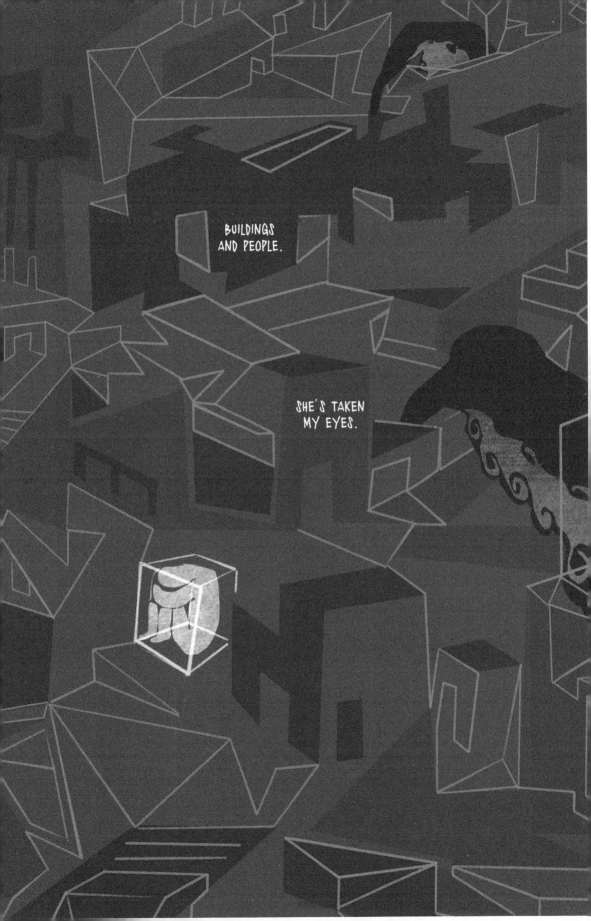

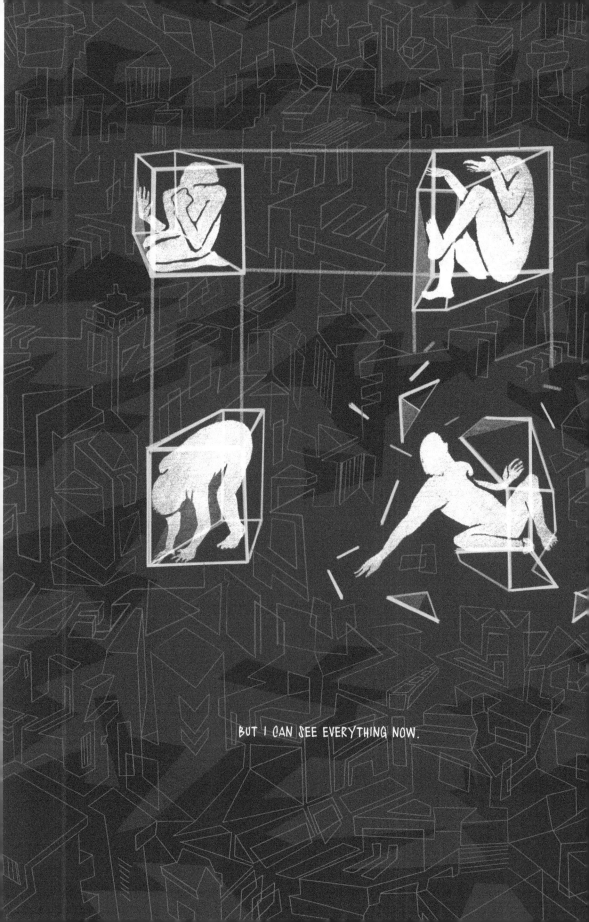

I AM AWAKE.

CHAPTER

1

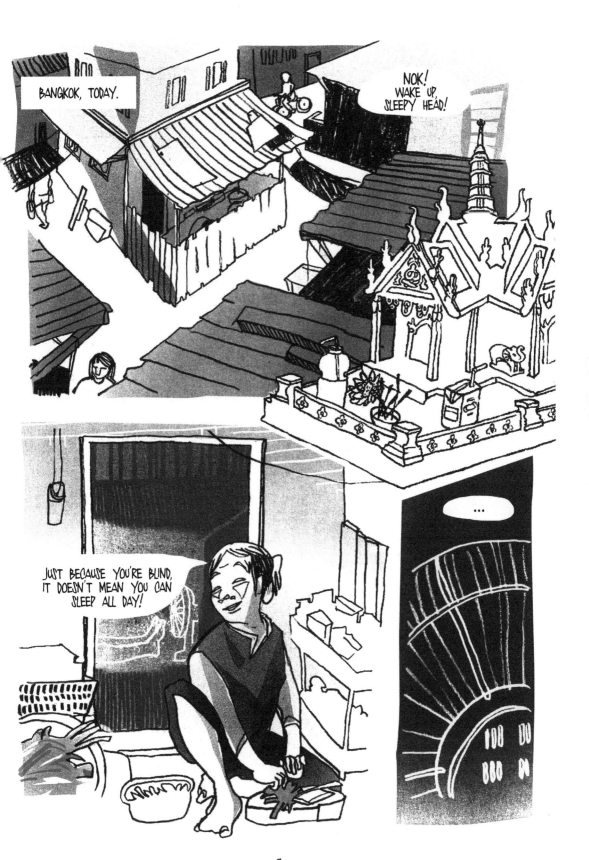

7

AFTER I LOST MY SIGHT, LEAVING THE HOUSE
WITHOUT MY WIFE USED TO BE SCARY.

EVERY STEP WAS EMPTINESS.

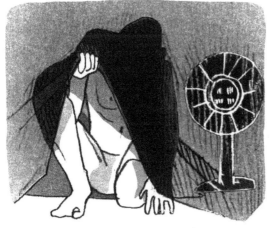

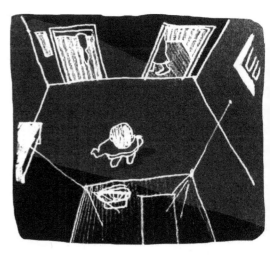

SLOWLY, I'VE LEARNED TO LISTEN TO THE WORLD.

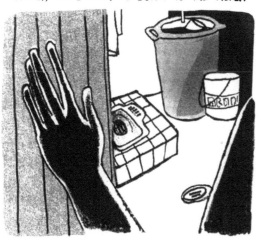

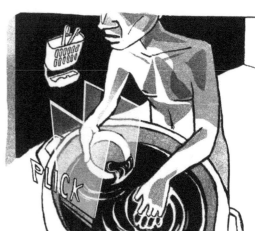

NOW, WHEN I'M NOT WITH HER, I DRIFT IN AN OCEAN OF SOUNDS. SOME BRIGHT AND SHARP, OTHERS DEEP AND SOLID.

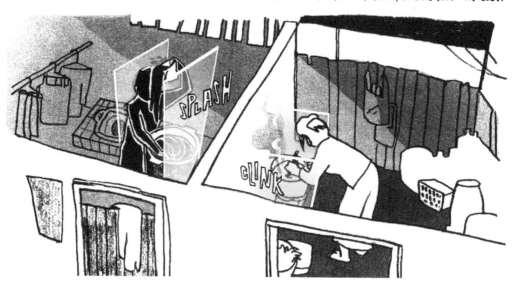

GAI IS MY ANCHOR TO THE PRESENT.

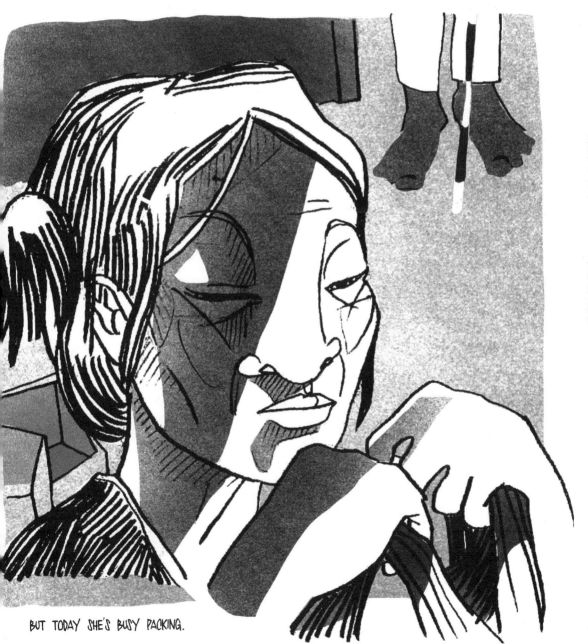

BUT TODAY SHE'S BUSY PACKING.

9

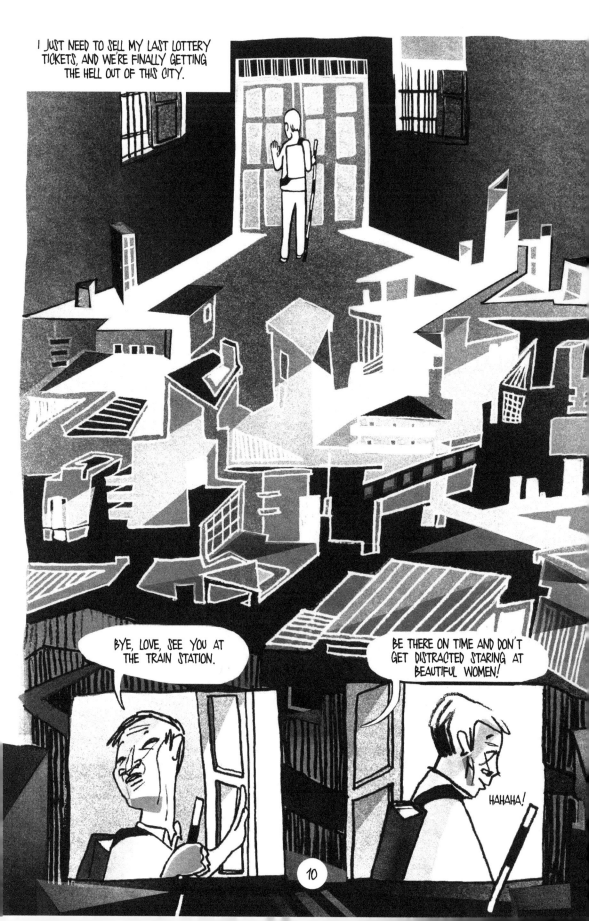

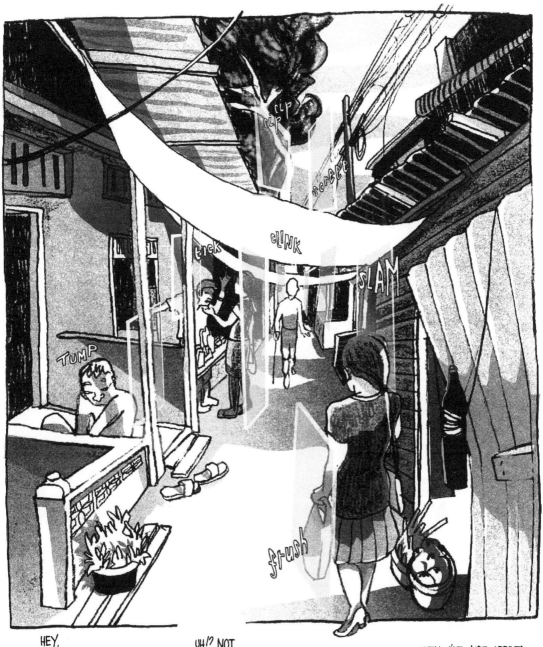

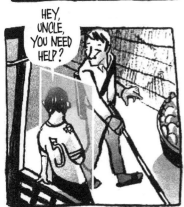

HEY, UNCLE, YOU NEED HELP?

UH!? NOT MANY NICE PEOPLE LEFT IN TOWN!

WELL, I'VE JUST ARRIVED.

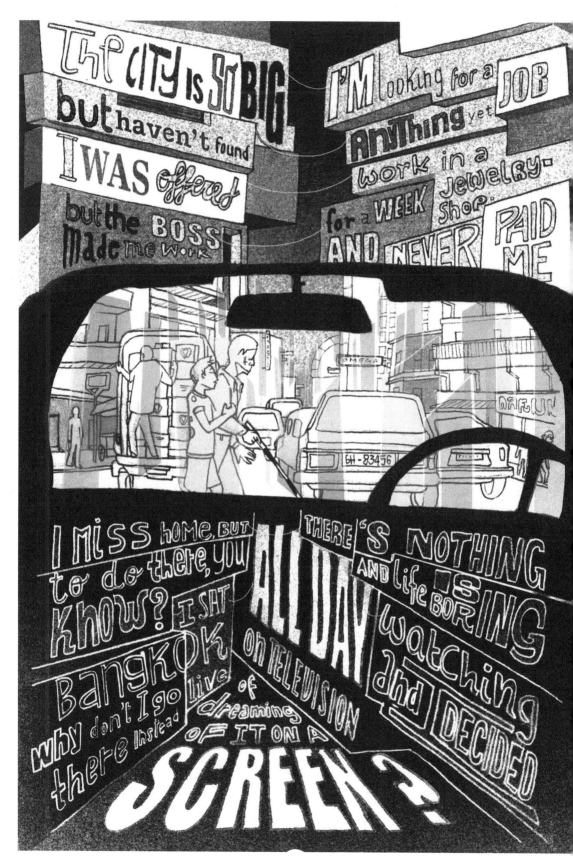

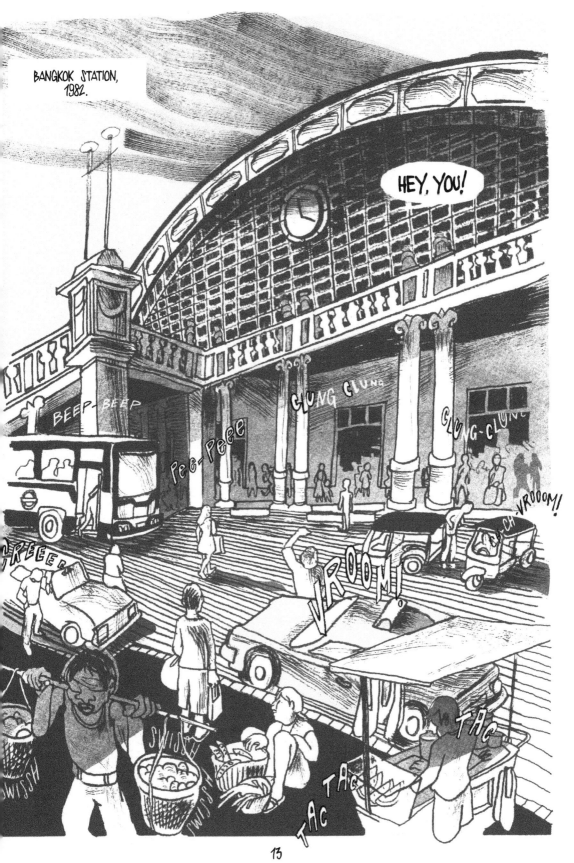

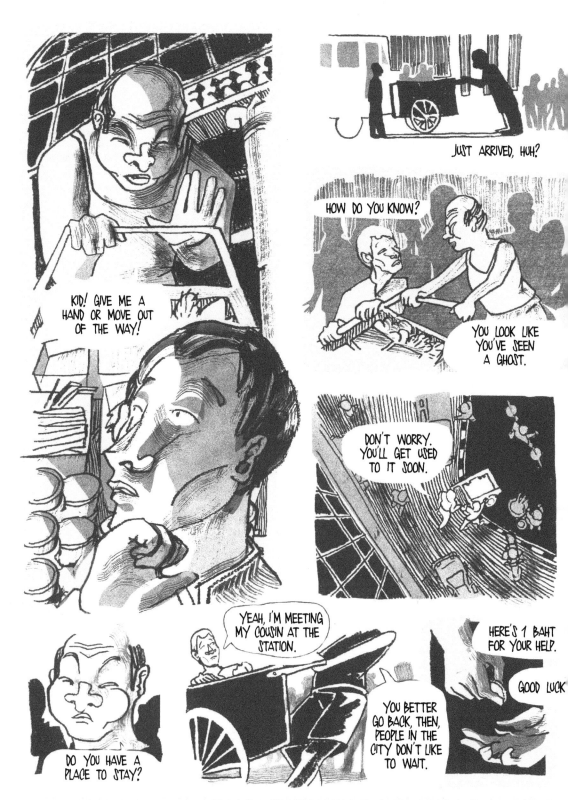

I HAD BEEN IN THE CITY FOR LESS THAN FIVE MINUTES AND I WAS ALREADY MAKING MONEY!

14

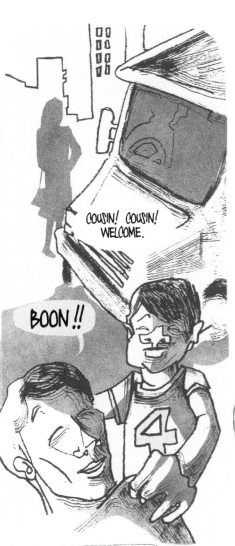

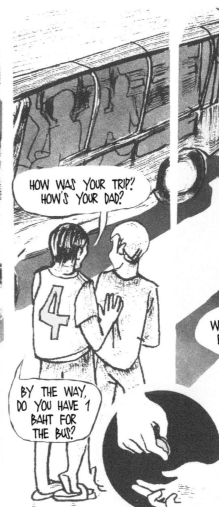

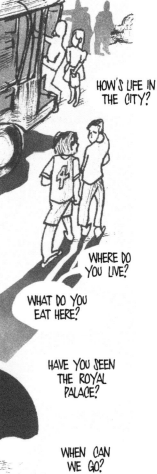

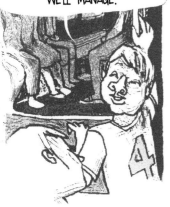

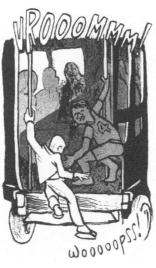

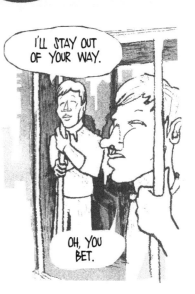

15

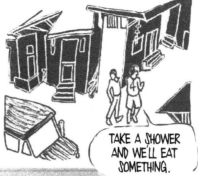

TAKE A SHOWER AND WE'LL EAT SOMETHING.

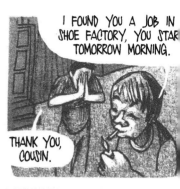

I FOUND YOU A JOB IN SHOE FACTORY, YOU STAR TOMORROW MORNING.

THANK YOU, COUSIN.

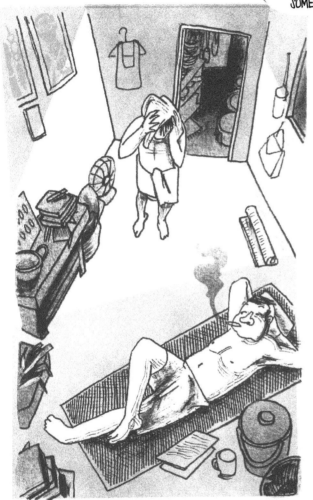

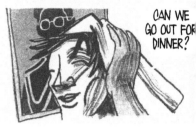

CAN WE GO OUT FOR DINNER?

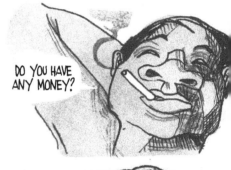

DO YOU HAVE ANY MONEY?

NO, I SPENT ALL I HAD TO GET HERE.

IT'S INSTANT NOODLES, THEN.

FOOD WAS BETTER AT HOME, BUT I FELL ASLEEP CRADLED BY THE SOUNDS OF THE CITY. I'D NEVER FELT SO ALIVE.

16

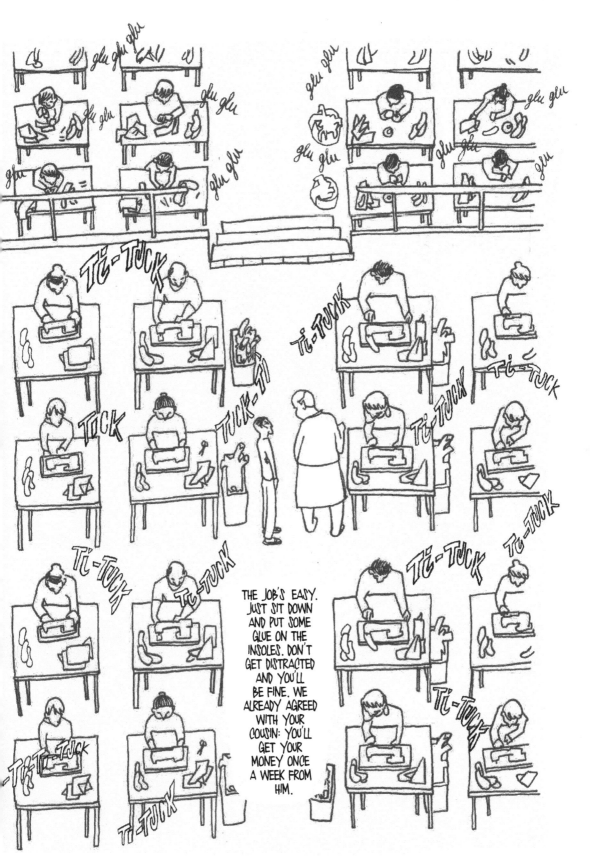

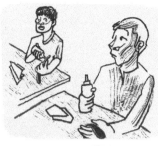

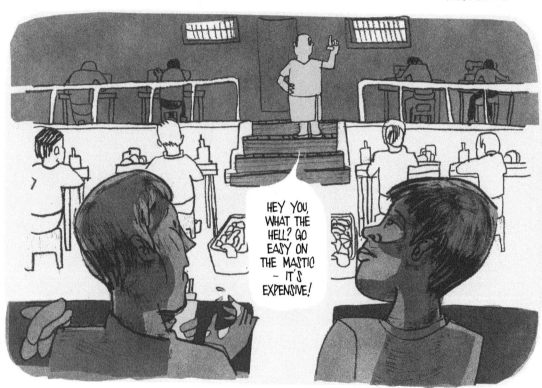

HEY YOU, WHAT THE HELL? GO EASY ON THE MASTIC — IT'S EXPENSIVE!

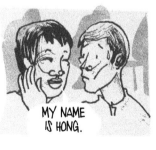

DON'T WORRY. HE YELLS A LOT BUT HE'S A GOOD GUY.

MY NAME IS HONG.

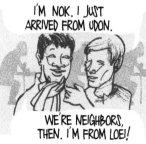

I'M NOK. I JUST ARRIVED FROM UDON.

WE'RE NEIGHBORS, THEN. I'M FROM LOEI!

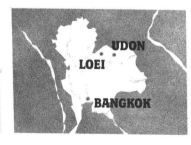

UDON

LOEI

BANGKOK

SITTING AT THAT TABLE, DAYS STARTED TO FLY BY.

WAIT!!

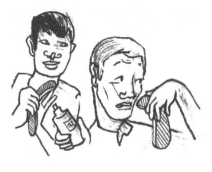

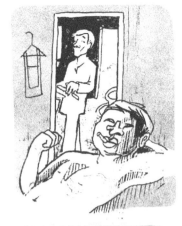

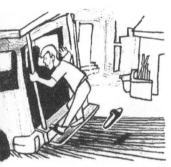

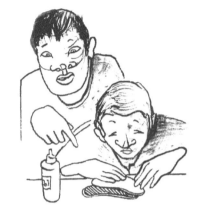

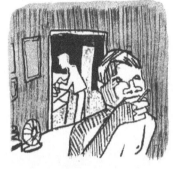

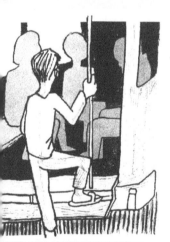

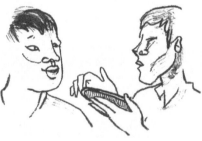

YOU'RE GETTING FASTER THAN ME.

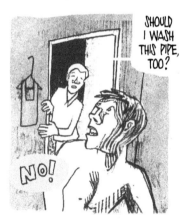

SHOULD I WASH THIS PIPE, TOO?

NO!

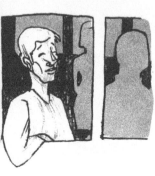

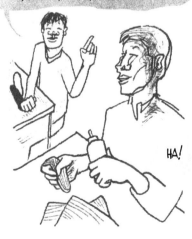

HA!

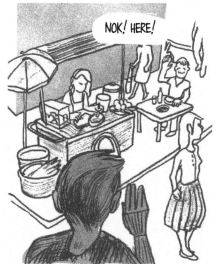

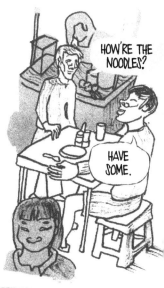

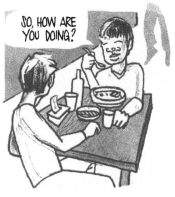

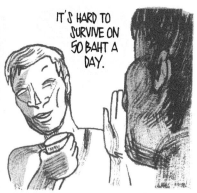

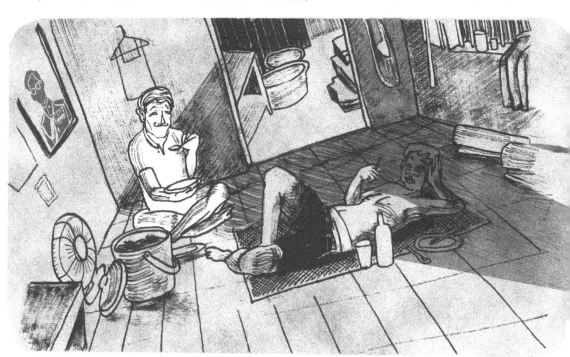

HERE'S YOUR MONEY.

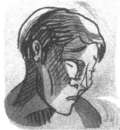

COUSIN, I DON'T MEAN TO BE DISRESPECTFUL...

BUT SOMEBODY TOLD ME THE PAY IS 100 BAHT.

WHO? WHO TOLD YOU THAT?

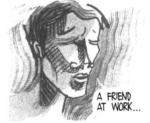

A FRIEND AT WORK...

A FRIEND AT WORK? DIDN'T THE BOSS TELL YOU TO JUST FOCUS ON THE SHOES?

YOU TRUST A STRANGER MORE THAN YOUR OWN COUSIN?

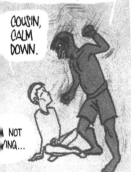

COUSIN, CALM DOWN.

NOT ...ING...

YES, YOU ARE. YOU SLEEP HERE FOR FREE AND...

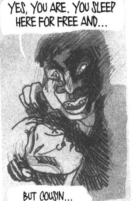

BUT COUSIN...

BUT WHAT?

YOU UNGRATEFUL ANIMAL.

YOU'RE JUST LIKE YOUR FATHER. LEANING ON YOUR MOTHER ALL THE TIME AND THEN, AFTER HER DEATH, ON US!!

ALWAYS ASKING FOR MORE...

LEAVE MY FATHER ALONE!!

YOU THINK I'M AN IDIOT?

YOU DO NOTHING ALL DAY!

YOU STEAL MY MONEY AND USE IT FOR DRUGS!

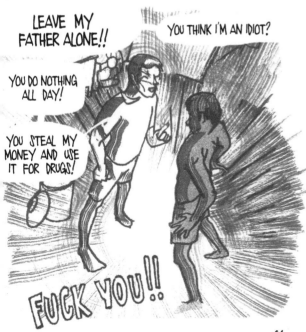

FUCK YOU!!

SLAM!!

21

I'D HEARD THE CITY

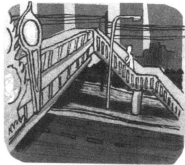

CHANGED EVERYBODY,

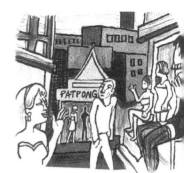

INCLUDING FAMILY.

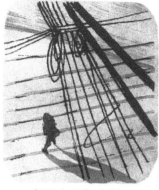

NOW I WAS ALONE,

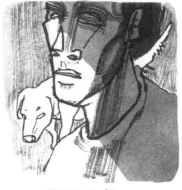

WITHOUT A JOB,

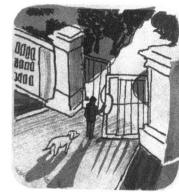

AND WITHOUT A HOME...

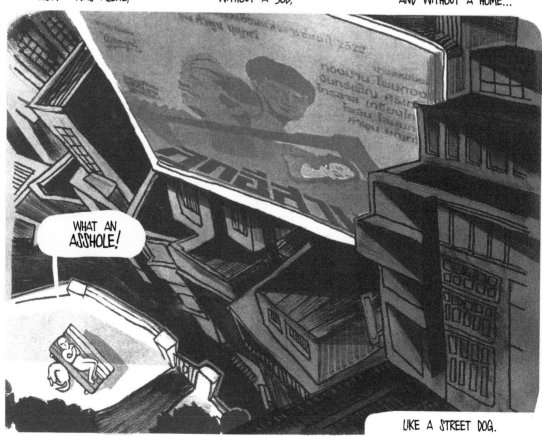

LIKE A STREET DOG.

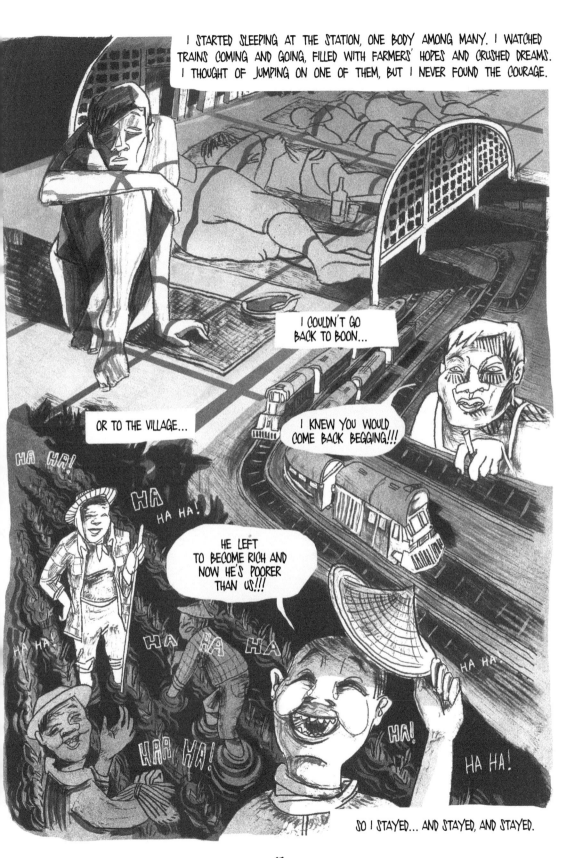

23

I BECAME PART OF THE CITY, INVISIBLE TO PASSERSBY.

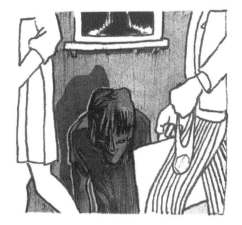

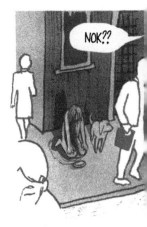

NOK??

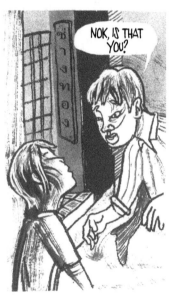

NOK, IS THAT YOU?

HONG!

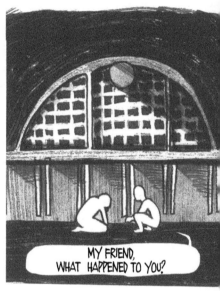

MY FRIEND, WHAT HAPPENED TO YOU?

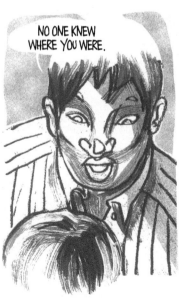

NO ONE KNEW WHERE YOU WERE.

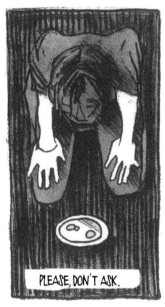

PLEASE, DON'T ASK.

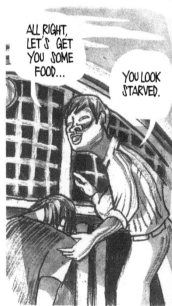

ALL RIGHT, LET'S GET YOU SOME FOOD...

YOU LOOK STARVED.

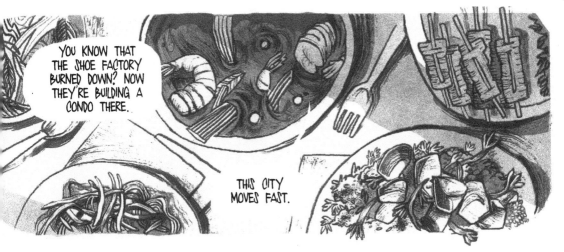

YOU KNOW THAT THE SHOE FACTORY BURNED DOWN? NOW THEY'RE BUILDING A CONDO THERE.

THIS CITY MOVES FAST.

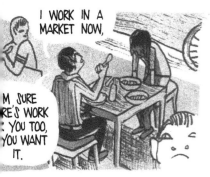

I WORK IN A MARKET NOW,

M SURE RE'S WORK YOU TOO, YOU WANT IT.

THERE'S ALWAYS ANOTHER TRAIN, NOK. YOU JUST MISSED ONE, DON'T LET THIS STOP YOU.

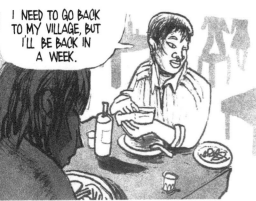

I NEED TO GO BACK TO MY VILLAGE, BUT I'LL BE BACK IN A WEEK.

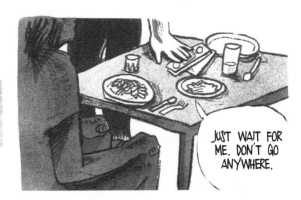

JUST WAIT FOR ME. DON'T GO ANYWHERE.

EVEN IF I'D WANTED TO...

WHERE COULD I HAVE GONE?

25

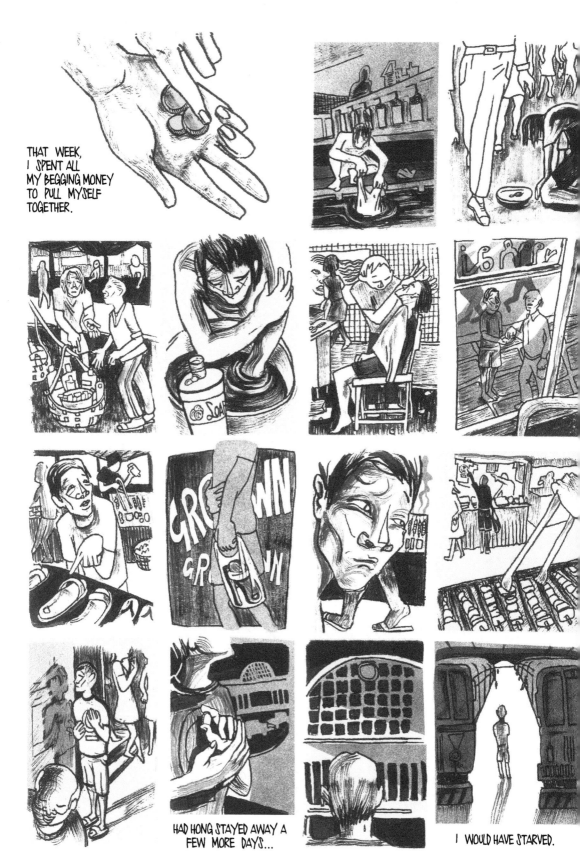

THAT WEEK,
I SPENT ALL
MY BEGGING MONEY
TO PULL MYSELF
TOGETHER.

HAD HONG STAYED AWAY A
FEW MORE DAYS...

I WOULD HAVE STARVED.

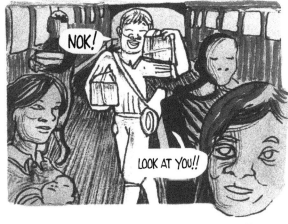

NOK!

LOOK AT YOU!!

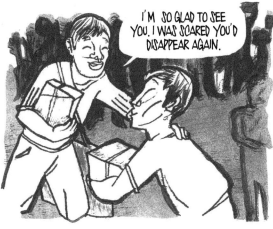

I'M SO GLAD TO SEE YOU. I WAS SCARED YOU'D DISAPPEAR AGAIN.

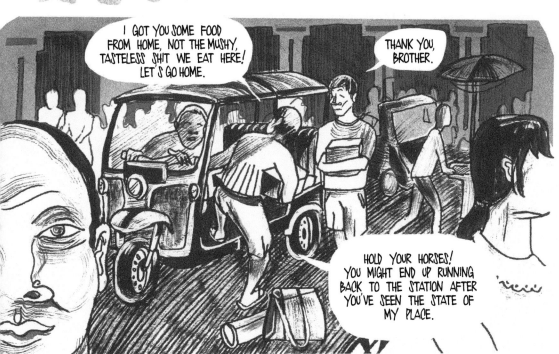

I GOT YOU SOME FOOD FROM HOME, NOT THE MUSHY, TASTELESS SHIT WE EAT HERE! LET'S GO HOME.

THANK YOU, BROTHER.

HOLD YOUR HORSES! YOU MIGHT END UP RUNNING BACK TO THE STATION AFTER YOU'VE SEEN THE STATE OF MY PLACE.

IT'S NOT MUCH...

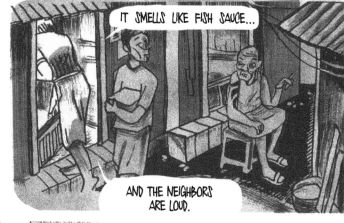

IT SMELLS LIKE FISH SAUCE...

AND THE NEIGHBORS ARE LOUD.

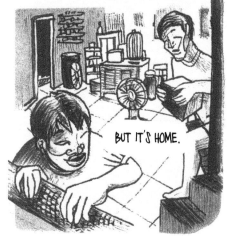

BUT IT'S HOME.

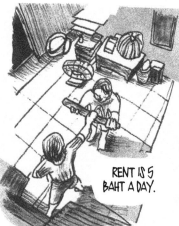

RENT IS 5 BAHT A DAY.

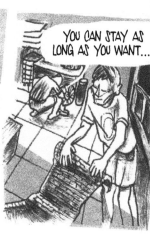

YOU CAN STAY AS LONG AS YOU WANT...

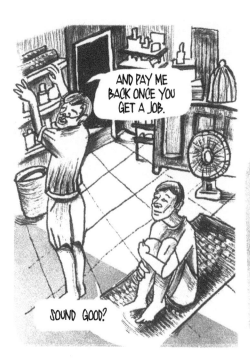

AND PAY ME BACK ONCE YOU GET A JOB.

SOUND GOOD?

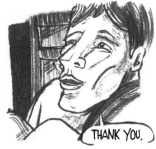

THANK YOU.

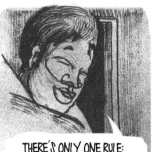

THERE'S ONLY ONE RULE: IF YOU COME BACK AND HEAR A WOMAN'S VOICE...

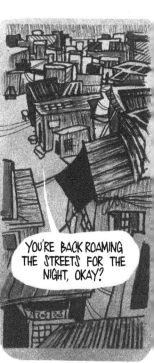

YOU'RE BACK ROAMING THE STREETS FOR THE NIGHT, OKAY?

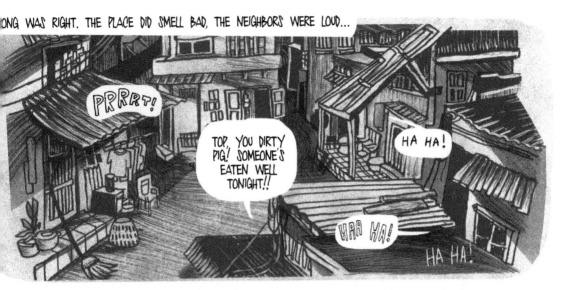

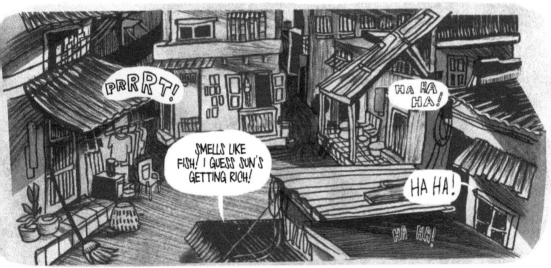

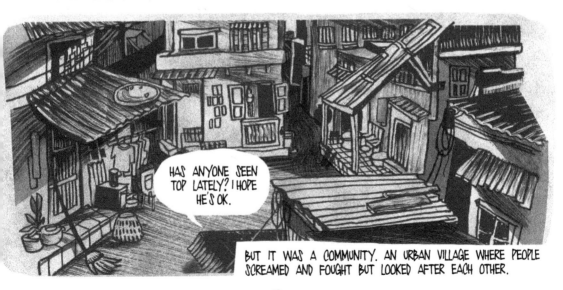

BUT IT WAS A COMMUNITY. AN URBAN VILLAGE WHERE PEOPLE SCREAMED AND FOUGHT BUT LOOKED AFTER EACH OTHER.

29

I STARTED WORKING AT THE MARKET WITH HONG.

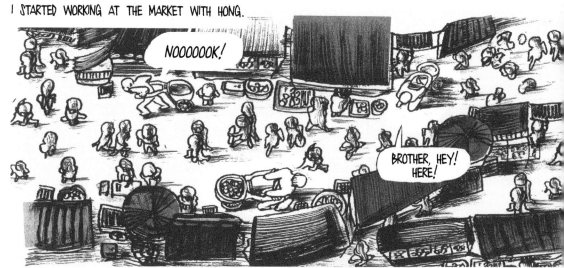

NOOOOOOK!

BROTHER, HEY! HERE!

YOU KNOW FAY, THE GIRL WHO SELLS COFFEE IN FRONT OF THE HOUSE? SHE FINALLY AGREED TO GO OUT WITH ME, BUT ONLY IF SHE CAN BRING A FRIEND ALONG. YOU GOTTA HELP ME OUT.

WHAT'S HER FRIEND LIKE?

WHO CARES? NOK, COME ON, YOU OWE ME! WE'LL HAVE FUN, I PROMISE!

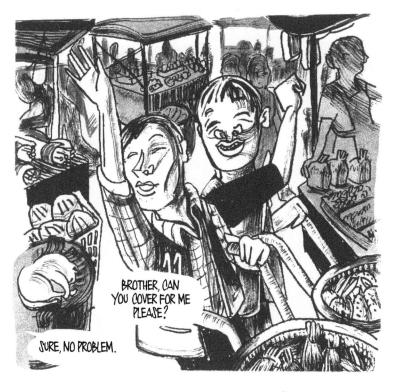

BROTHER, CAN YOU COVER FOR ME PLEASE?

SURE, NO PROBLEM.

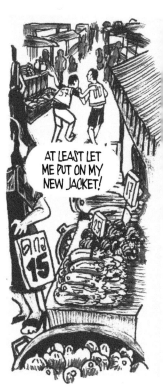

AT LEAST LET ME PUT ON MY NEW JACKET!

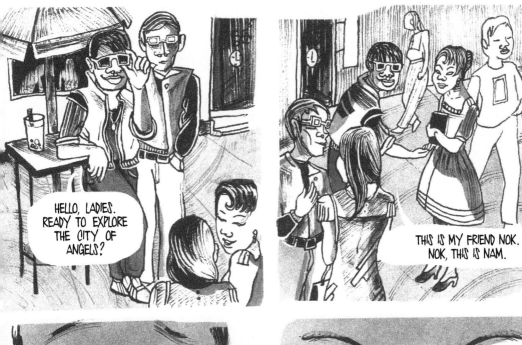

She was stunning. Had it not been for my sunglasses, she'd have noticed I couldn't stop looking at her.

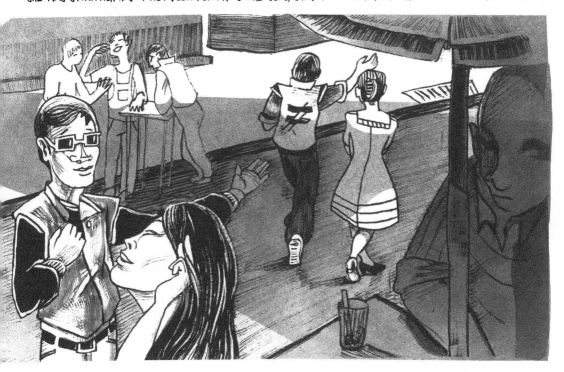

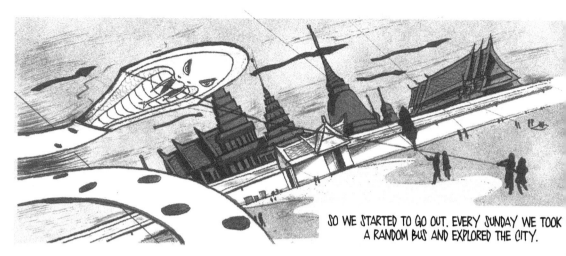

SO WE STARTED TO GO OUT. EVERY SUNDAY WE TOOK A RANDOM BUS AND EXPLORED THE CITY.

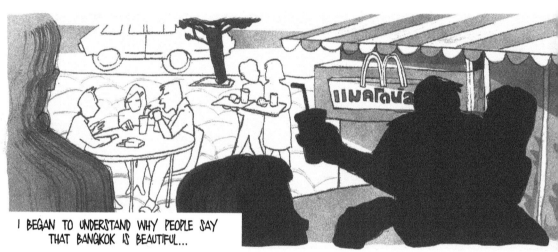

I BEGAN TO UNDERSTAND WHY PEOPLE SAY THAT BANGKOK IS BEAUTIFUL...

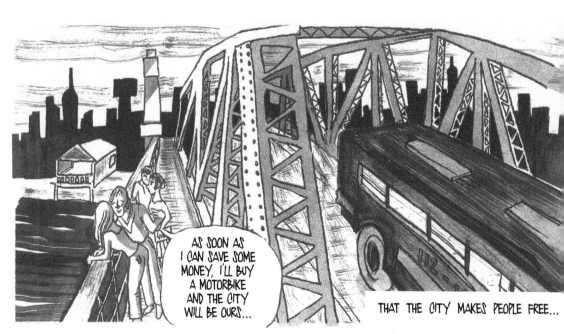

AS SOON AS I CAN SAVE SOME MONEY, I'LL BUY A MOTORBIKE AND THE CITY WILL BE OURS...

THAT THE CITY MAKES PEOPLE FREE...

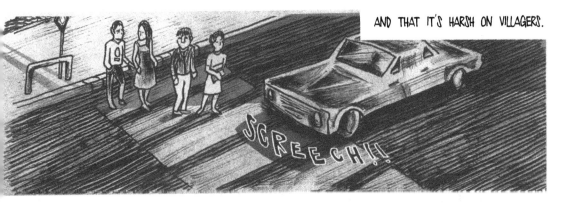
AND THAT IT'S HARSH ON VILLAGERS.

SCREECH!!

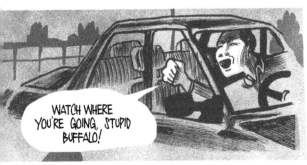
WATCH WHERE YOU'RE GOING, STUPID BUFFALO!

FUCK YOU

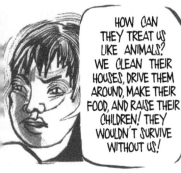
HOW CAN THEY TREAT US LIKE ANIMALS? WE CLEAN THEIR HOUSES, DRIVE THEM AROUND, MAKE THEIR FOOD, AND RAISE THEIR CHILDREN! THEY WOULDN'T SURVIVE WITHOUT US!

DON'T TAKE EVERYTHING SO SERIOUSLY. IF HE KEEPS DRIVING LIKE THAT, HE'LL TAKE CARE OF HIMSELF. LET'S GO, THE MOVIE IS STARTING.

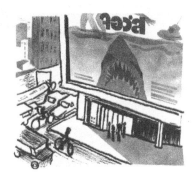

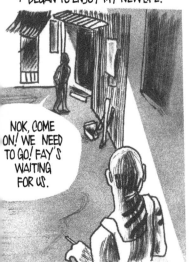
I BEGAN TO ENJOY MY NEW LIFE.

NOK, COME ON! WE NEED TO GO! FAY'S WAITING FOR US.

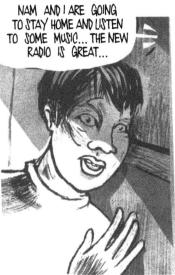
NAM AND I ARE GOING TO STAY HOME AND LISTEN TO SOME MUSIC... THE NEW RADIO IS GREAT...

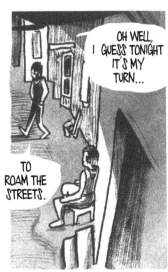
OH WELL, I GUESS TONIGHT IT'S MY TURN...

TO ROAM THE STREETS.

HONG AND I BECAME LIKE FAMILY.

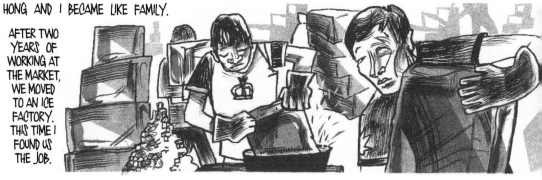

AFTER TWO YEARS OF WORKING AT THE MARKET, WE MOVED TO AN ICE FACTORY. THIS TIME I FOUND US THE JOB.

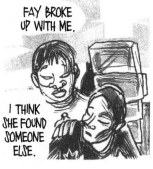

FAY BROKE UP WITH ME.

I THINK SHE FOUND SOMEONE ELSE.

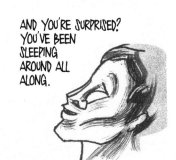

AND YOU'RE SURPRISED? YOU'VE BEEN SLEEPING AROUND ALL ALONG.

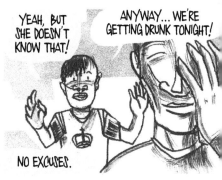

YEAH, BUT SHE DOESN'T KNOW THAT!

NO EXCUSES.

ANYWAY... WE'RE GETTING DRUNK TONIGHT!

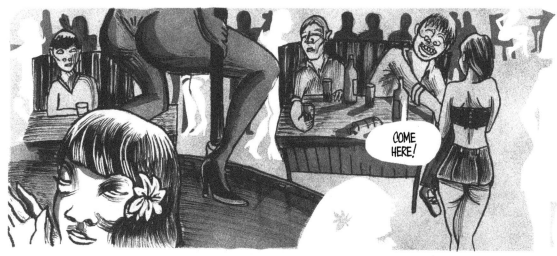

COME HERE!

WHY DON'T WE GO IN THE BACK?

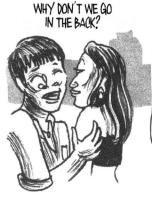

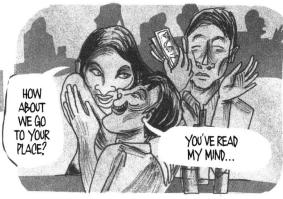

HOW ABOUT WE GO TO YOUR PLACE?

YOU'VE READ MY MIND...

ROAM, MY FRIEND, ROAM!

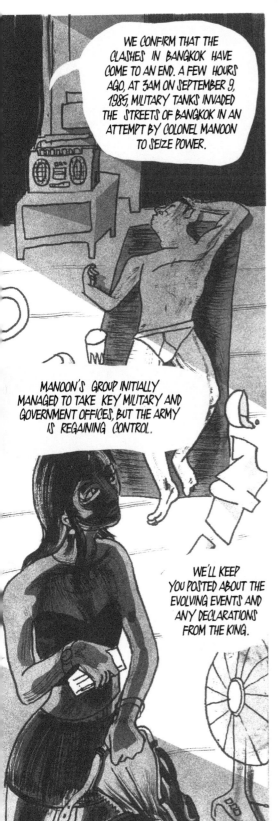

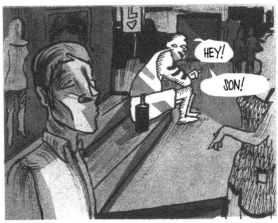

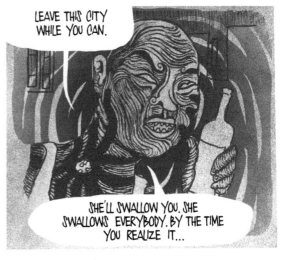

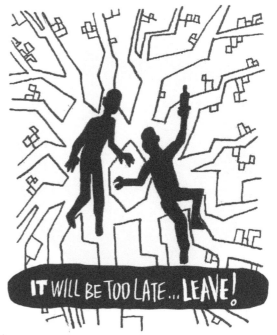

35

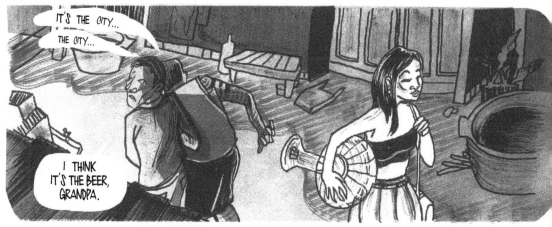

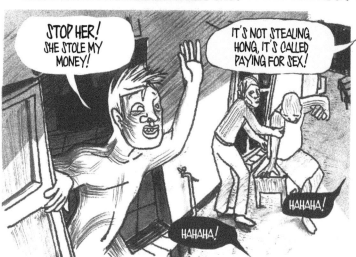

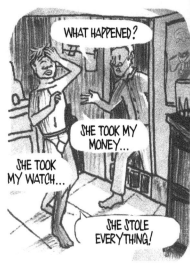

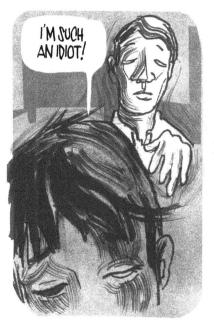

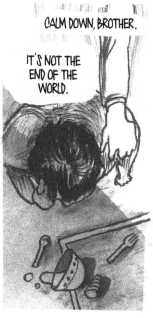

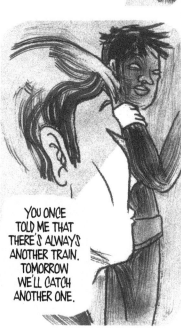

36

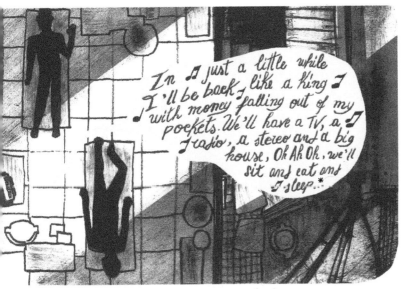

*"SA-UDON" BY CARABAO, FROM THE ALBUM "AMERI-GOY" (1985).

STARTING ANEW WASN'T HARD. THE ECONOMY WAS GOOD AND WORK EASY TO COME BY.

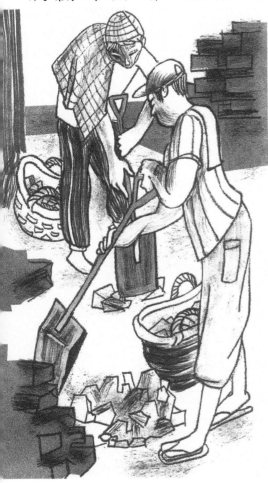

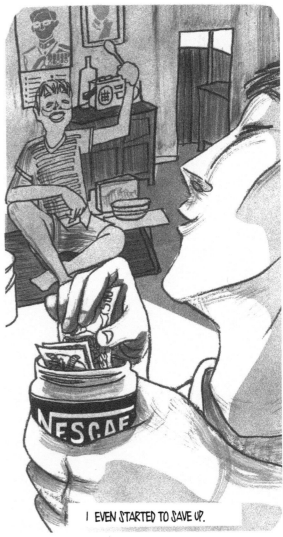

I EVEN STARTED TO SAVE UP.

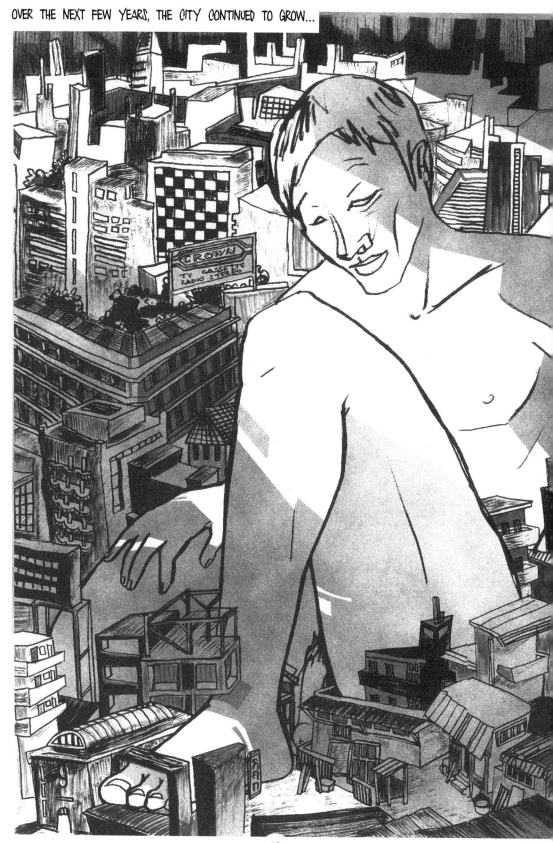

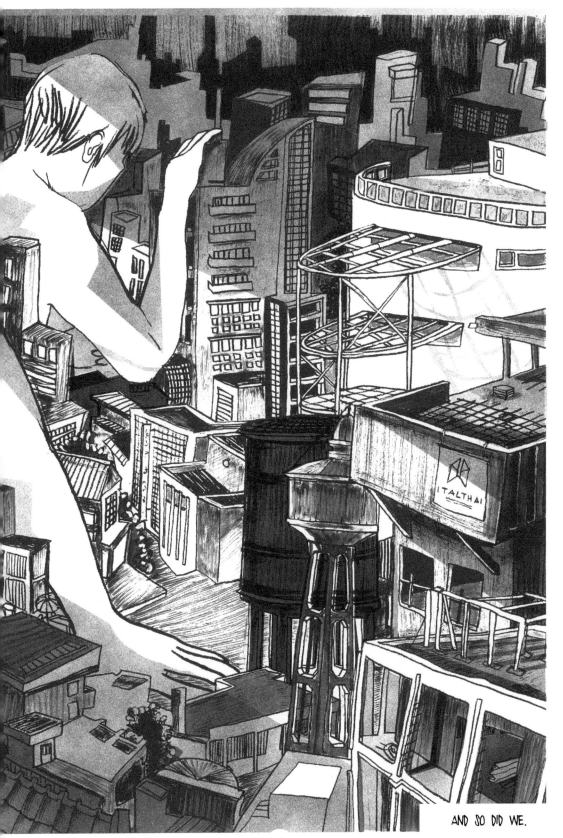

AND SO DID WE.

FINALLY, I COULD GET
THE MOTORBIKE I'D ALWAYS
DREAMT OF: THE YAMAHA FZR.

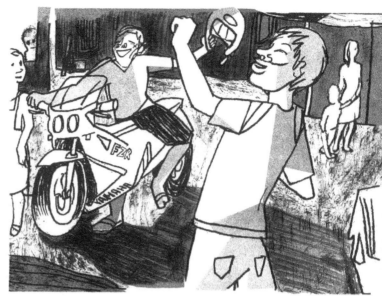

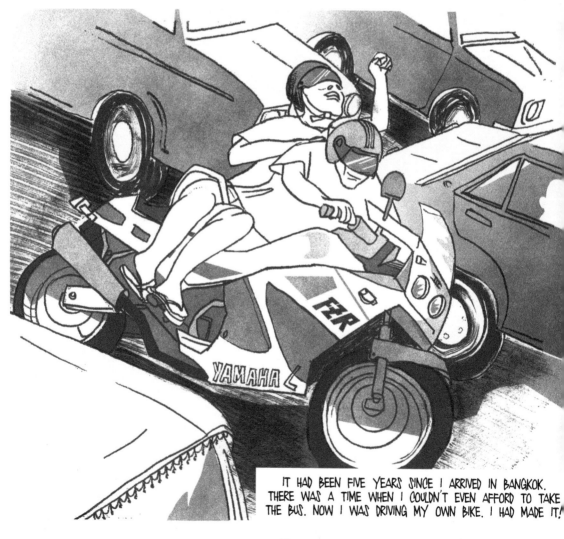

IT HAD BEEN FIVE YEARS SINCE I ARRIVED IN BANGKOK.
THERE WAS A TIME WHEN I COULDN'T EVEN AFFORD TO TAKE
THE BUS. NOW I WAS DRIVING MY OWN BIKE. I HAD MADE IT!

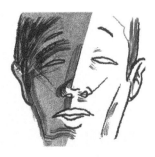

BROTHER, I THINK IT'S TIME FOR ME TO GO BACK HOME, AT LEAST FOR A WHILE.

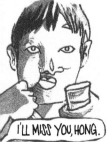

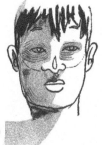

I'LL MISS YOU, HONG.

I WON'T!

I'LL BE HAVING ALL THE FUN AND YOU'LL BE BORED TO DEATH BACK THERE. HAHAHA!

NOK, YOU KNOW YOU'LL ALWAYS HAVE A PLACE HERE.

YOU TOO, WHEREVER I END UP.

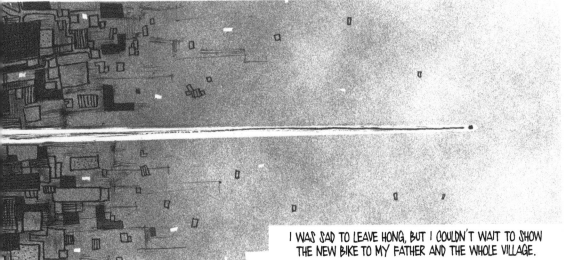

I WAS SAD TO LEAVE HONG, BUT I COULDN'T WAIT TO SHOW THE NEW BIKE TO MY FATHER AND THE WHOLE VILLAGE.

41

CHAPTER

2

EVER SINCE MY VISION WENT BLACK, THE CITY HAS LOST ITS ATTRACTION.
IT USED TO BE FILLED WITH OBJECTS AND PEOPLE. NOW I MOVE ABOUT IN A BLANK SPACE, WASHED
OVER BY WAVES OF SOUND THAT BOUNCE OFF THE CONCRETE...

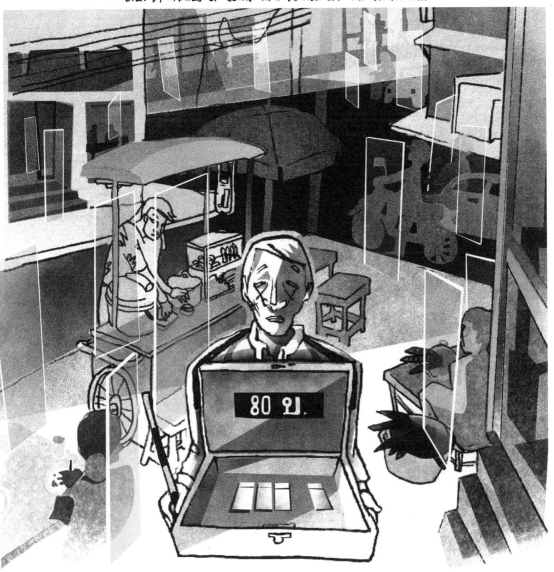

AT TIMES, FROM THE TIDE,
A SOUND SURFACES, SHINY.

43

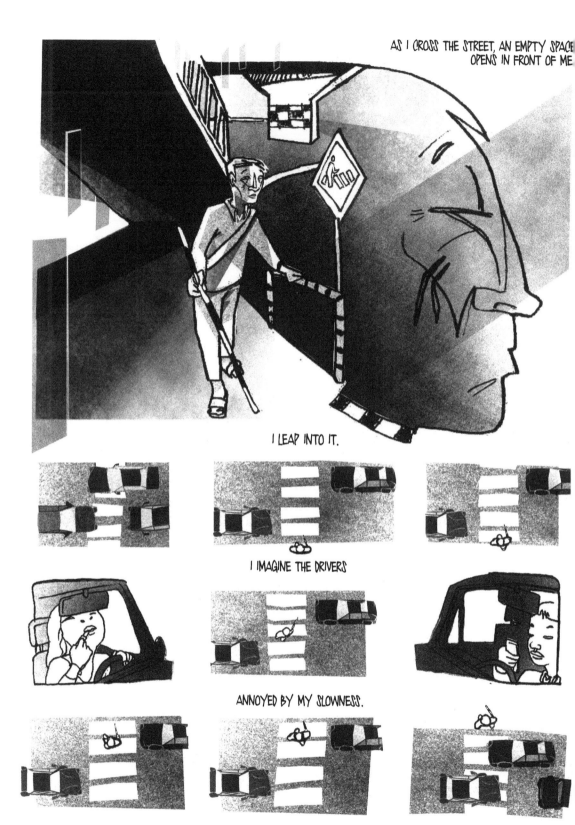

AS I CROSS THE STREET, AN EMPTY SPACE OPENS IN FRONT OF ME.

I LEAP INTO IT.

I IMAGINE THE DRIVERS

ANNOYED BY MY SLOWNESS.

TIME IS MONEY IN BANGKOK, AND THERE'S NOTHING MORE IMPORTANT THAN MONEY HERE.

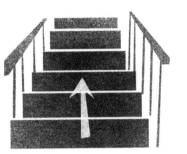

WHEN I FINALLY REACH
THE STAIRS, I FEEL SAFE.

PEOPLE WHO CAN SEE THINK THE
STAIRS MUST BE DIFFICULT FOR ME.

BUT THERE'S ALWAYS A HANDRAIL
OR A WALL TO LEAN ON.

THEY'RE MUCH HARDER FOR THE VENDOR DRAGGING HIS CART.

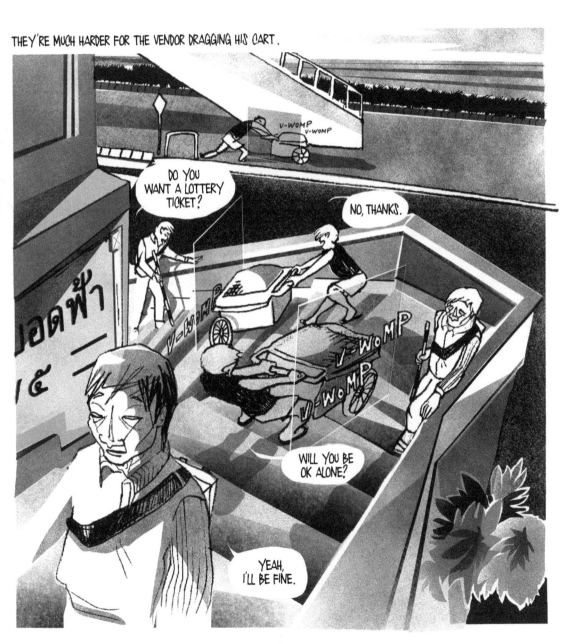

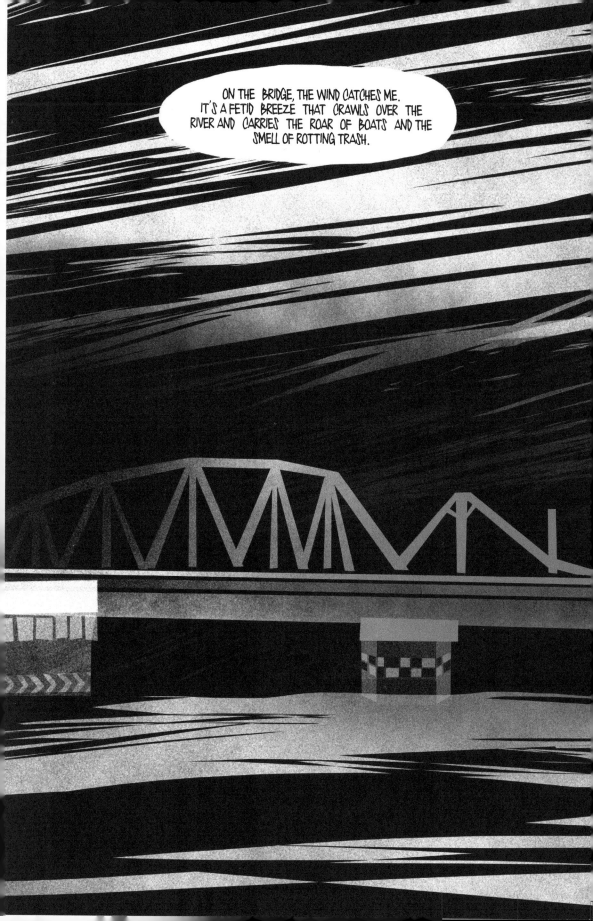

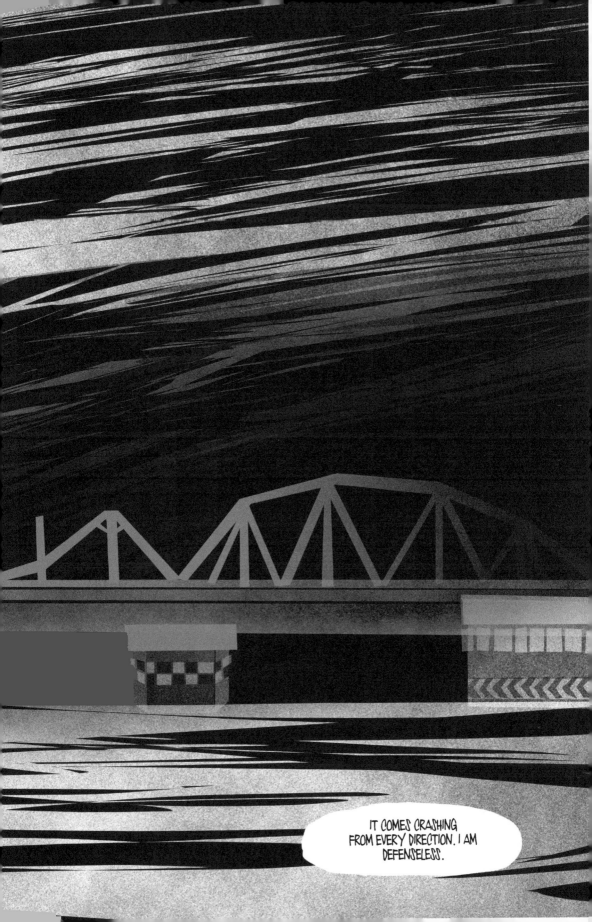

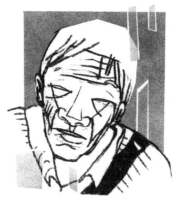

BEFORE, I COULD JUST CLOSE
MY EYES AND THE CITY WOULD
LEAVE ME ALONE.

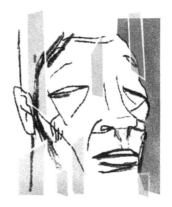

NOW I CAN'T STOP ITS SOUNDS
OR ITS SMELLS.

I JUST WANT TO BE ABLE TO
TURN THEM OFF.

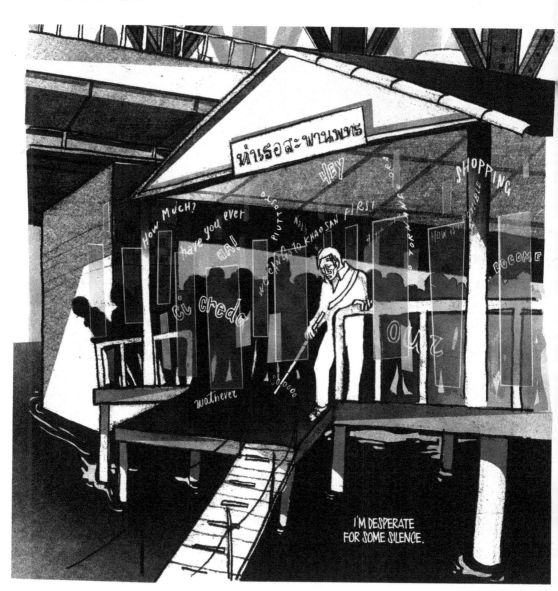

I'M DESPERATE
FOR SOME SILENCE.

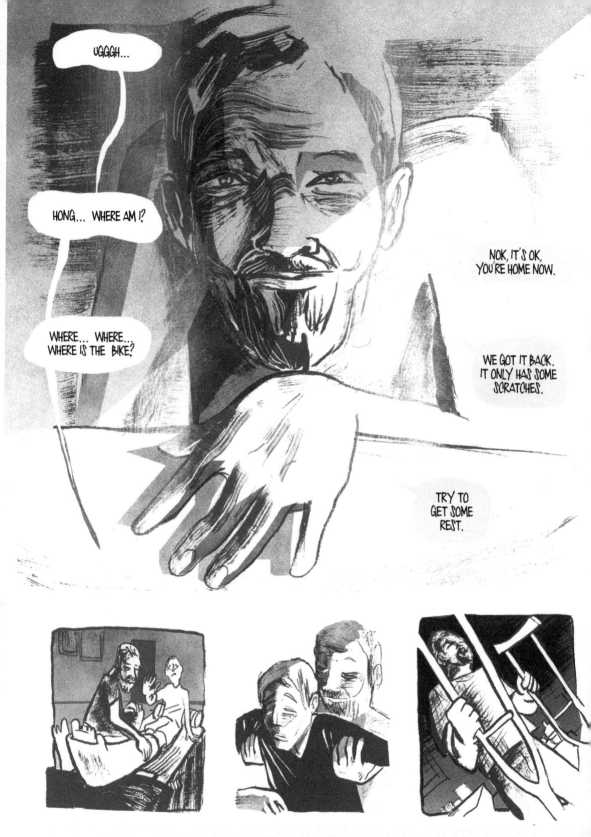

I WAS BACK IN THE VILLAGE. BUT INSTEAD OF THE WELCOME PARTY I EXPECTED, MY FATHER BECAME MY NURSE.

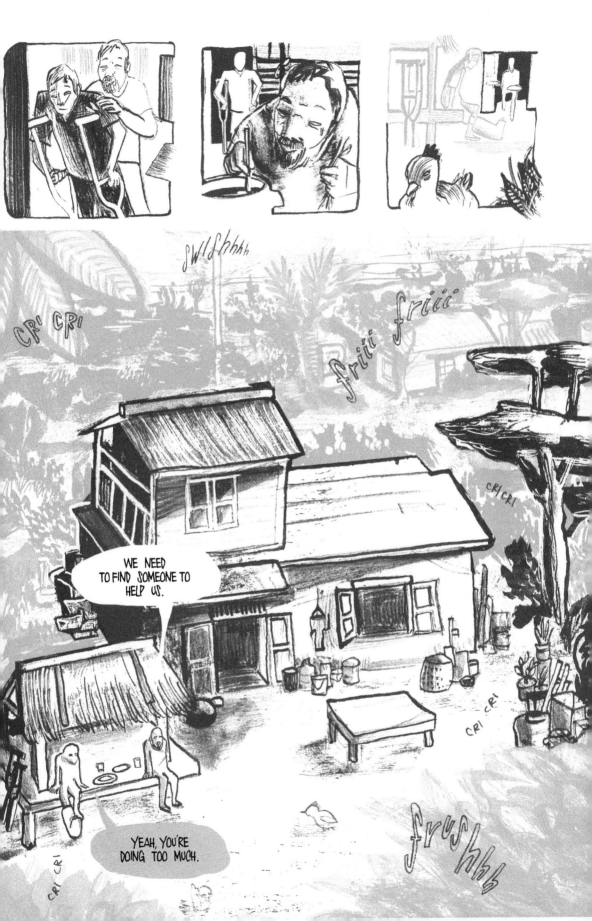

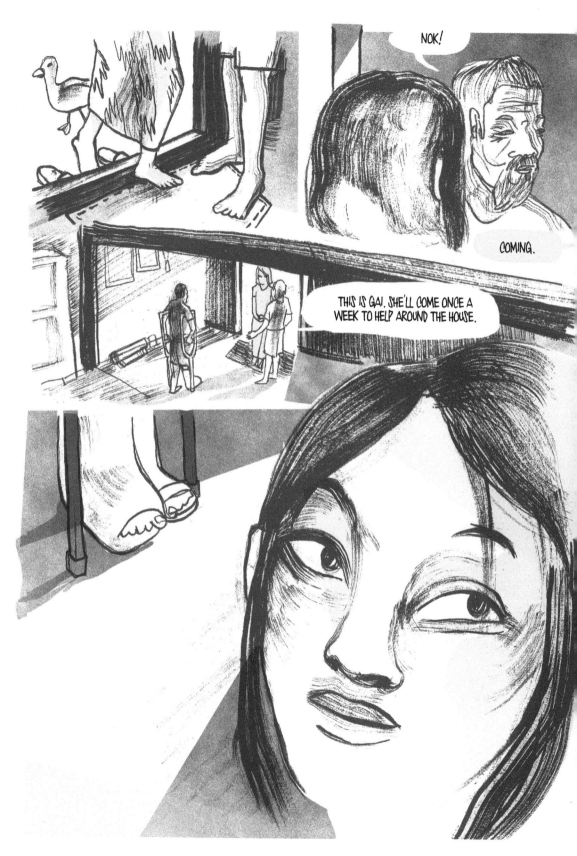

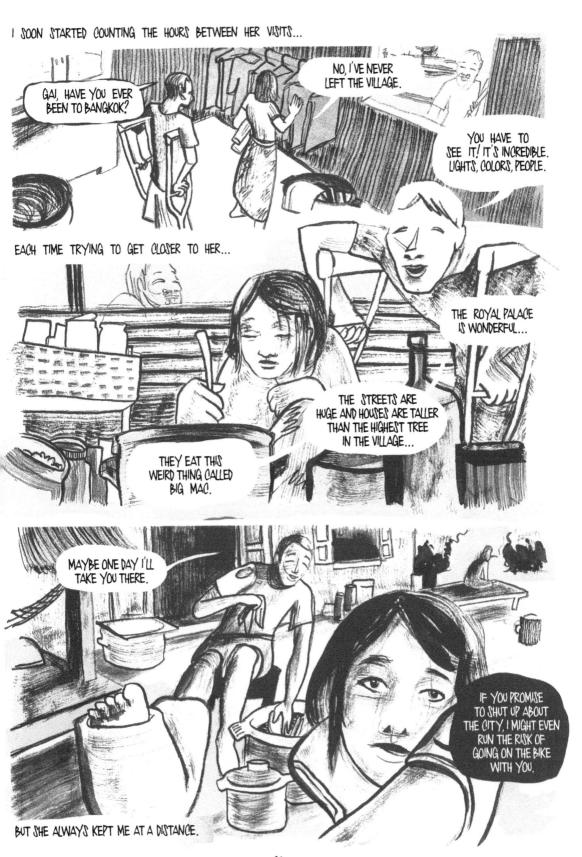

53

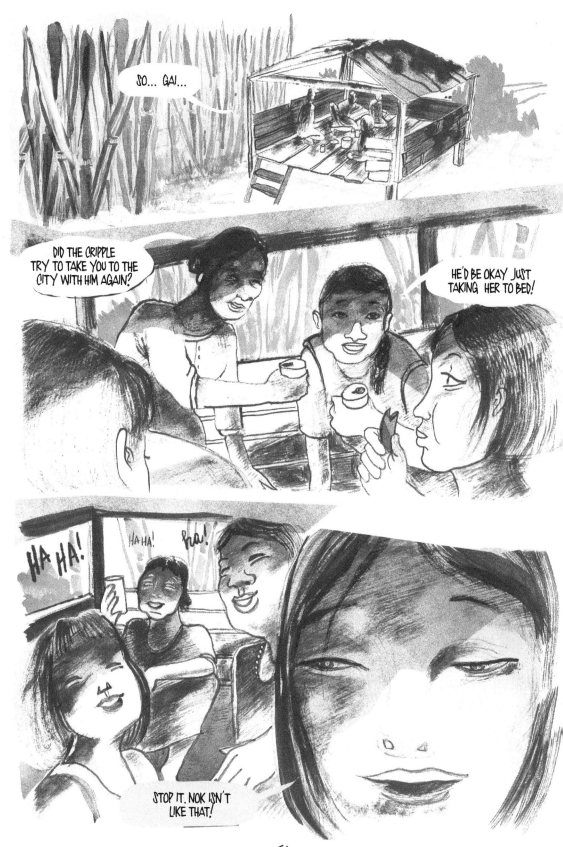

54

AFTER A FEW MONTHS, I COULD FINALLY WALK AGAIN. BUT THAT MEANT THAT GAI STOPPED COMING OVER. I WANTED TO ASK HER OUT, BUT FIRST I HAD A DEBT TO REPAY.

AUNTIE, CAN I MAKE A CALL TO BANGKOK?

MY FATHER HAD DONE SO MUCH FOR ME. IN THE VILLAGE, WHEN YOU FEEL INDEBTED TO YOUR PARENTS, YOU BECOME A MONK FOR SOME MONTHS TO EARN THEM BETTER KARMA IN THE NEXT LIFE. I KNEW MY DAD WOULD BE HAPPY, BUT I COULDN'T MAKE SUCH A BIG DECISION WITHOUT TELLING MY BEST FRIEND.

WHAT'S THE NUMBER?

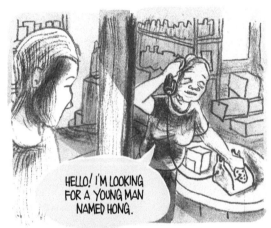

HELLO! I'M LOOKING FOR A YOUNG MAN NAMED HONG.

HONG!!!

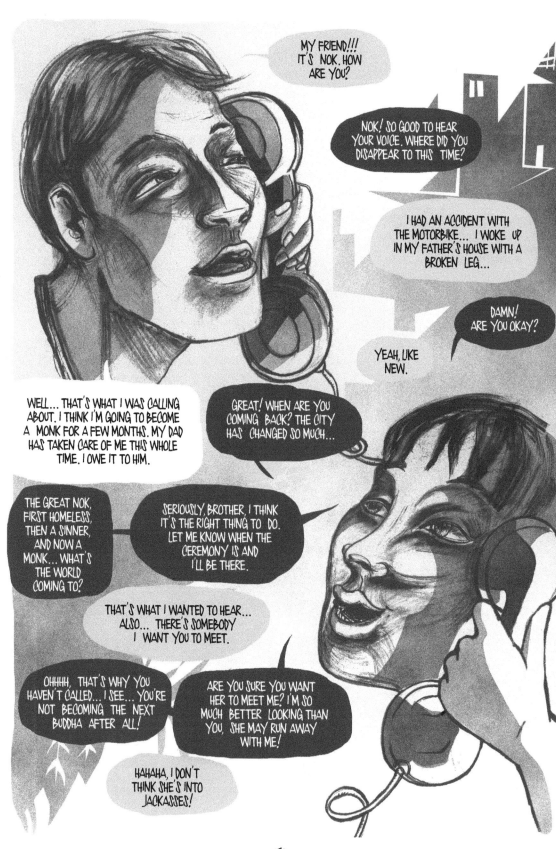

56

THE ORDINATION CEREMONY LASTED THREE DAYS.

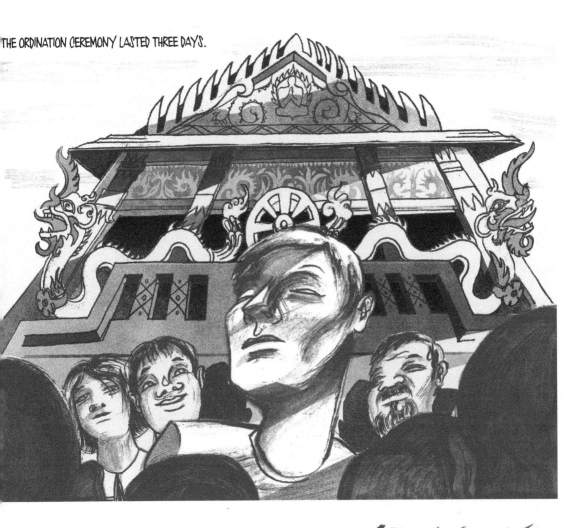

FIRST THEY CUT MY HAIR.

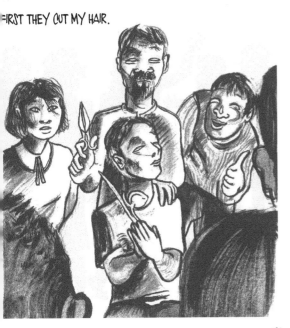

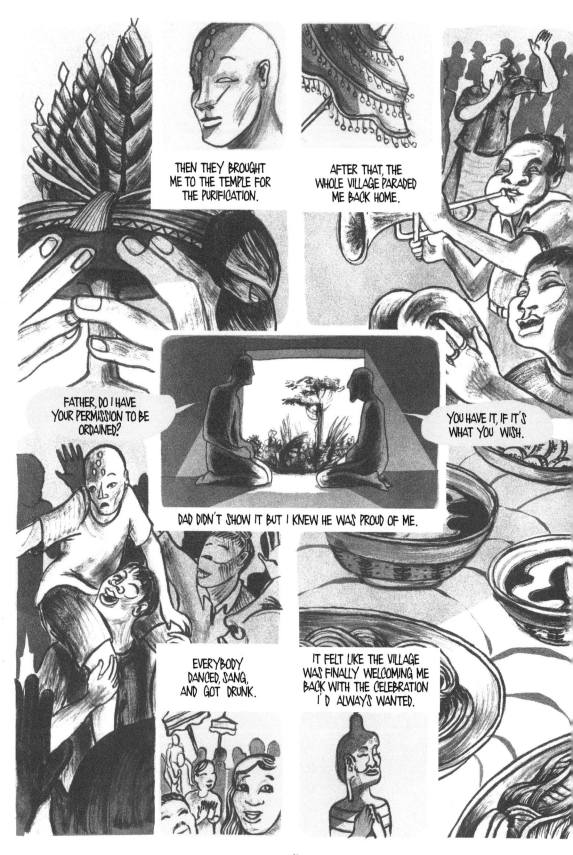

THEN THEY BROUGHT ME TO THE TEMPLE FOR THE PURIFICATION.

AFTER THAT, THE WHOLE VILLAGE PARADED ME BACK HOME.

FATHER, DO I HAVE YOUR PERMISSION TO BE ORDAINED?

YOU HAVE IT, IF IT'S WHAT YOU WISH.

DAD DIDN'T SHOW IT BUT I KNEW HE WAS PROUD OF ME.

EVERYBODY DANCED, SANG, AND GOT DRUNK.

IT FELT LIKE THE VILLAGE WAS FINALLY WELCOMING ME BACK WITH THE CELEBRATION I'D ALWAYS WANTED.

58

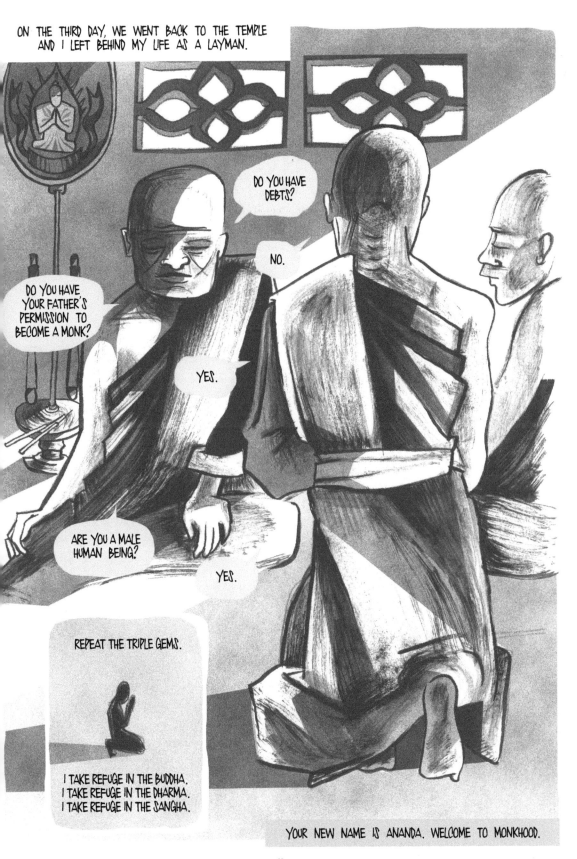

59

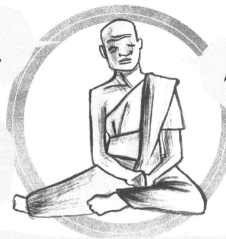

LORD BUDDHA TEACHES US THAT THERE ARE THREE CHARACTERISTICS OF EXISTENCE: SUFFERING, IMPERMANENCE, AND SELFLESSNESS.

BUDDHA ASKS: WHAT MAKES US SUFFER? ANANDA, DO YOU KNOW WHAT MAKES YOU SUFFER?

SUFFERING IS EVERYWHERE. YOU WANT TO ACHIEVE SOMETHING AND YOU FAIL. YOU LOVE A PERSON, BUT SHE DOES NOT RECIPROCATE. YOU WANT TO CONTROL YOUR LIFE, BUT YOU CANNOT.

...

IT IS A HARD QUESTION, RIGHT? WE ALL KNOW WHAT SUFFERING FEELS LIKE BUT NOT WHERE IT COMES FROM. THE BUDDHA TEACHES US THAT IT DOES NOT COME FROM LIFE ITSELF BUT FROM HOW WE REACT TO IT. WE DESIRE SOMETHING AND WE CANNOT ACCEPT THE GAP BETWEEN WHAT WE WANT AND WHAT WE GET. THIS COMES FROM OUR IGNORANCE. WE DO NOT KNOW AND DO NOT ACCEPT THE WORLD AS IT IS, BUT WE CLING TO OUR DESIRES. THIS ATTACHMENT IS POINTLESS. THINGS COME AND GO, DESIRES COME AND GO, ALWAYS CHANGING. THIS IS THE SECOND TEACHING OF THE BUDDHA: EVERYTHING IS IMPERMANENT. EVEN THE TALLEST MOUNTAIN IS WORN BY THE RIVER. SO DOES IT MAKE ANY SENSE TO SAY THAT THE MOUNTAIN EXISTS, IF IT IS BOUND TO DISAPPEAR?

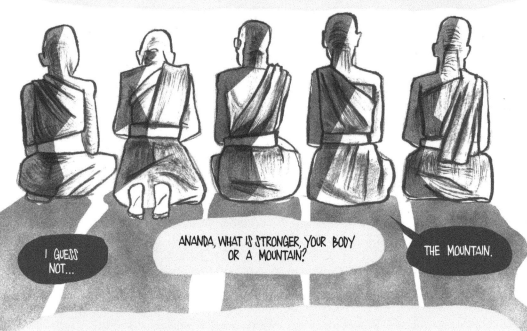

I GUESS NOT...

ANANDA, WHAT IS STRONGER, YOUR BODY OR A MOUNTAIN?

THE MOUNTAIN.

AND YET EVEN THE MOUNTAIN WILL BE CONSUMED, IT IS BUT A FORM DESTINED TO CHANGE. WE KNOW THIS, BUT WE STILL BELIEVE THAT OUR BODY AND OUR MIND ARE UNCHANGING. THIS IS OUR MAIN IGNORANCE. WE DO NOT REALIZE THAT OUR SELF IS NOTHING OTHER THAN A PASSING FORM THAT WILL CHANGE AND FALL APART. THIS IS THE THIRD TEACHING OF THE BUDDHA: THERE IS NO SELF, JUST IMPERMANENT STATES TO WHICH WE SHOULD NOT BE ATTACHED. THIS IS WHERE OUR SUFFERING COMES FROM.

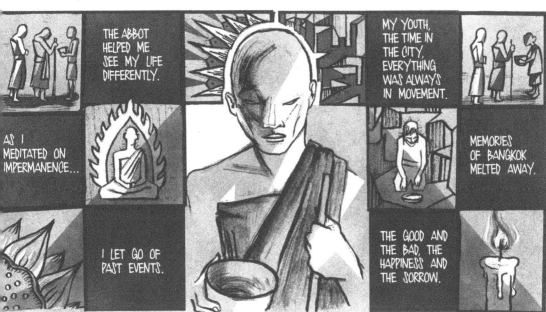

THE ABBOT HELPED ME SEE MY LIFE DIFFERENTLY.

MY YOUTH, THE TIME IN THE CITY, EVERYTHING WAS ALWAYS IN MOVEMENT.

AS I MEDITATED ON IMPERMANENCE...

MEMORIES OF BANGKOK MELTED AWAY.

I LET GO OF PAST EVENTS.

THE GOOD AND THE BAD, THE HAPPINESS AND THE SORROW.

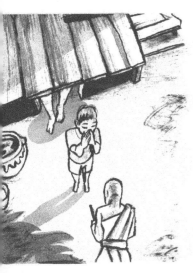
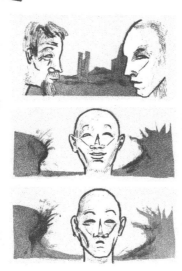

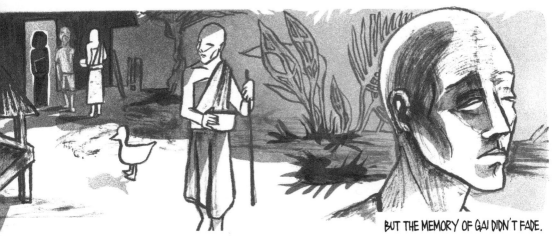

BUT THE MEMORY OF GAI DIDN'T FADE.

61

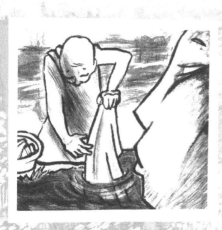

ABBOT, I'M LISTENING TO THE WORDS OF THE BUDDHA, FOLLOWING HIS PATH, AND MEDITATING WITH CONCENTRATION, BUT THE THOUGHT OF A GIRL KEEPS COMING BACK. THEY'RE NOT IMPURE THOUGHTS, BUT THEY WON'T LET ME GO. WHAT SHOULD I DO?

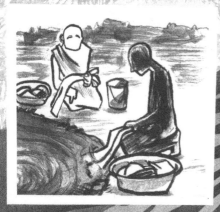

ANANDA, THE LIFE OF THE MONKS IS NOT FOREVER. JUST LIKE EVERYTHING ELSE IN LIFE, IT IS JUST A PHASE. FOR SOME PEOPLE IT LASTS AS LONG AS LIFE, BUT NOT FOR EVERYONE. GO BE WITH HER BUT REMAIN ON THE PATH OF BUDDHA. ALWAYS REMEMBER RIGHT UNDERSTANDING, RIGHT SPEECH, AND RIGHT ACTION.

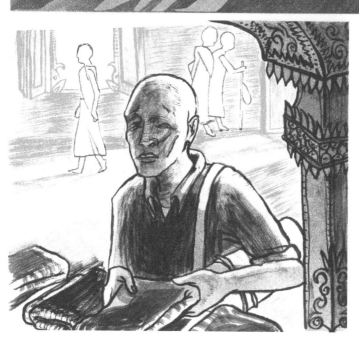

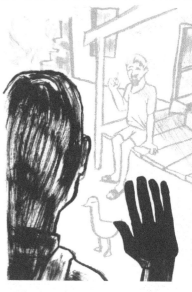

THE FOLLOWING DAY, I LEFT THE TEMPLE...

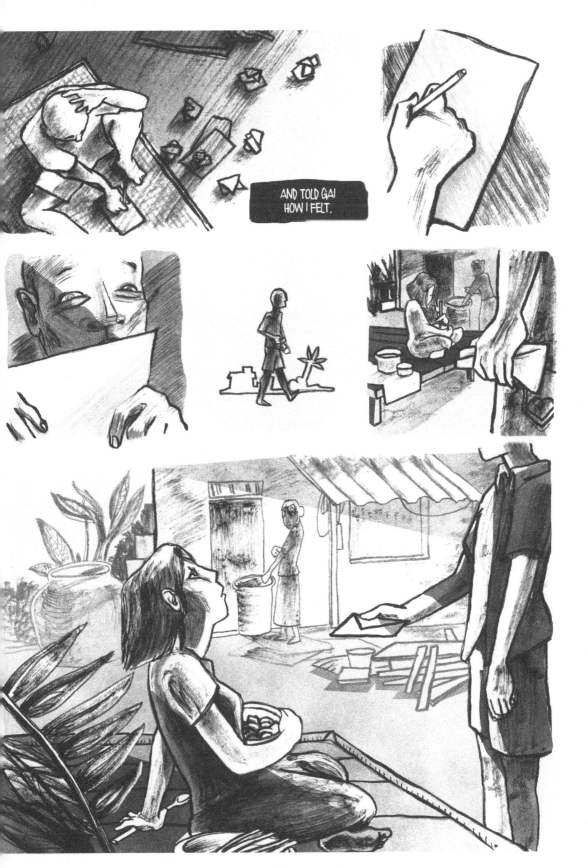

AND TOLD GAI
HOW I FELT.

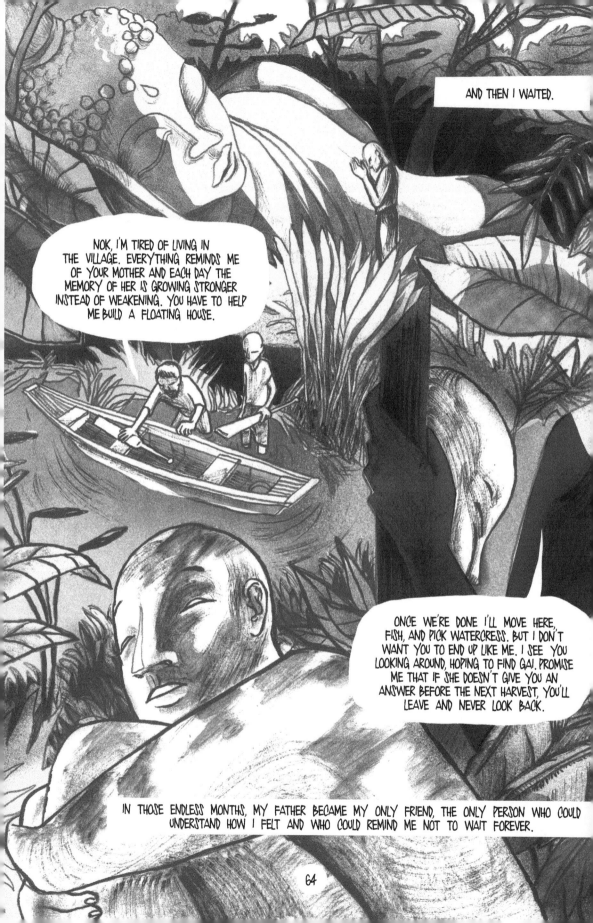

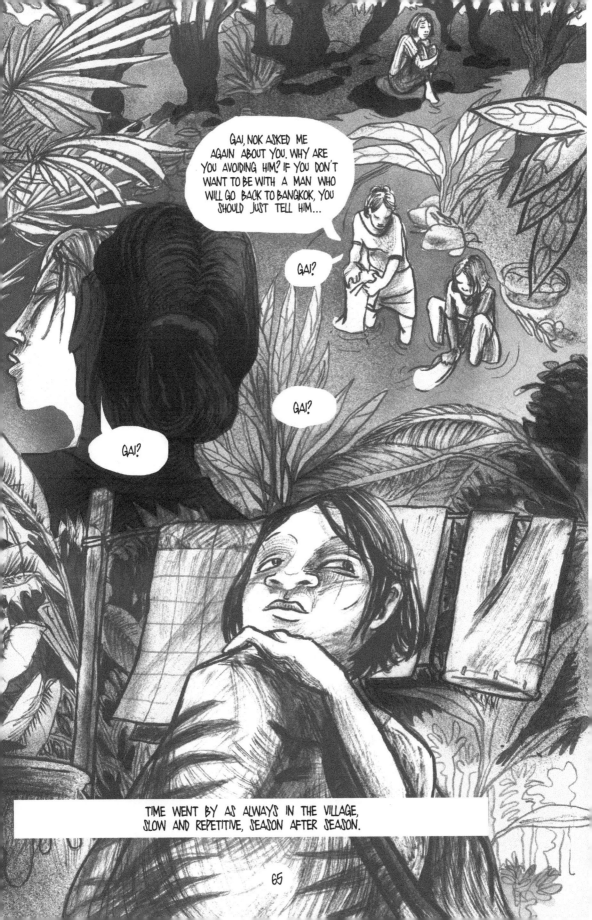

GAI, NOK ASKED ME AGAIN ABOUT YOU. WHY ARE YOU AVOIDING HIM? IF YOU DON'T WANT TO BE WITH A MAN WHO WILL GO BACK TO BANGKOK, YOU SHOULD JUST TELL HIM...

GAI?

GAI?

GAI?

TIME WENT BY AS ALWAYS IN THE VILLAGE, SLOW AND REPETITIVE, SEASON AFTER SEASON.

65

THEN ANOTHER SEASON ARRIVED, THAT OF THE MILITARY DRAFT. I WAS SCARED THAT THE ARMY WOULD TAKE ME AWAY. I HADN'T SEEN GAI FOR A LONG TIME. IF I LEFT, I WAS SURE SHE WOULD FORGET ABOUT ME.

EACH OF YOU WILL PICK A PIECE OF PAPER. THE ONES WITH THE RED SCRIPT WILL BECOME SOLDIERS, THE OTHERS WILL STAY HOME.

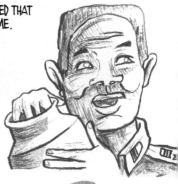

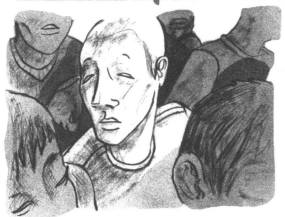

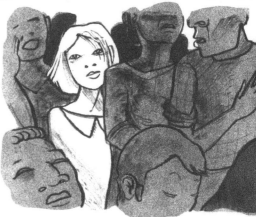

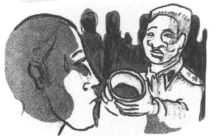

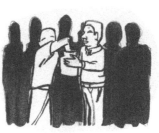

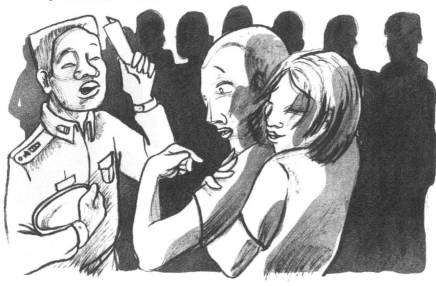

I DODGED A BULLET. AND GAI'S HUG MADE ME REALIZE SHE WAS ALSO SCARED OF LOSING ME. THAT NIGHT WE WENT OUT.

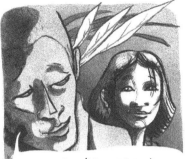

I THOUGHT I'D NEVER SEE YOU AGAIN. YOU KEPT ME WAITING FOR SO LONG. HAVE YOU DECIDED ANYTHING?

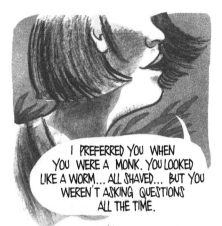

I PREFERRED YOU WHEN YOU WERE A MONK. YOU LOOKED LIKE A WORM... ALL SHAVED... BUT YOU WEREN'T ASKING QUESTIONS ALL THE TIME.

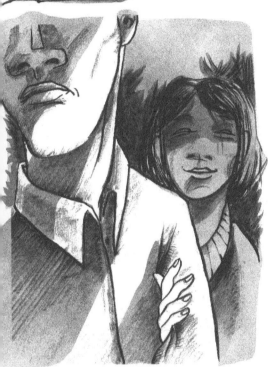

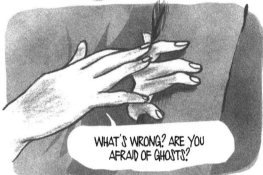

WHAT'S WRONG? ARE YOU AFRAID OF GHOSTS?

NO, I'M AFRAID OF HOW I FEEL WHEN I'M AROUND YOU.

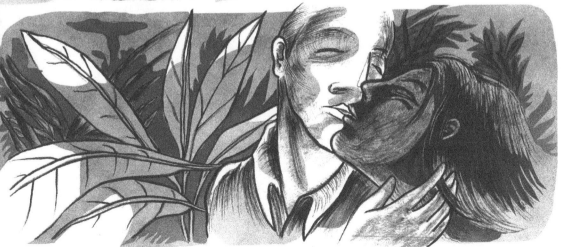

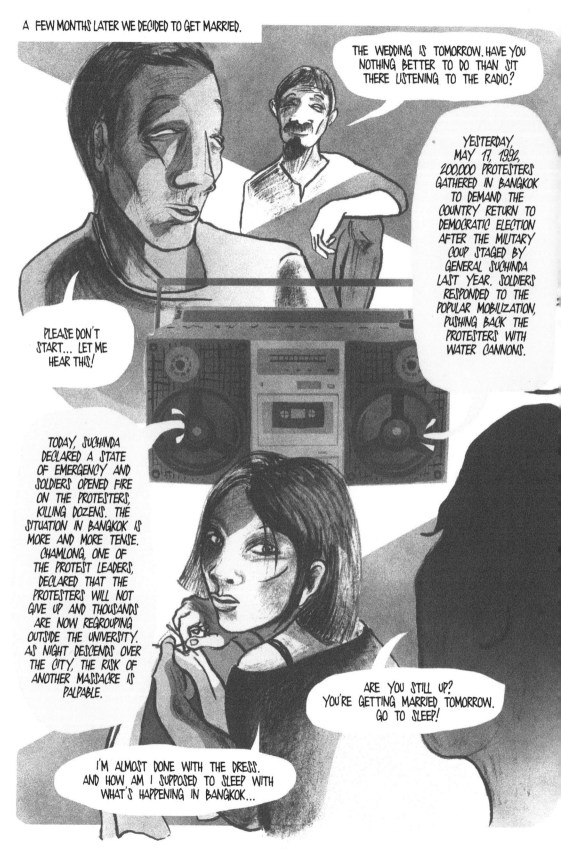

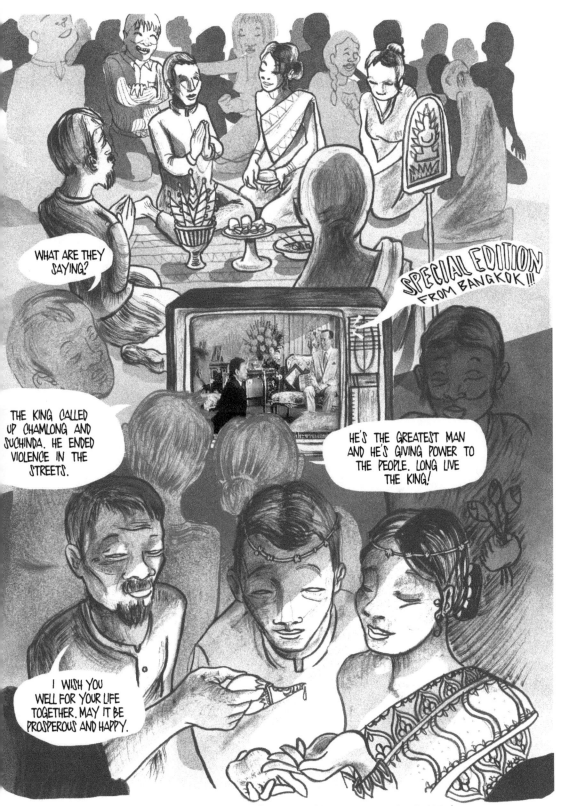

IT WAS AN UNFORGETTABLE DAY FOR US AND FOR THE WHOLE COUNTRY.
WE ALL FELT LIKE WE HAD A CHANCE TO START ANEW.

69

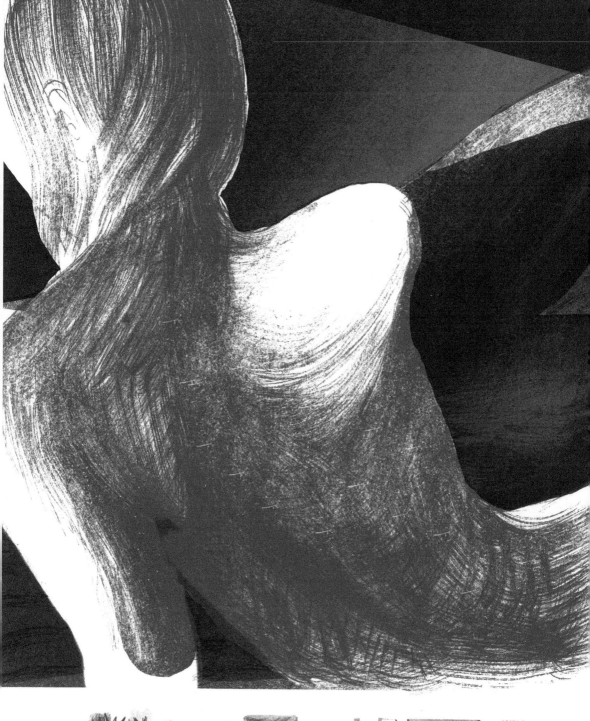

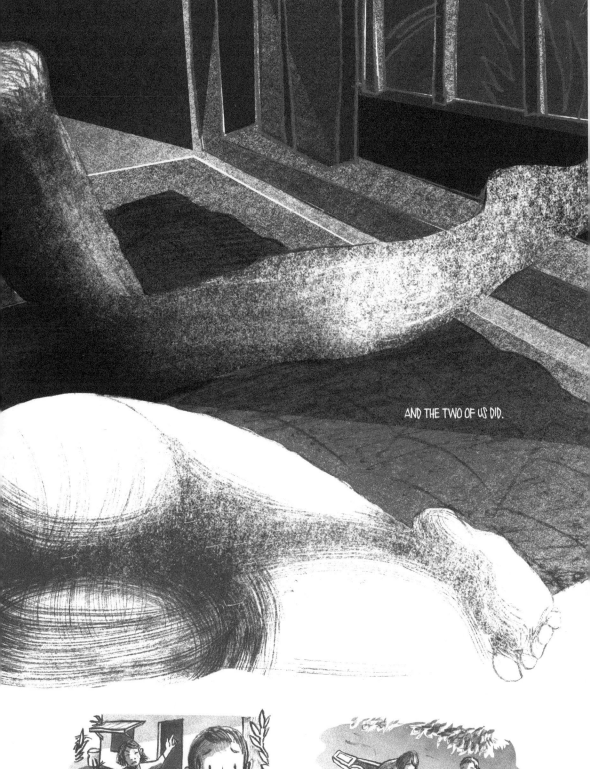

AND THE TWO OF US DID.

MONRAK

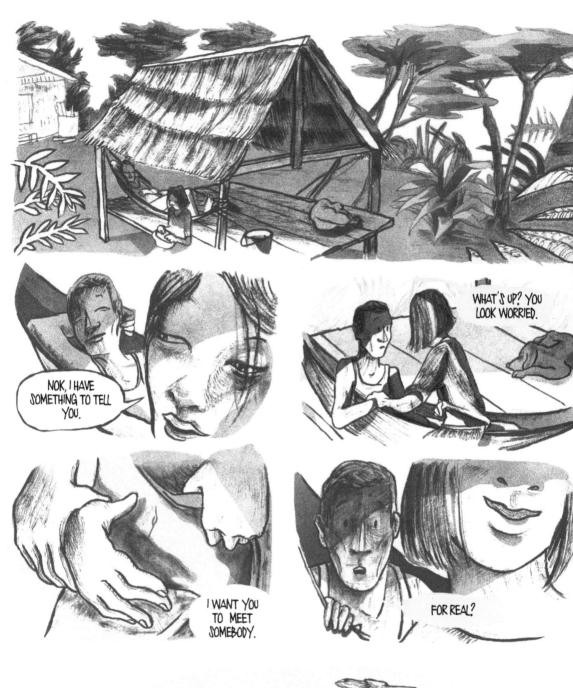

AS THE MONKS HAD TAUGHT US, EVERYTHING IS IMPERMANENT.
ONCE AGAIN, OUR LIFE WAS ABOUT TO TAKE A NEW FORM.

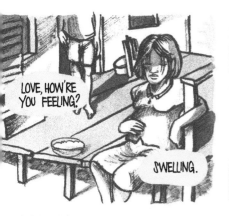

LOVE, HOW'RE YOU FEELING?

SWELLING.

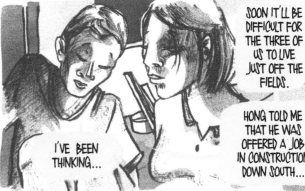

I'VE BEEN THINKING...

SOON IT'LL BE DIFFICULT FOR THE THREE OF US TO LIVE JUST OFF THE FIELDS.

HONG TOLD ME THAT HE WAS OFFERED A JOB IN CONSTRUCTION DOWN SOUTH...

AND HE SAYS THEY'RE LOOKING FOR PEOPLE.

...

I KNOW IT'LL BE HARD ON YOU, BUT I DON'T SEE HOW ELSE WE CAN MANAGE.

FIRST YOU GET ME PREGNANT AND THEN YOU LEAVE... THE TYPICAL THAI MAN...

STOP JOKING. WHAT DO YOU THINK?

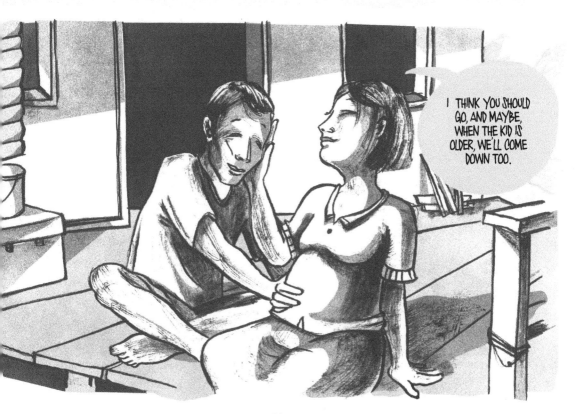

I THINK YOU SHOULD GO, AND MAYBE, WHEN THE KID IS OLDER, WE'LL COME DOWN TOO.

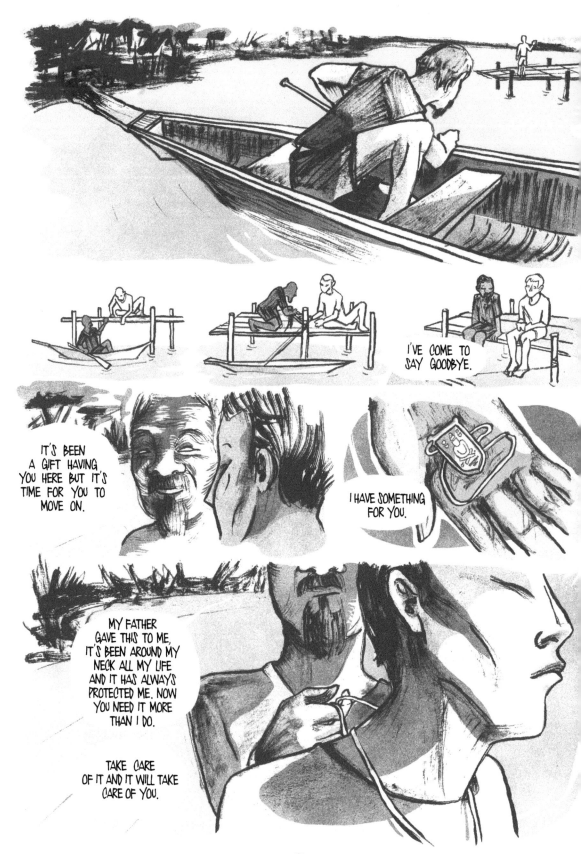

74

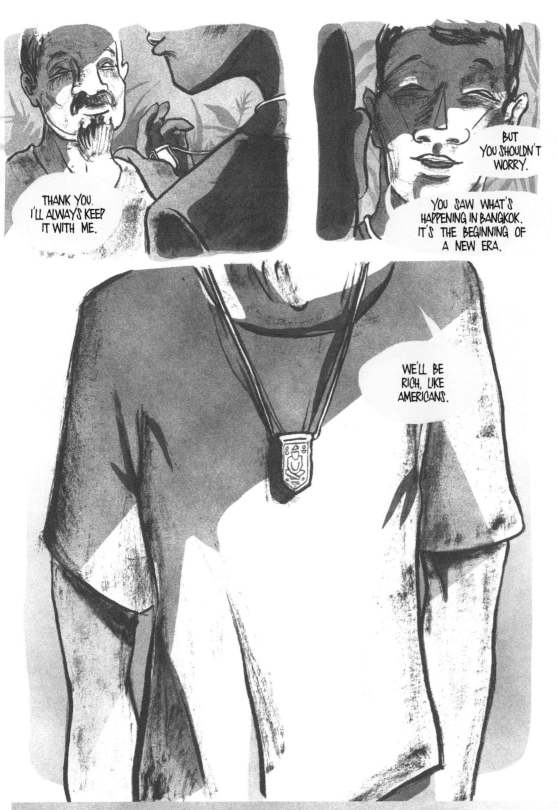

AND SO I LEFT. THAT WAS THE LAST TIME I SAW MY FATHER.

CHAPTER

3

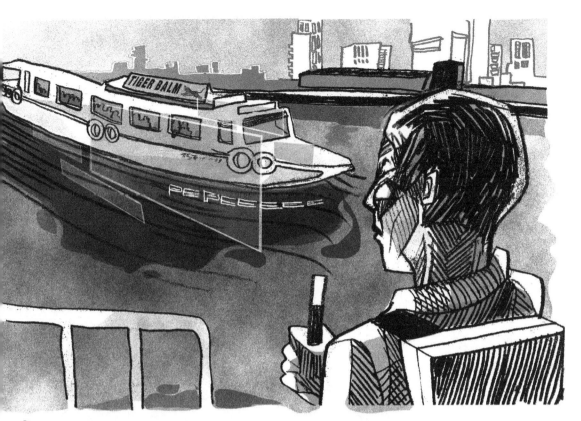

SINCE I LOST MY SIGHT, I'VE RELIED ON STRANGERS TO SURVIVE.

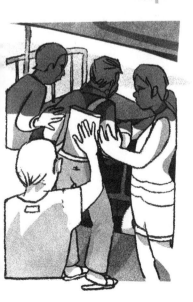

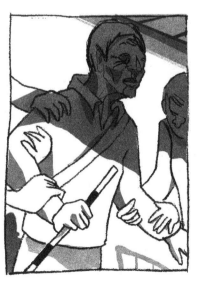

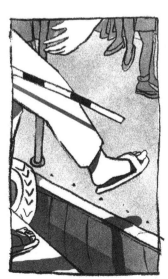

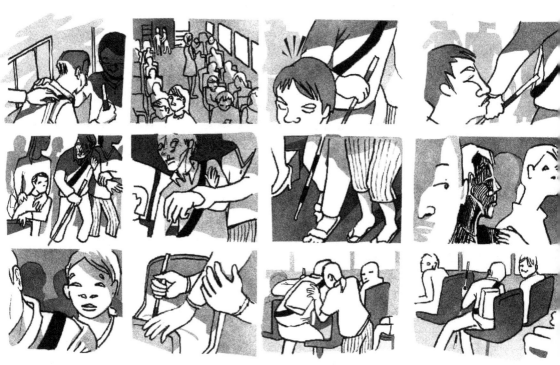

I'M AT THE MERCY OF UNPREDICTABLE HANDS.

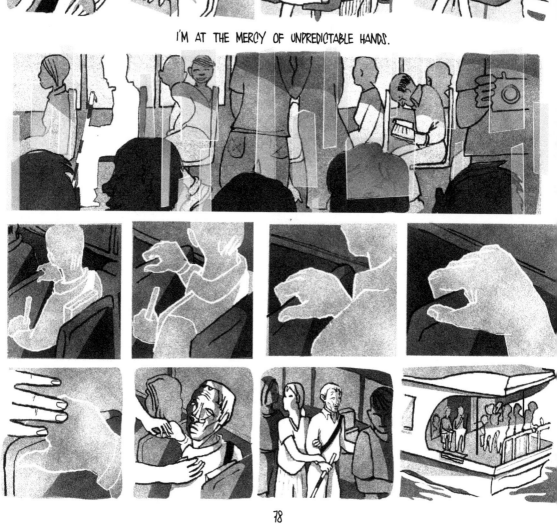

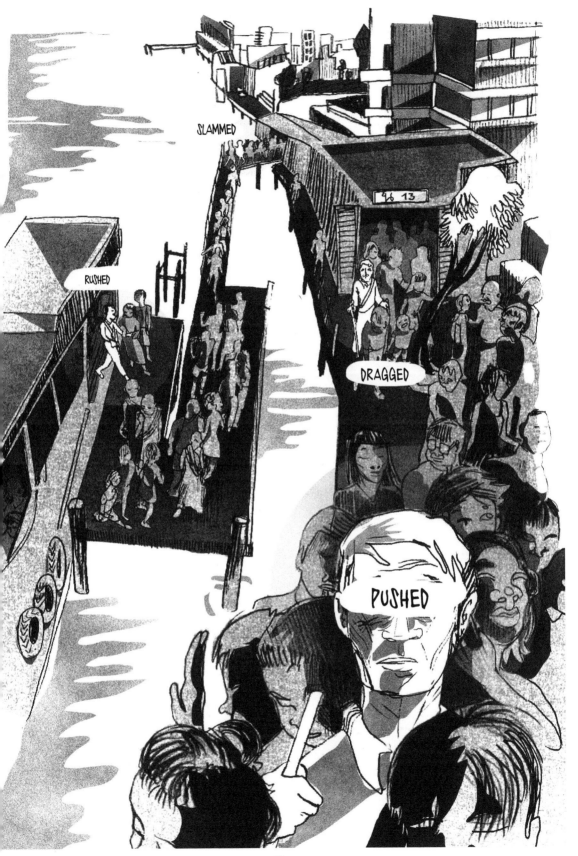

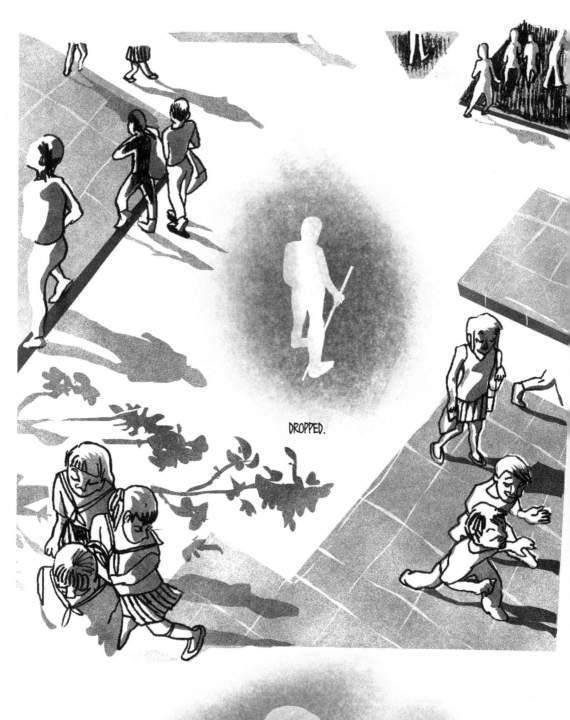

DROPPED.

FOR SIGHTED PEOPLE,
GETTING LOST MEANS
NOT KNOWING WHERE
THEY'RE GOING.
I LOSE EVERYTHING.

WITHOUT A SOUND
TO DIRECT ME,
REALITY DISAPPEARS.
THE WORLD ENDS
AT MY FINGERTIPS.

...AND THEN SOMEBODY COMES TO RESCUE ME.

HEY, UNCLE, CAN I HELP YOU?

I'M TRYING TO REACH KHAOSAN ROAD.

I'LL WALK YOU THERE.

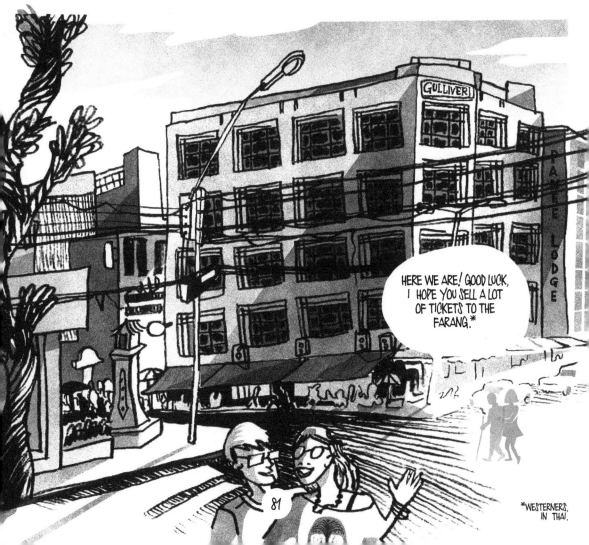

HERE WE ARE! GOOD LUCK, I HOPE YOU SELL A LOT OF TICKETS TO THE FARANG.*

81

*WESTERNERS, IN THAI.

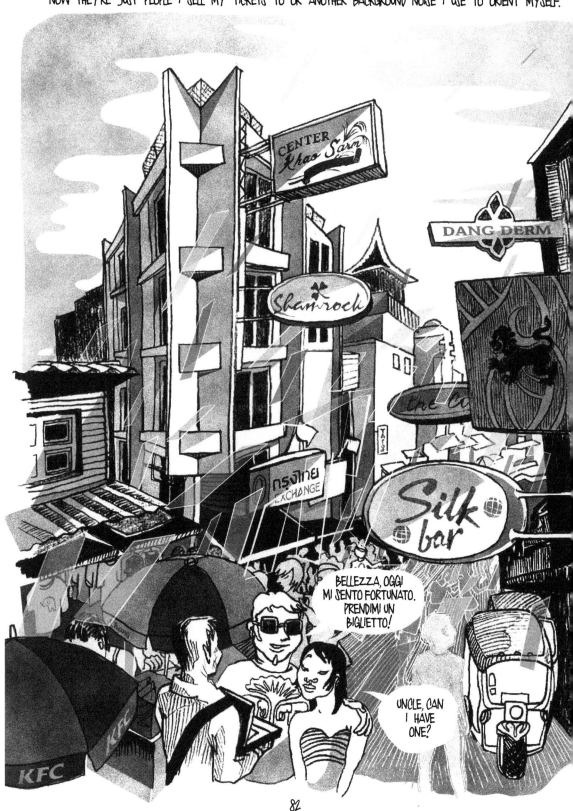

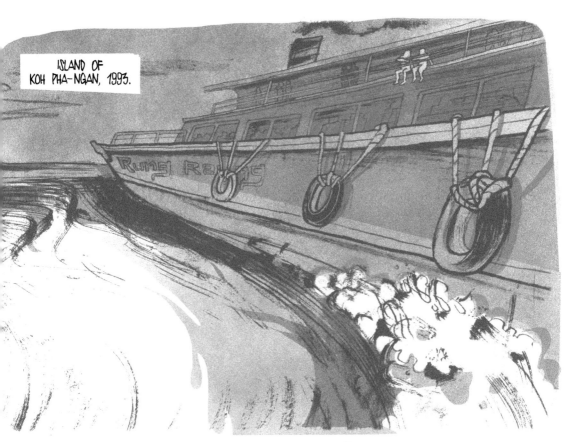

ISLAND OF
KOH PHA-NGAN, 1993.

HONG, ARE YOU SURE WE'RE NOT GOING TO SINK? WE'RE SO FAR AWAY FROM EVERYTHING...

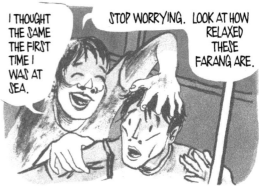

I THOUGHT THE SAME THE FIRST TIME I WAS AT SEA.

STOP WORRYING. LOOK AT HOW RELAXED THESE FARANG ARE.

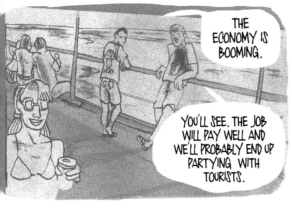

THE ECONOMY IS BOOMING.

YOU'LL SEE. THE JOB WILL PAY WELL AND WE'LL PROBABLY END UP PARTYING WITH TOURISTS.

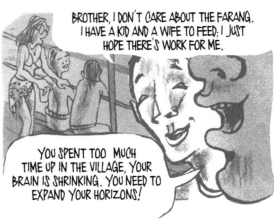

BROTHER, I DON'T CARE ABOUT THE FARANG. I HAVE A KID AND A WIFE TO FEED; I JUST HOPE THERE'S WORK FOR ME.

YOU SPENT TOO MUCH TIME UP IN THE VILLAGE, YOUR BRAIN IS SHRINKING. YOU NEED TO EXPAND YOUR HORIZONS!

83

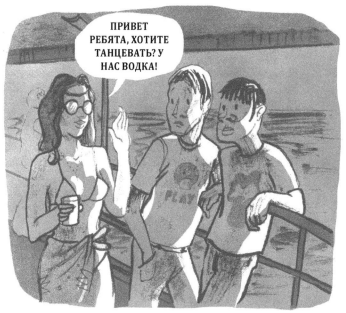

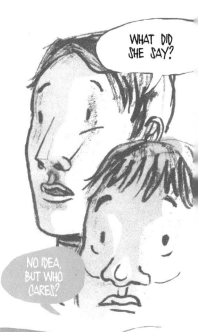

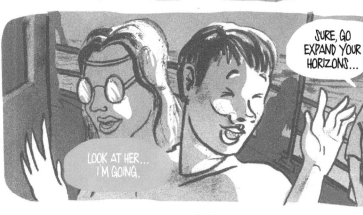

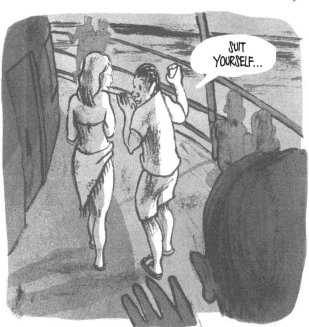

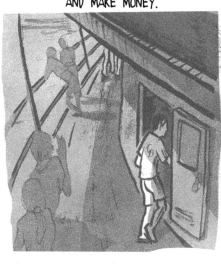

BUT I HAD MISSED HONG AND OUR ADVENTURES.

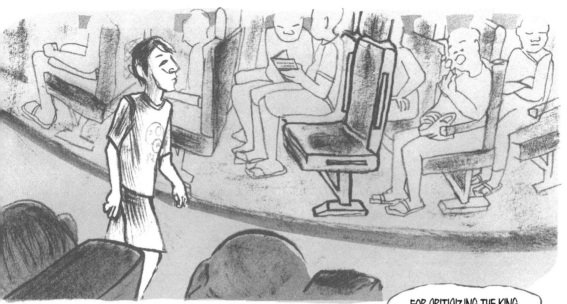

THIS BOOK IS AMAZING!

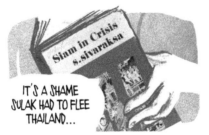

IT'S A SHAME SULAK HAD TO FLEE THAILAND...

FOR CRITICIZING THE KING...

CRITICIZING THE KING??

HOW CAN ANYBODY CRITICIZE THE KING? HE SAVED OUR COUNTRY AND GAVE US DEMOCRACY...

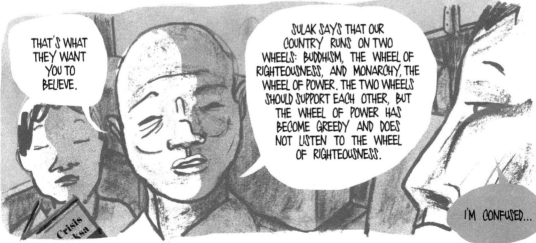

THAT'S WHAT THEY WANT YOU TO BELIEVE.

SULAK SAYS THAT OUR COUNTRY RUNS ON TWO WHEELS: BUDDHISM, THE WHEEL OF RIGHTEOUSNESS, AND MONARCHY, THE WHEEL OF POWER. THE TWO WHEELS SHOULD SUPPORT EACH OTHER, BUT THE WHEEL OF POWER HAS BECOME GREEDY AND DOES NOT LISTEN TO THE WHEEL OF RIGHTEOUSNESS.

I'M CONFUSED...

LOOK AROUND YOU: HALF-NAKED TOURISTS DRINKING, LOUD MUSIC PLAYING EVERYWHERE, THAI YOUTH RUNNING AFTER THEM... GLOBALIZATION MAKES US FEEL STRONG AND RICH. BUT WHAT ARE WE LOSING IN THE PROCESS?

SO... IF GLOBALIZATION IS SO TERRIBLE, WHY ARE YOU GOING TO AN ISLAND FULL OF TOURISTS?

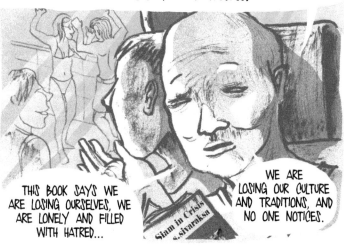

THIS BOOK SAYS WE ARE LOSING OURSELVES, WE ARE LONELY AND FILLED WITH HATRED...

WE ARE LOSING OUR CULTURE AND TRADITIONS, AND NO ONE NOTICES.

WELL...

I LIKE TO SWIM...

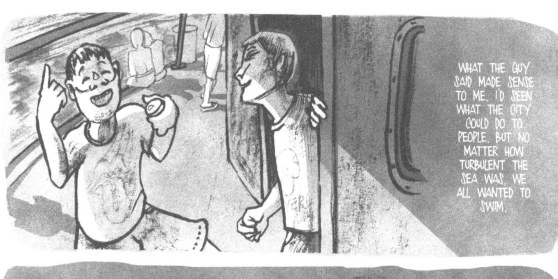

WHAT THE GUY SAID MADE SENSE TO ME. I'D SEEN WHAT THE CITY COULD DO TO PEOPLE. BUT NO MATTER HOW TURBULENT THE SEA WAS, WE ALL WANTED TO SWIM.

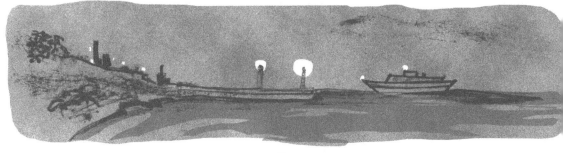

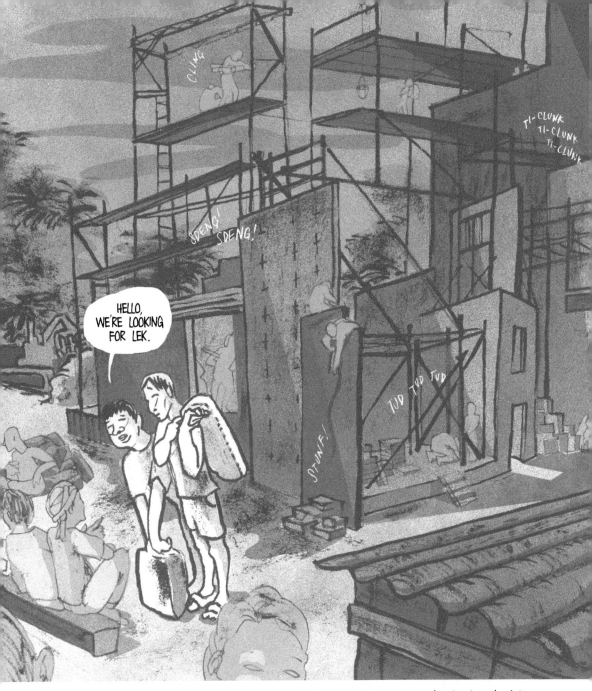

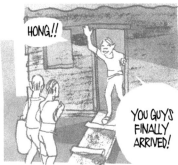

THE CONSTRUCTION SITE WAS LIKE AN ANT'S HILL.

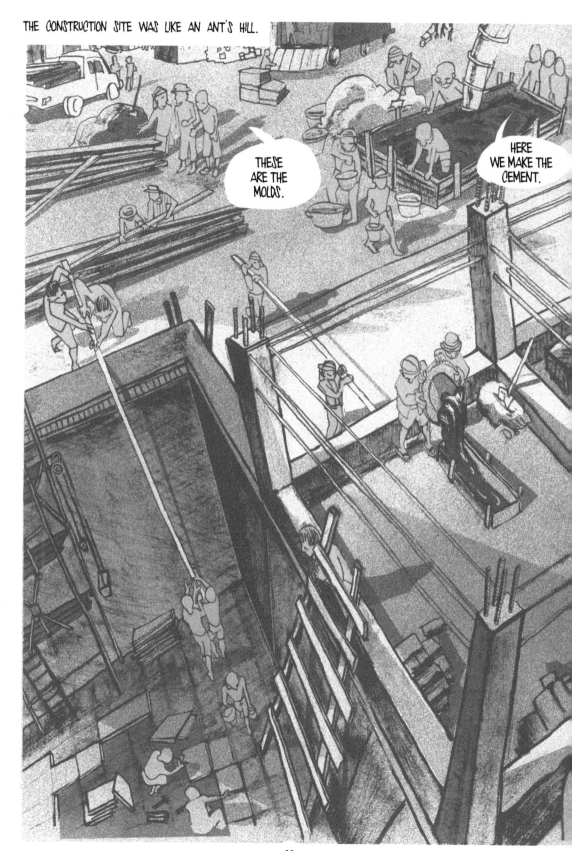

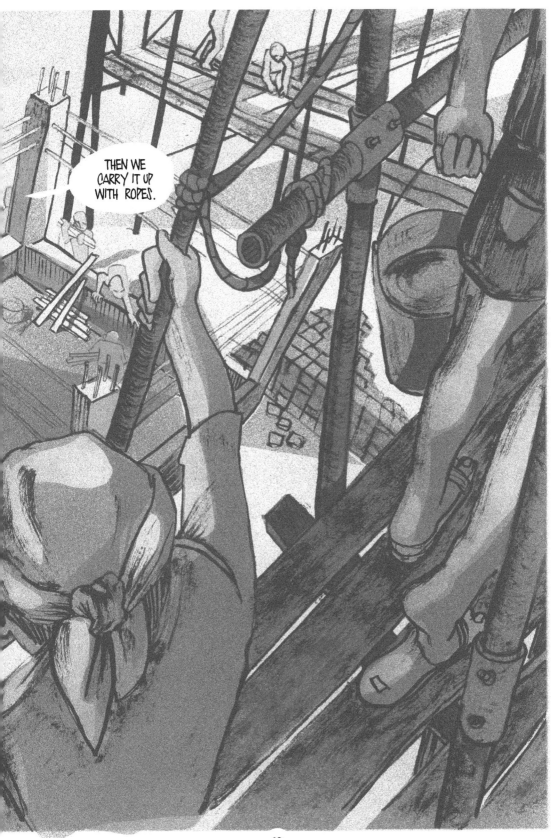

89

IN A FEW MONTHS, WE BECAME ANTS TOO.

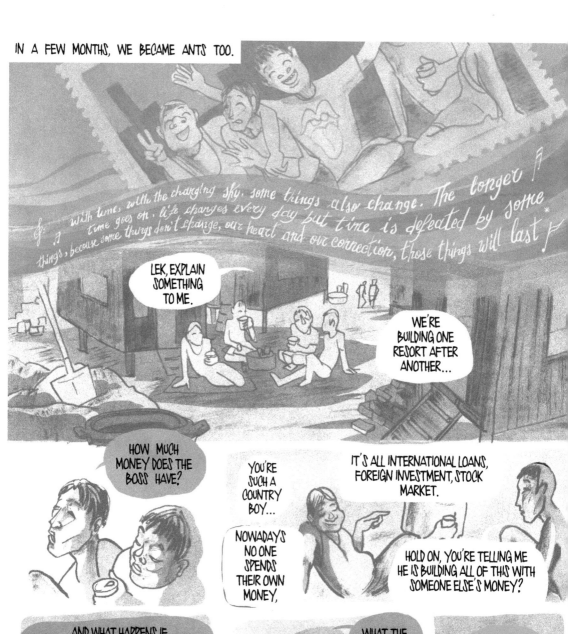

with time, with the changing sky, some things also change. The longer
time goes on, life changes every day but time is defeated by some
things, because some things don't change, our heart and our connection, those things will last *

LEK, EXPLAIN SOMETHING TO ME.

WE'RE BUILDING ONE RESORT AFTER ANOTHER...

HOW MUCH MONEY DOES THE BOSS HAVE?

YOU'RE SUCH A COUNTRY BOY...

IT'S ALL INTERNATIONAL LOANS, FOREIGN INVESTMENT, STOCK MARKET.

NOWADAYS NO ONE SPENDS THEIR OWN MONEY,

HOLD ON, YOU'RE TELLING ME HE IS BUILDING ALL OF THIS WITH SOMEONE ELSE'S MONEY?

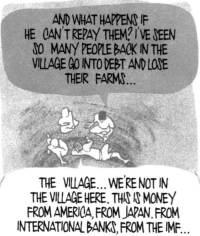

AND WHAT HAPPENS IF HE CAN'T REPAY THEM? I'VE SEEN SO MANY PEOPLE BACK IN THE VILLAGE GO INTO DEBT AND LOSE THEIR FARMS...

THE VILLAGE... WE'RE NOT IN THE VILLAGE HERE. THIS IS MONEY FROM AMERICA, FROM JAPAN. FROM INTERNATIONAL BANKS, FROM THE IMF...

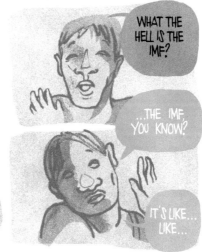

WHAT THE HELL IS THE IMF?

...THE IMF, YOU KNOW?

IT'S LIKE... LIKE...

DAMN YOU WITH ALL YOUR QUESTIONS... GO TO SLEEP NOW!!!

90

*"KONG DERM" BY ASANEE W
FROM THE ALBUM "SAPPAROT"

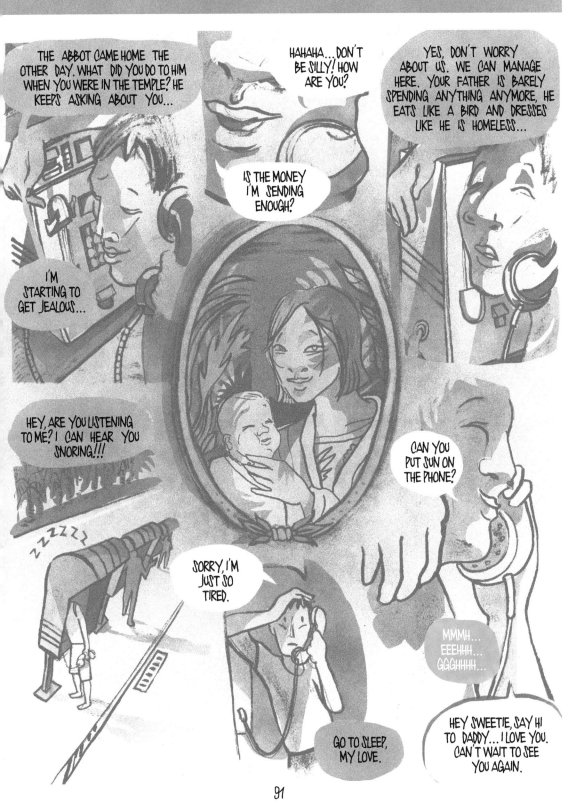

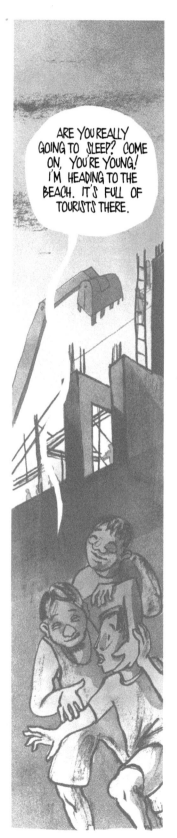

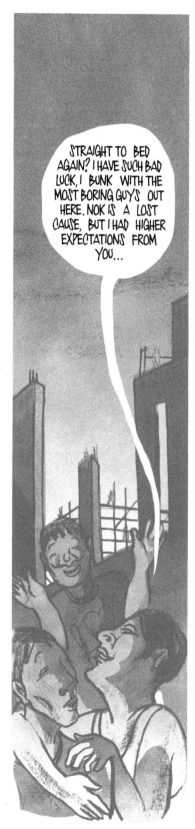

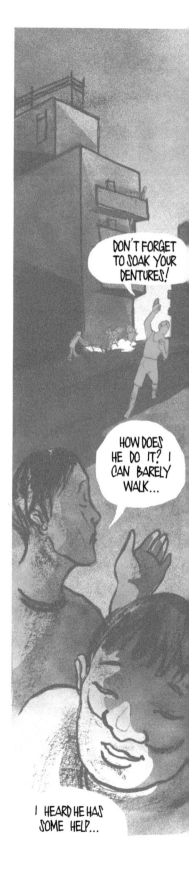

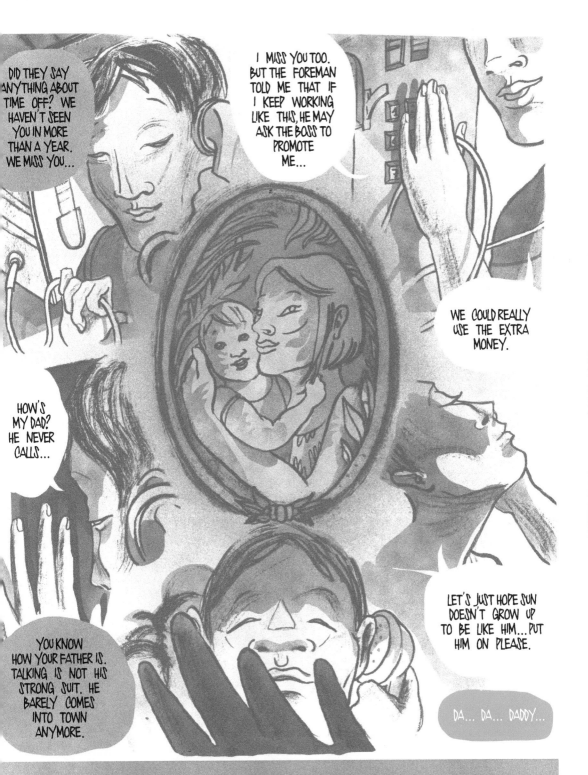

I MISSED SUN AND GAI, AND I OFTEN ASKED MYSELF IF WORKING MY ASS OFF LIKE THIS WAS REALLY WORTH IT. THE CONVERSATION ON THE BOAT KEPT BUGGING ME. EVERYBODY SEEMS TO WANT MORE, BUT THE MONK WAS CLEAR: THESE DESIRES MAKE US SUFFER. HAD I FALLEN INTO A TRAP WITHOUT REALIZING IT?

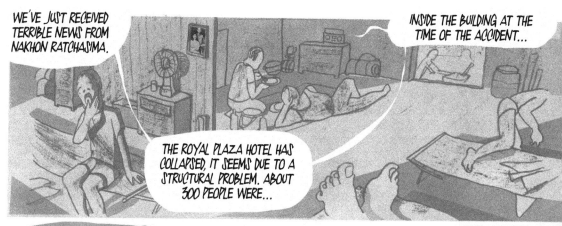

WE'VE JUST RECEIVED TERRIBLE NEWS FROM NAKHON RATCHASIMA.

INSIDE THE BUILDING AT THE TIME OF THE ACCIDENT...

THE ROYAL PLAZA HOTEL HAS COLLAPSED, IT SEEMS DUE TO A STRUCTURAL PROBLEM. ABOUT 300 PEOPLE WERE...

HEY, NOK, YOUR FRIEND IS A REAL PARTY ANIMAL...

YOU SHOULD LEARN FROM HIM. SINCE YOU GOT HERE, YOU'VE NEVER GONE OUT...

BUT I HAVE...

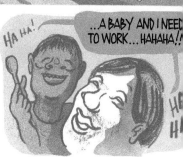

HA HA!

...A BABY AND I NEED TO WORK... HAHAHA!!

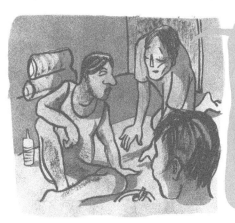

LAUGH, LAUGH. YOU HEARD THE RADIO: I BET THE PEOPLE WHO BUILT THAT HOTEL WERE OUT PARTYING EVERY DAY LIKE THE TWO OF YOU...

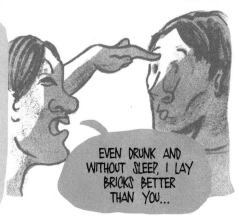

EVEN DRUNK AND WITHOUT SLEEP, I LAY BRICKS BETTER THAN YOU...

CALM DOWN THE TWO OF YOU. I HAVE A TERRIBLE HEADACHE. THE FULL MOON PARTY IS TOMORROW. PEOPLE FROM ALL AROUND THE WORLD COME HERE FOR IT AND YOU'VE NEVER BEEN. YOU'RE COMING!

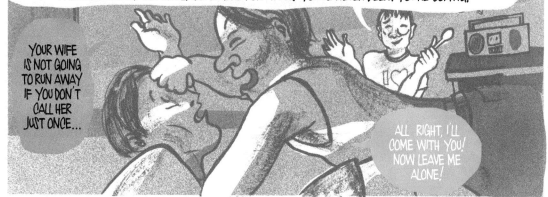

YOUR WIFE IS NOT GOING TO RUN AWAY IF YOU DON'T CALL HER JUST ONCE...

ALL RIGHT, I'LL COME WITH YOU! NOW LEAVE ME ALONE!

94

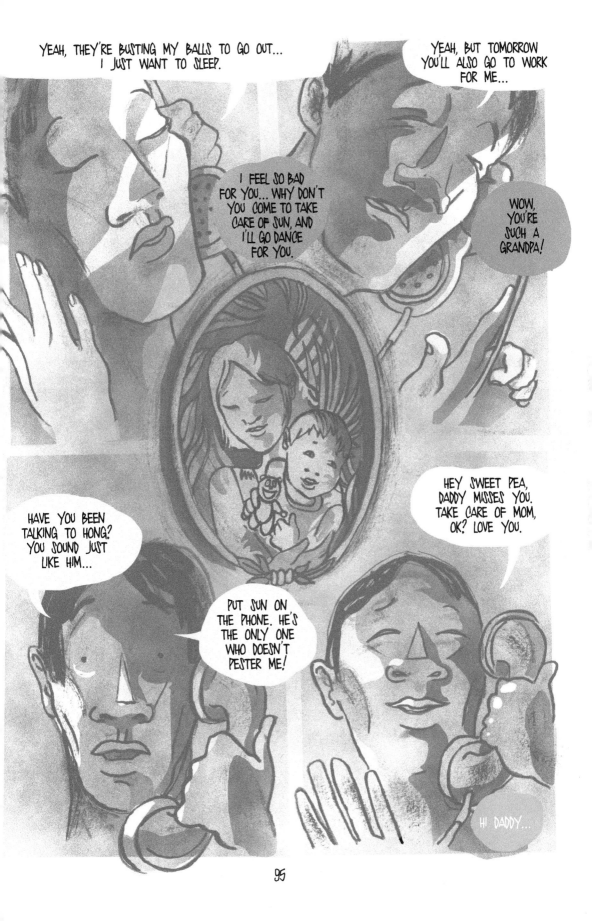

95

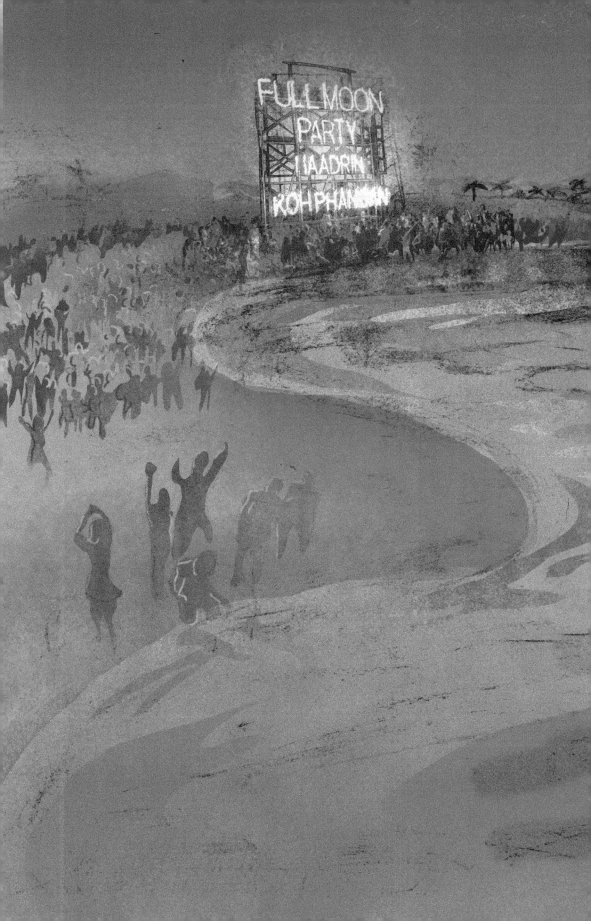

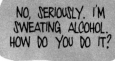
NO, SERIOUSLY. I'M SWEATING ALCOHOL. HOW DO YOU DO IT?

UGH... THAT MUSIC IS STILL RINGING IN MY EARS. I FEEL HORRIBLE.

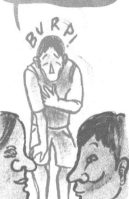

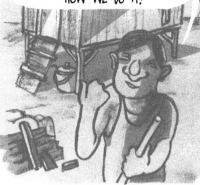
HAHAHA... SEE THAT WATER DOWN THERE, THE BUCKET UNDER THE STAIRS. THE BOSS PUTS YA-BAA INSIDE IT SO WE CAN KEEP WORKING. THAT'S HOW WE DO IT!

I HAD NO IDEA WHAT YA-BAA WAS, BUT AFTER A FEW SIPS, THE PAIN AND THE HEADACHE WENT AWAY.

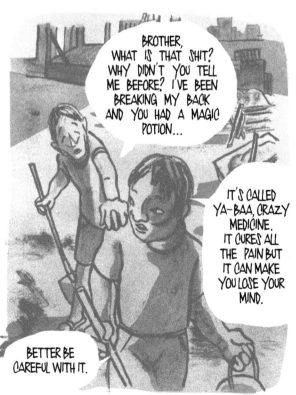
BROTHER, WHAT IS THAT SHIT? WHY DIDN'T YOU TELL ME BEFORE? I'VE BEEN BREAKING MY BACK AND YOU HAD A MAGIC POTION...

IT'S CALLED YA-BAA, CRAZY MEDICINE. IT CURES ALL THE PAIN BUT IT CAN MAKE YOU LOSE YOUR MIND.

BETTER BE CAREFUL WITH IT.

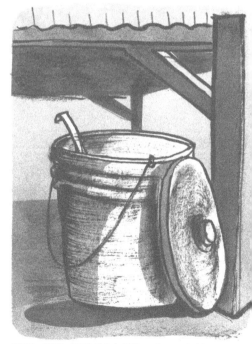

HONG WAS PROBABLY RIGHT, BUT FROM THAT DAY, WHENEVER I FELT TIRED, I JUST CLIMBED DOWN AND TOOK A SIP.

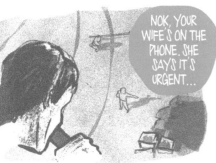

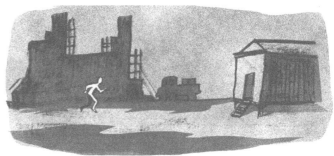

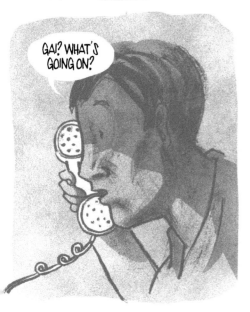

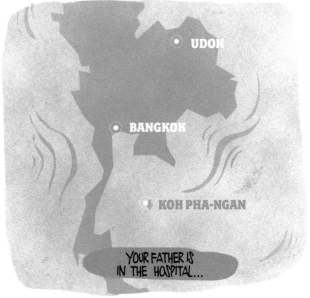

SIR?

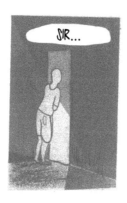

SIR...

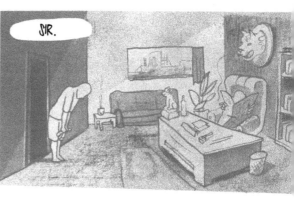

SIR.

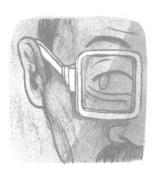

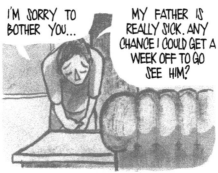

I'M SORRY TO BOTHER YOU...

MY FATHER IS REALLY SICK. ANY CHANCE I COULD GET A WEEK OFF TO GO SEE HIM?

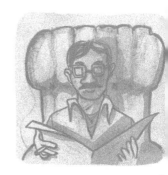

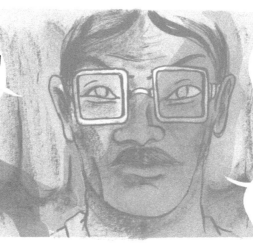

DO YOU KNOW HOW MANY PEOPLE WORK HERE? YOU'VE SEEN HOW FAST CONSTRUCTION MOVES. WE RUN ON CREDIT HERE AND EVERY DAY IT'S GETTING HARDER TO REPAY.

BESIDES, YOUR FATHER WILL NEED MONEY FOR MEDS, RIGHT?

I CAN'T WAIT FOR YOU. LEAVE IF YOU WANT. BUT IF YOU DO, YOU'RE FIRED.

YOU SHOULD STAY.

CLIC.

THE BOSS TREATED ME LIKE PEOPLE IN BANGKOK USED TO, AS IF I WAS AN ANIMAL. BUT MAYBE HE WAS RIGHT ABOUT THE MEDICINES. I HAD COME TO THE ISLAND TO SUPPORT MY FAMILY AND NOW THEY NEEDED MY MONEY MORE THAN EVER. THANKFULLY YA-BAA KEPT ME GOING.

100

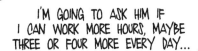
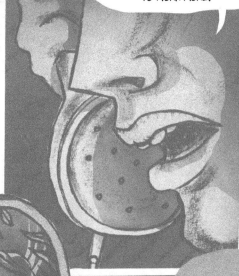

I'M GOING TO ASK HIM IF I CAN WORK MORE HOURS, MAYBE THREE OR FOUR MORE EVERY DAY...

DON'T WORRY, I'VE FOUND A WAY TO WORK MORE.

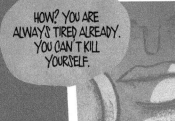

HOW? YOU ARE ALWAYS TIRED ALREADY. YOU CAN'T KILL YOURSELF.

HOW? WHAT'S GOING ON?

STOP ASKING QUESTIONS!

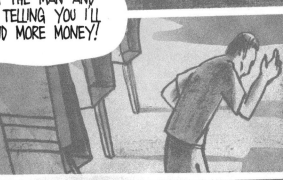

I'M THE MAN AND I'M TELLING YOU I'LL SEND MORE MONEY!

IT WAS THE FIRST TIME I HAD EVER SHOUTED AT GAI. UNFORTUNATELY, IT WASN'T THE LAST.

101

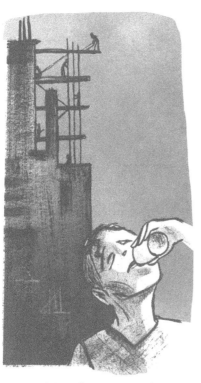
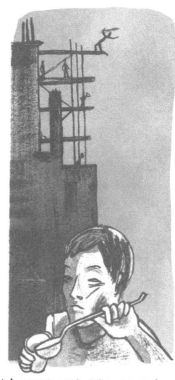
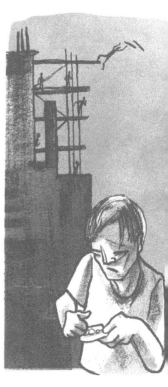

THE ECONOMY WAS SLOWING DOWN, MY FATHER WAS SICK, AND MY RELATIONSHIP WITH GAI WAS GETTING TENSER AND TENSER. I PUT MY HEAD DOWN AND WORKED. AFTER A FEW MONTHS THE PAIN CAME BACK. THE WATER WAS NOT ENOUGH. LEK TOLD ME THAT I COULD GET YA-BAA PILLS. YOU CRUSH THEM, SPRINKLE THE DUST ON ALUMINUM FOIL, LIGHT IT UP, AND SMOKE IT WITH A MAKESHIFT PIPE. THE PAIN IMMEDIATELY DISAPPEARED, BUT SOON I COULDN'T EVEN GET OUT OF BED WITHOUT SMOKING.

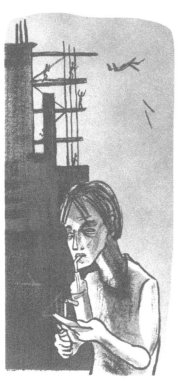
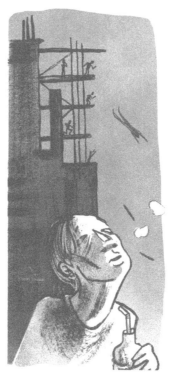
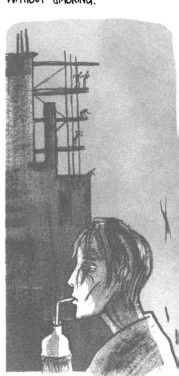

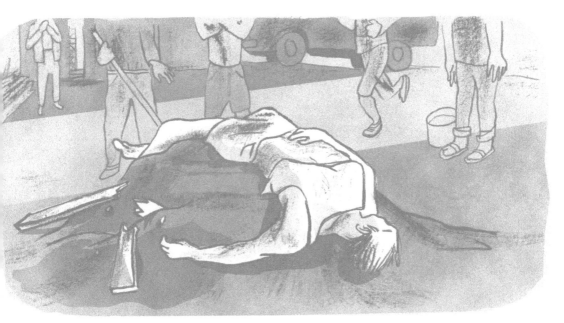

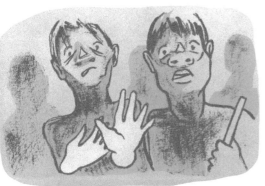

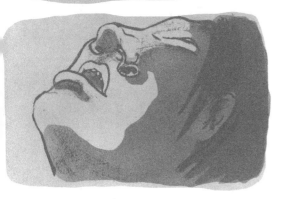

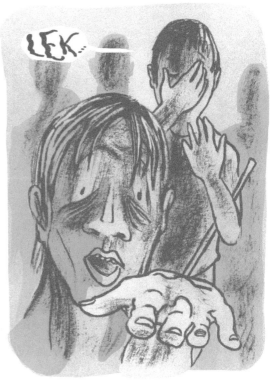

LEK...

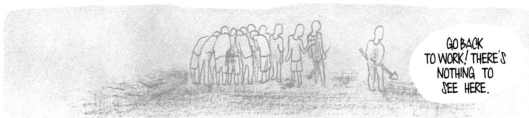

GO BACK
TO WORK! THERE'S
NOTHING TO
SEE HERE.

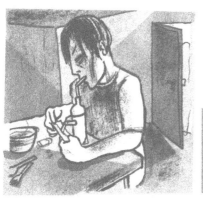

WHAT THE FUCK ARE YOU DOING?

LEK JUST DIED BECAUSE THAT SHIT MADE HIM RECKLESS, AND YOU GO BACK TO SMOKE?

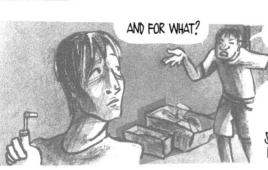

AND FOR WHAT?

THESE PEOPLE DON'T GIVE A SHIT ABOUT US. YOU THINK THE BOSS GIVES US THAT WATER SO WE FEEL BETTER?

YOU HEARD HIM. THERE'S NOTHING TO SEE! AS IF LEK NEVER EXISTED.

WE'RE LIKE ANIMALS TO PEOPLE LIKE HIM AND YOU ARE JUST ACTING THE PART. THE BOSS GIVES YOU A CARROT AND YOU PUSH THROUGH. WHY CAN'T YOU SEE IT? YOU'RE BECOMING...

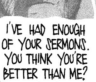
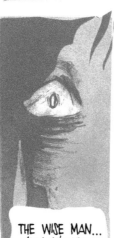
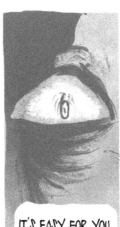
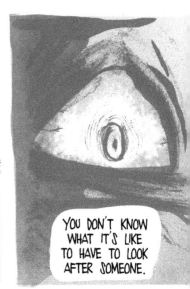

I'VE HAD ENOUGH OF YOUR SERMONS. YOU THINK YOU'RE BETTER THAN ME?

THE WISE MAN... YOU DON'T KNOW SHIT!

IT'S EASY FOR YOU. YOU DON'T HAVE A FAMILY TO FEED.

YOU DON'T KNOW WHAT IT'S LIKE TO HAVE TO LOOK AFTER SOMEONE.

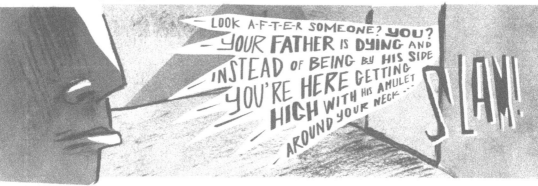

LOOK A-F-T-E-R SOMEONE? YOU? YOUR FATHER IS DYING AND INSTEAD OF BEING BY HIS SIDE YOU'RE HERE GETTING HIGH WITH HIS AMULET AROUND YOUR NECK... SLAM!

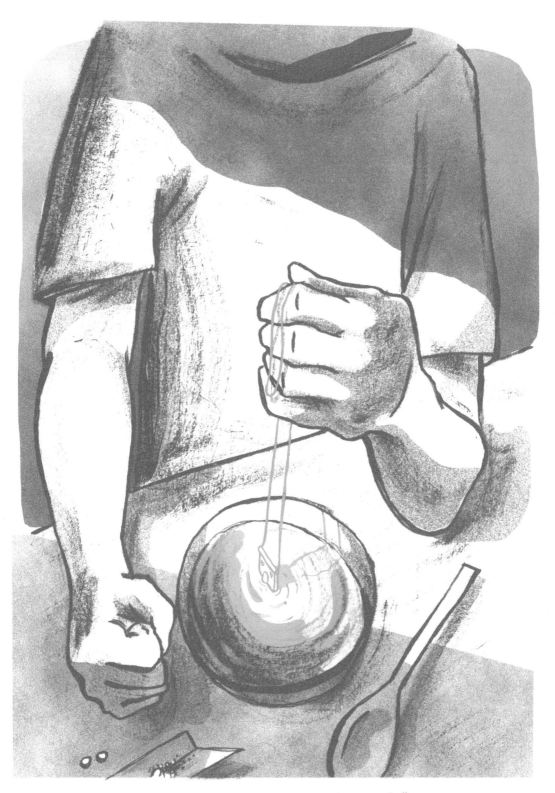

"TAKE CARE OF IT AND IT WILL TAKE CARE OF YOU."

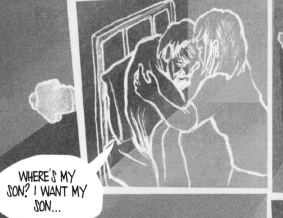

NO DREAMS, NO REST, JUST A DARK VOID.

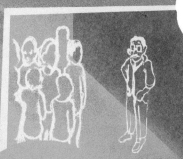

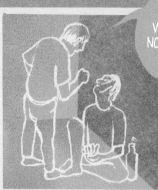

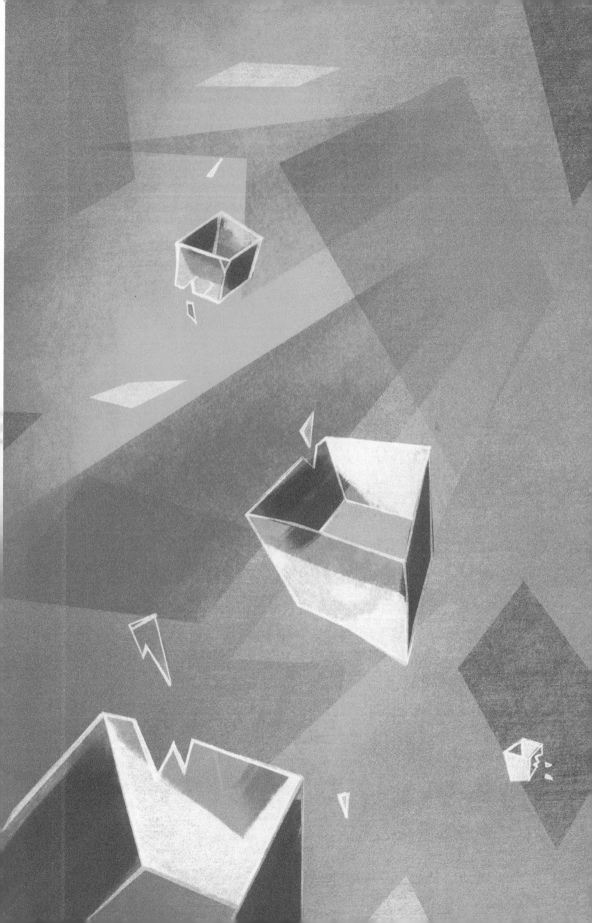

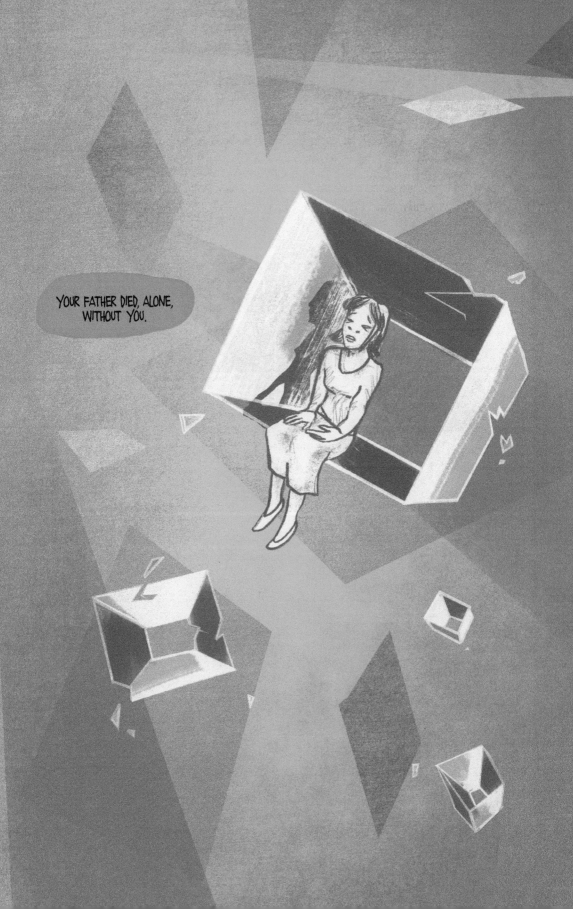

MY DAD,
THE MAN WHO HAD ALWAYS LOOKED
AFTER ME, WAS GONE.
I COULD SEE GAI'S PAIN,
MUFFLED AND DISTANT,
AS IF I WERE UNDER WATER.

I TOLD MYSELF THAT I'D DONE
EXACTLY WHAT I WAS SUPPOSED TO DO,
WORK AND MAKE MONEY.
BUT EVERY PENNY HAD TAKEN ME FURTHER AWAY,
DEEPER AND DEEPER UNDER WATER.

EVERYTHING CHANGES.
NOTHING REMAINS THE SAME FOREVER.
YET THE CAGE I HAD BUILT AROUND MYSELF
SEEMED TO BE ENDLESS.

GAI KEPT CALLING ME,
ASKING ME TO COME BACK TO HER AND TO OUR SON.
ALL I WANTED WAS TO DISAPPEAR,
TO MELT INTO THE CEMENT I POURED EVERY DAY,
PRETENDING TO GIVE THEM A BETTER LIFE
WHILE I JUST CONTINUED TO BUILD TALLER WALLS.

SOMETIMES I WONDER
IF LEK REALLY FELL
OR SIMPLY LET HIMSELF GO.

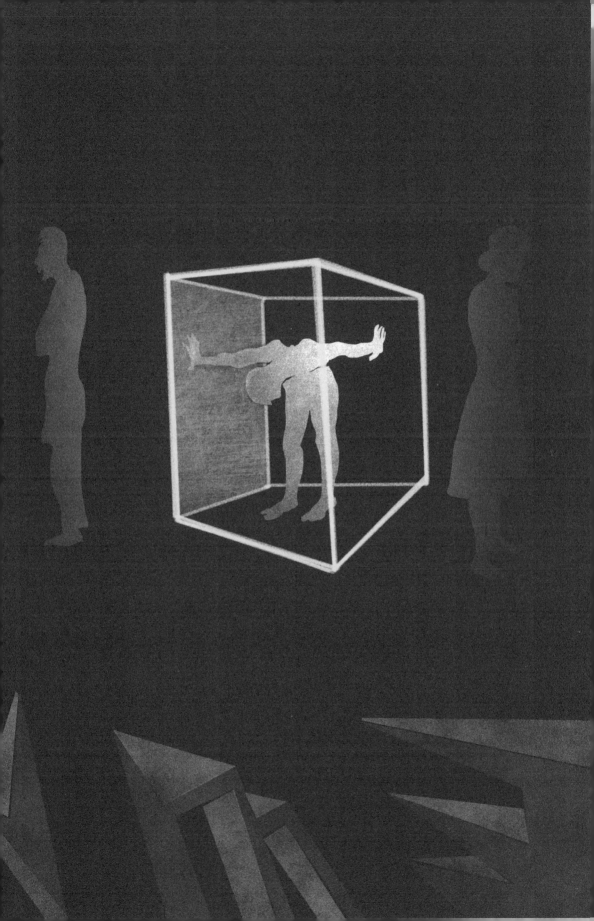

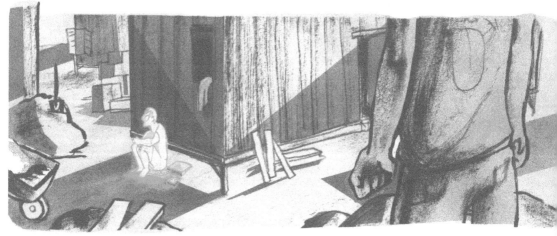

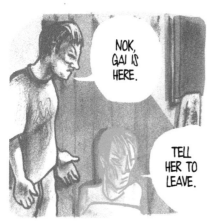

NOK, GAI IS HERE.

TELL HER TO LEAVE.

YOU TELL HER! SHE TOOK CARE OF YOUR SICK FATHER...

SHE ORGANIZED HIS FUNERAL WITHOUT A PENNY WHILE YOU WERE HERE GETTING HIGH...

FUCK OFF.

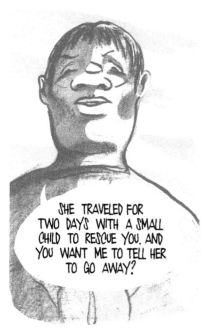

SHE TRAVELED FOR TWO DAYS WITH A SMALL CHILD TO RESCUE YOU. AND YOU WANT ME TO TELL HER TO GO AWAY?

LOOK AT YOURSELF. YOU'RE A MESS.

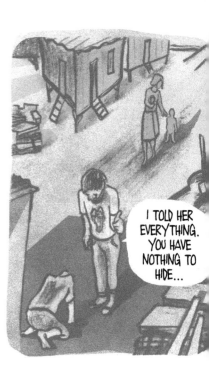

I TOLD HER EVERYTHING. YOU HAVE NOTHING TO HIDE...

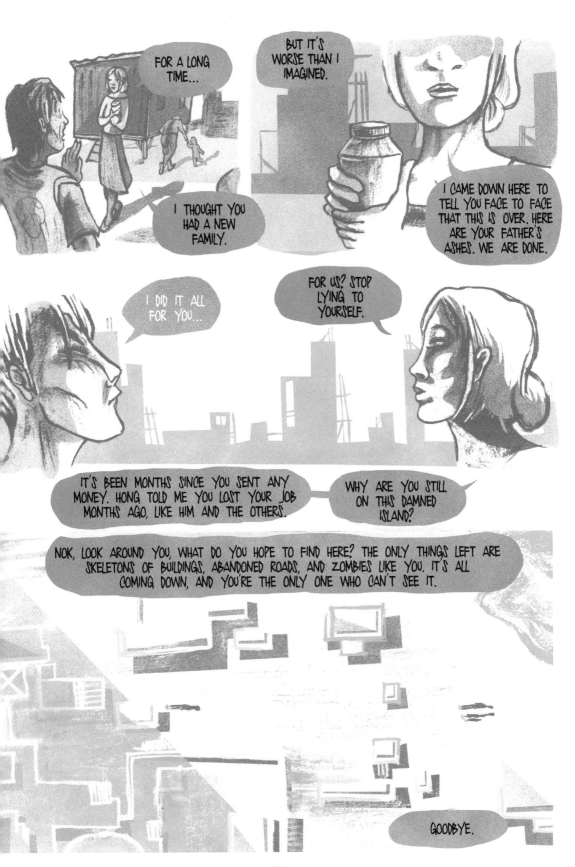

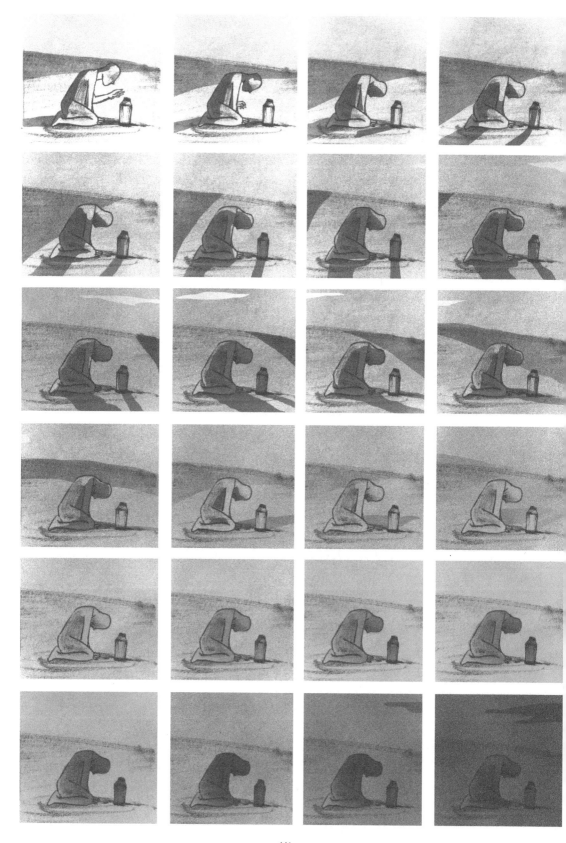

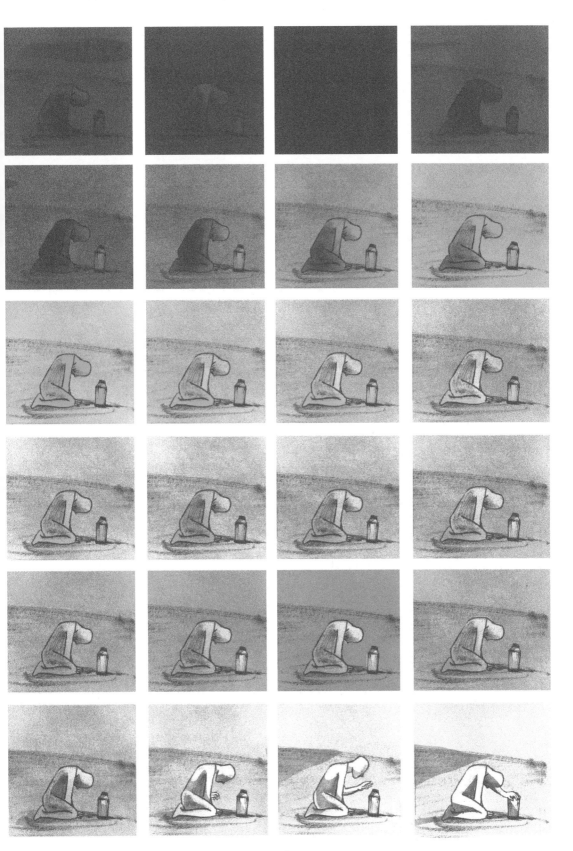

FOR YEARS I TOLD MYSELF THAT BEING A GOOD
HUSBAND AND FATHER MEANT SENDING MONEY HOME...

EVEN IF THAT MEANT
NEVER GOING BACK.

116

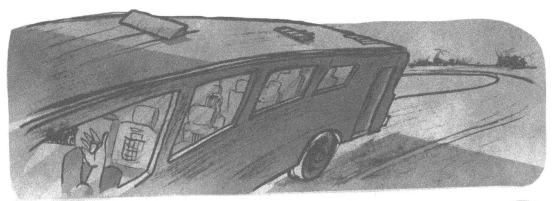

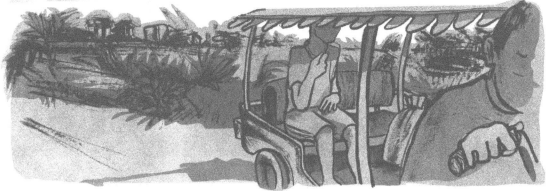

FACED WITH MY FATHER'S ASHES, I REALIZED IT WAS TIME TO FOLLOW IN HIS FOOTSTEPS AND BECOME WHAT HE HAD ALWAYS BEEN FOR ME: A MAN. AND THAT MEANT, FIRST OF ALL, RECOGNIZING MY MISTAKES.

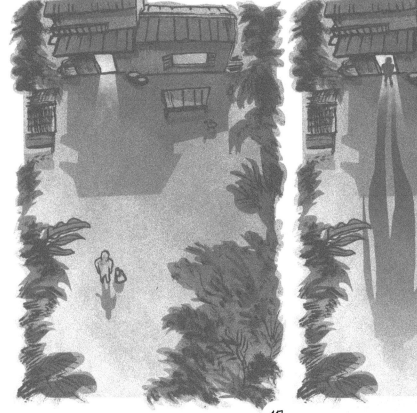

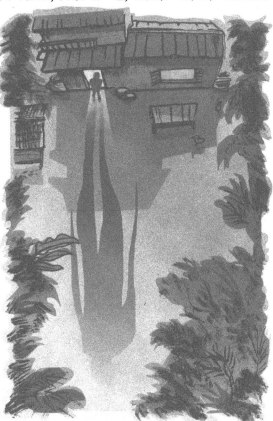

CHAPTER

4

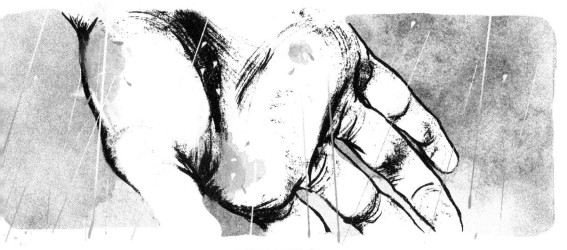

I ADORE THE RAIN.

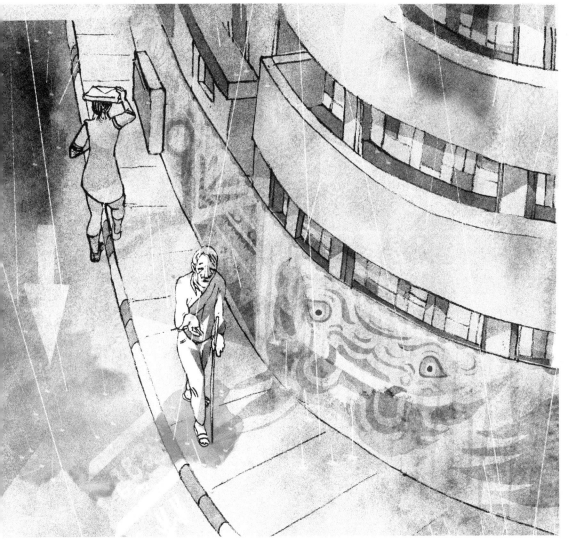

IT GIVES ME BACK THE CITY I USED TO LOVE.

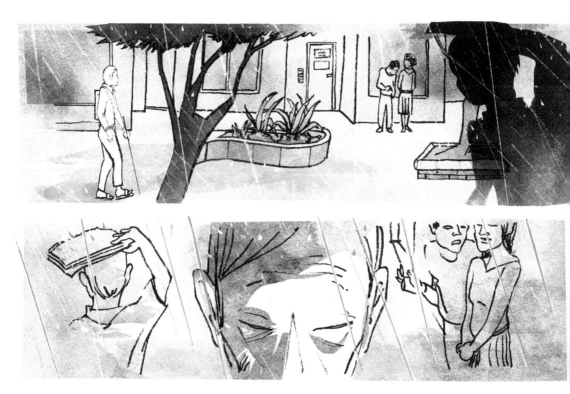

IT FALLS LIKE PAINT OVER ALL THE THINGS THAT HAVE BECOME INVISIBLE TO ME.

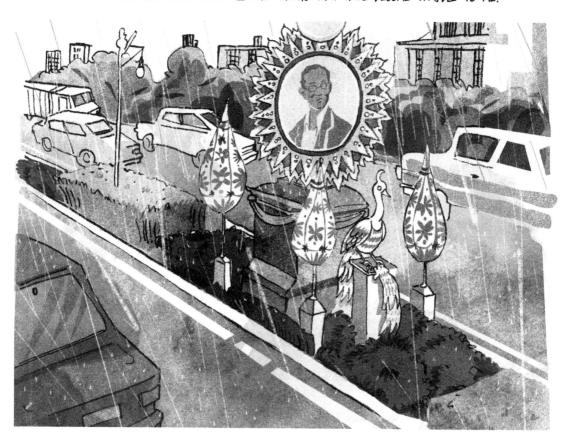

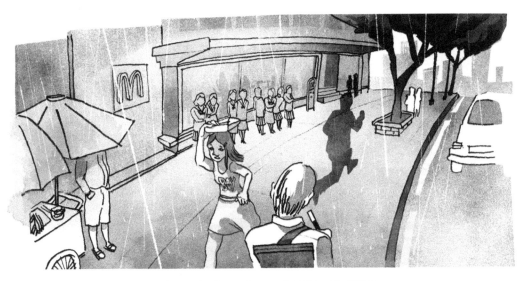

THE SIGHTED PEOPLE RUN; THEY LOOK FOR COVER.

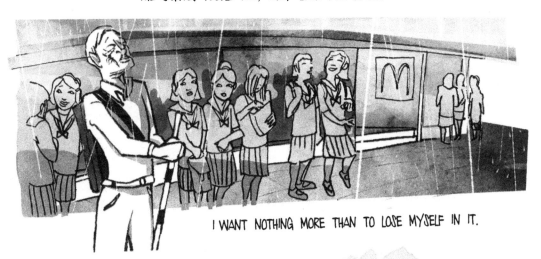

I WANT NOTHING MORE THAN TO LOSE MYSELF IN IT.

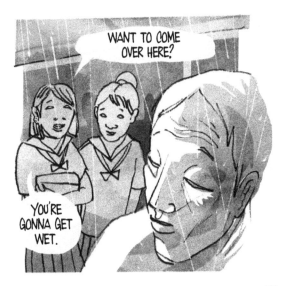

WANT TO COME OVER HERE?

YOU'RE GONNA GET WET.

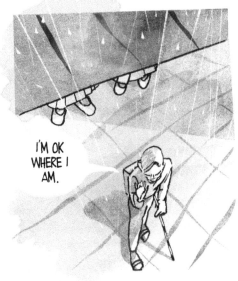

I'M OK WHERE I AM.

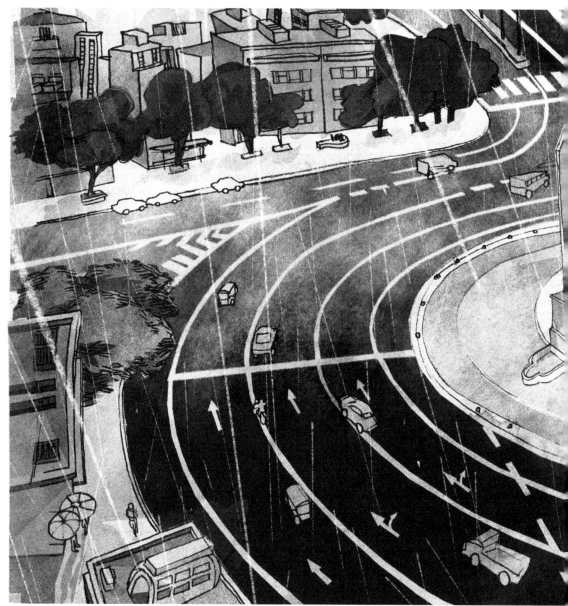

ON ONE SIDE OF THE ROAD, THE WATER GURGLES IN A FLOODED GUTTER.

ON THE OTHER, IT DRUMS ON THE STREET VENDOR'S PLASTIC TARP.

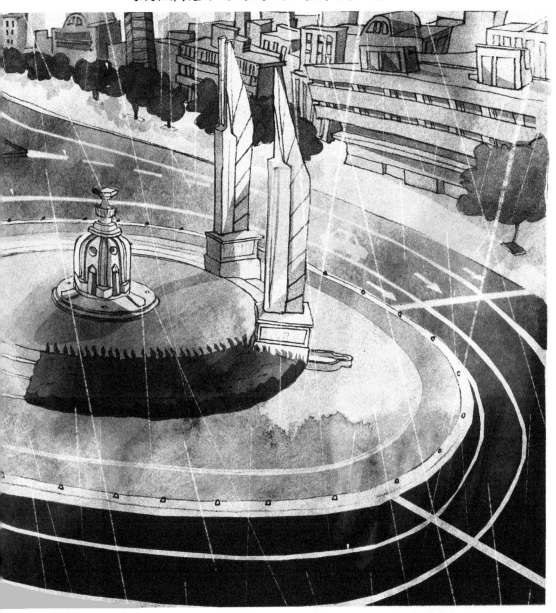

UNDER MY FEET, IT GIVES SHAPE TO THE COBBLES.

DOWN THE ROAD, IT PATTERS ON THE ROOF OF A MOTORTAXI STATION...

BEFORE SPLASHING ONTO A MOTORCYCLE SEAT.

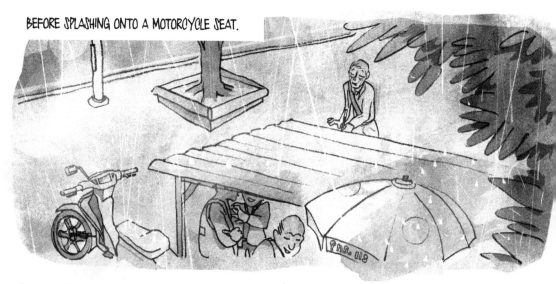

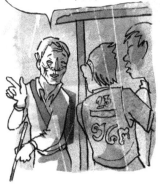

KID, YOU'D BETTER MOVE THAT BIKE.

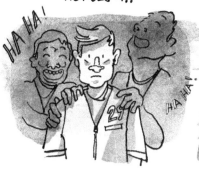

EVEN A *BLIND* MAN NOTICES IT!!

HA HA!

HA HA!

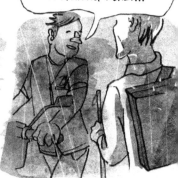

UNCLE, WOULD YOU SELL ME A WINNING TICKET...

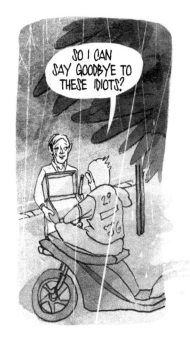

SO I CAN SAY GOODBYE TO THESE IDIOTS?

HAHAHA, I HOPE I DO.

YOU KNOW, I USED TO BE A DRIVER MYSELF...

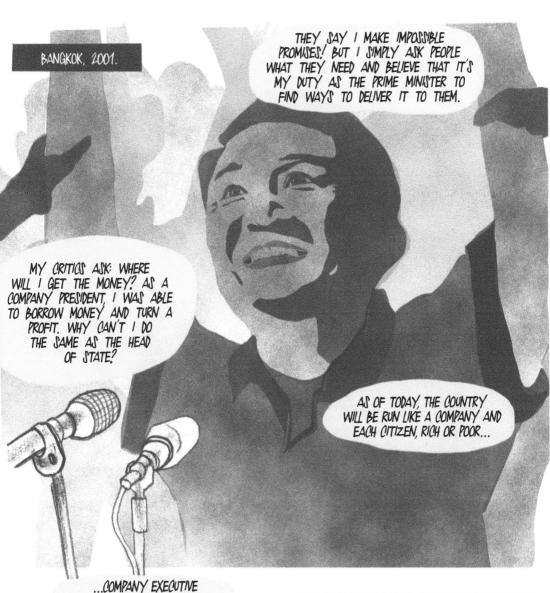

BANGKOK, 2001.

THEY SAY I MAKE IMPOSSIBLE PROMISES! BUT I SIMPLY ASK PEOPLE WHAT THEY NEED AND BELIEVE THAT IT'S MY DUTY AS THE PRIME MINISTER TO FIND WAYS TO DELIVER IT TO THEM.

MY CRITICS ASK: WHERE WILL I GET THE MONEY? AS A COMPANY PRESIDENT, I WAS ABLE TO BORROW MONEY AND TURN A PROFIT. WHY CAN'T I DO THE SAME AS THE HEAD OF STATE?

AS OF TODAY, THE COUNTRY WILL BE RUN LIKE A COMPANY AND EACH CITIZEN, RICH OR POOR...

...COMPANY EXECUTIVE OR MOTORTAXI DRIVER...

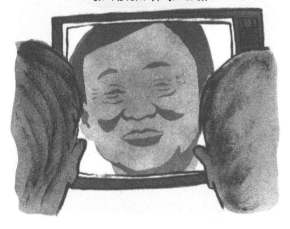

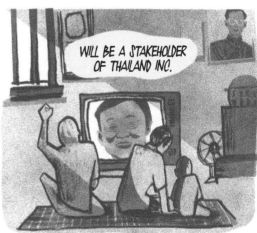

WILL BE A STAKEHOLDER OF THAILAND INC.

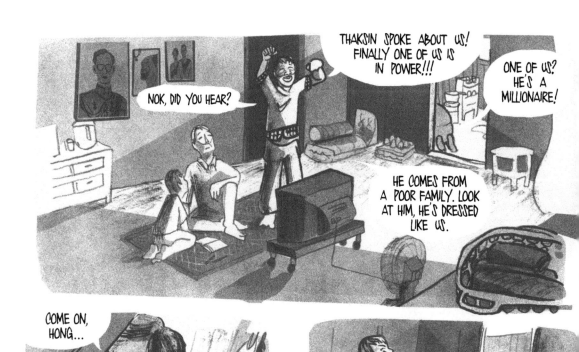

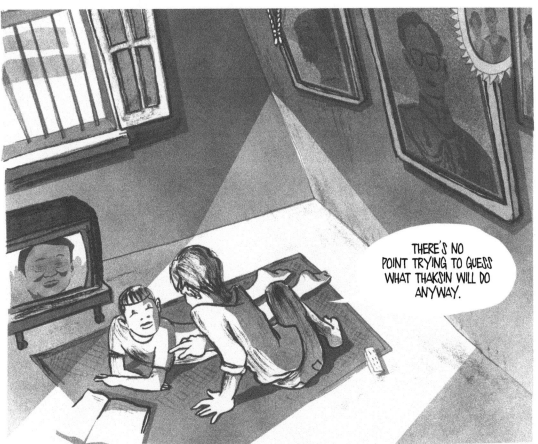

IN THOSE YEARS, WE FINALLY FOUND SOME PEACE. I'D LEFT DRUGS BEHIND. SUN, GAI, AND I MOVED TO BANGKOK, AND HONG WAS STILL AT OUR SIDE. I FELT FORTUNATE, EVEN WHEN GAI AND HONG WENT AT EACH OTHER.

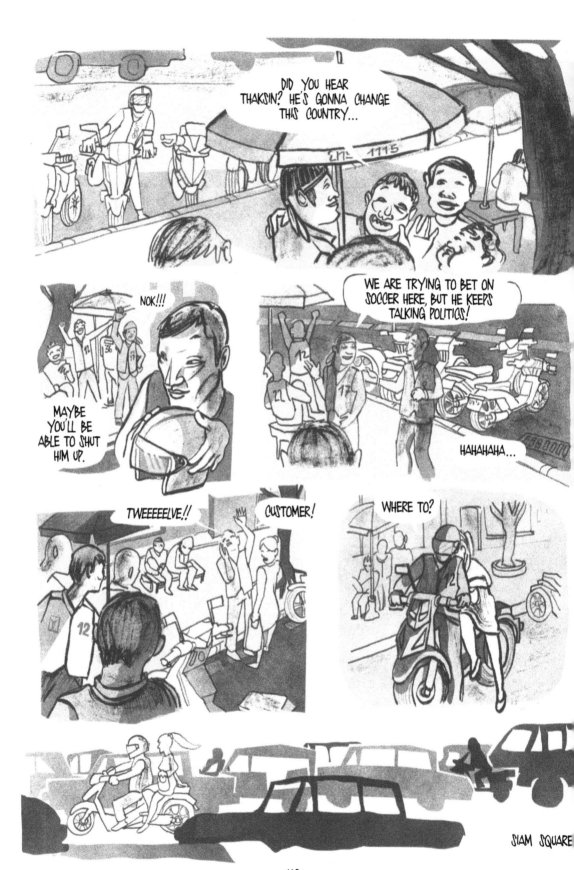

128

WORKING AS A MOTORTAXI DRIVER WASN'T ALWAYS EASY. THE WHOLE CITY WAS UNDER CONSTRUCTION. TRAFFIC WAS GETTING WORSE BY THE DAY, AND THE POLICE KEPT STOPPING US TO GIVE US FINES. BUT IN A FEW MONTHS, I KNEW THE CITY LIKE THE BACK OF MY HAND.

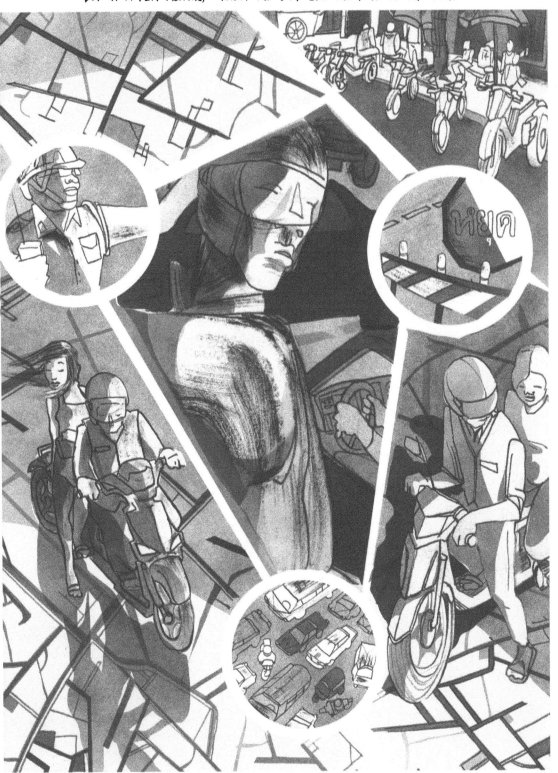

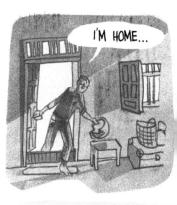

I'M HOME...

HELLO, LOVE, HOW WAS YOUR DAY?

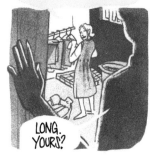

LONG. YOURS?

ACTUALLY, PRETTY GOOD! I GOT A PROMOTION! I'M A STORE SUPERVISOR NOW.

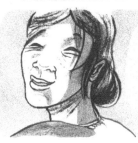

NO MORE SPENDING THE DAY STOCKING SHELVES.

BUT I WON'T BE ABLE TO PICK SUN UP FROM SCHOOL ANYMORE. CAN YOU DO IT AND BRING HIM TO YOUR STATION?

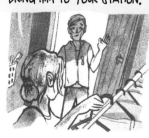

NO PROBLEM. IT WILL ACTUALLY BE GOOD FOR HIM TO SEE WHAT WORK'S LIKE. HE'S GETTING BIGGER...

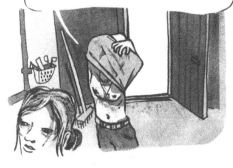

HE NEEDS TO LEARN. NEXT PLANTING SEASON I'LL BRING HIM TO THE VILLAGE WITH ME, I DON'T WANT HIM TO FORGET WHERE WE COME FROM.

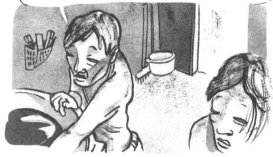

JUST DON'T BE TOO HARD ON HIM. HE'S NOT LIKE US.

DADDY!!!

CAN WE GO PLAY??

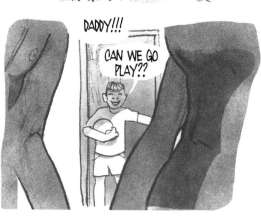

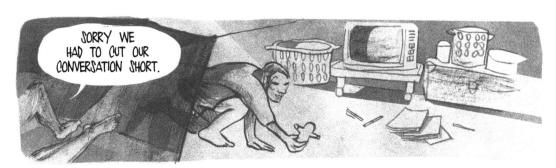

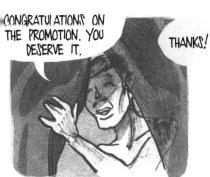

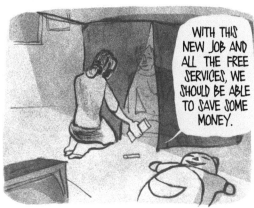

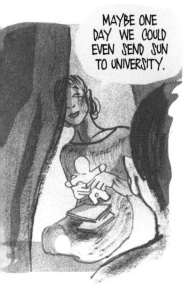

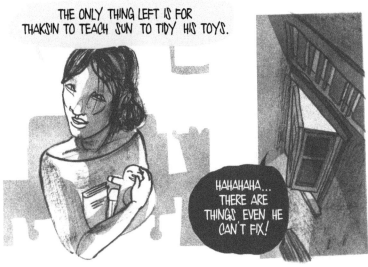

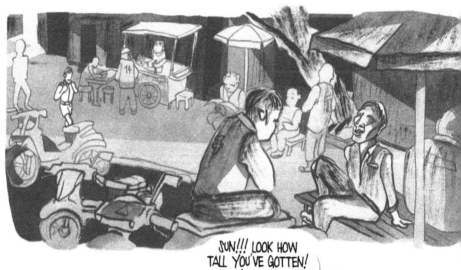

OVER THE NEXT FEW YEARS, IT FELT LIKE THE COUNTRY AND OUR LIVES MOVED IN SYNC. THE ISLAND AND THE 1997 ECONOMIC CRISIS WERE MILES AWAY.

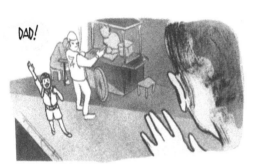

DAD!

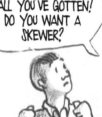

SUN!!! LOOK HOW TALL YOU'VE GOTTEN! DO YOU WANT A SKEWER?

YOU DON'T NEED YOUR FATHER'S PERMISSION! COME HERE...

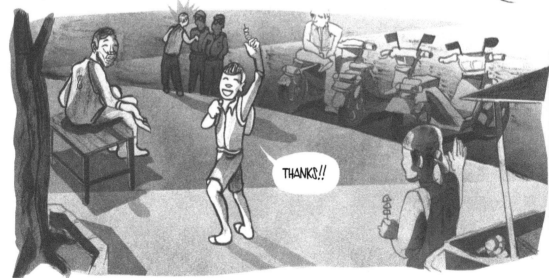

THANKS!!

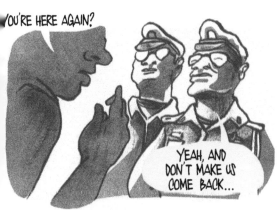

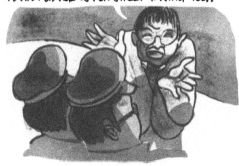

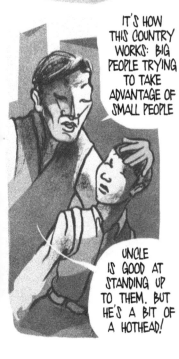

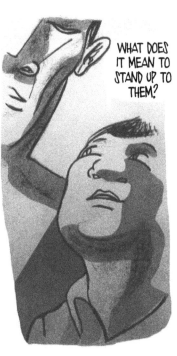

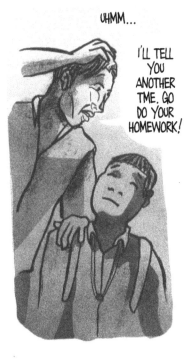

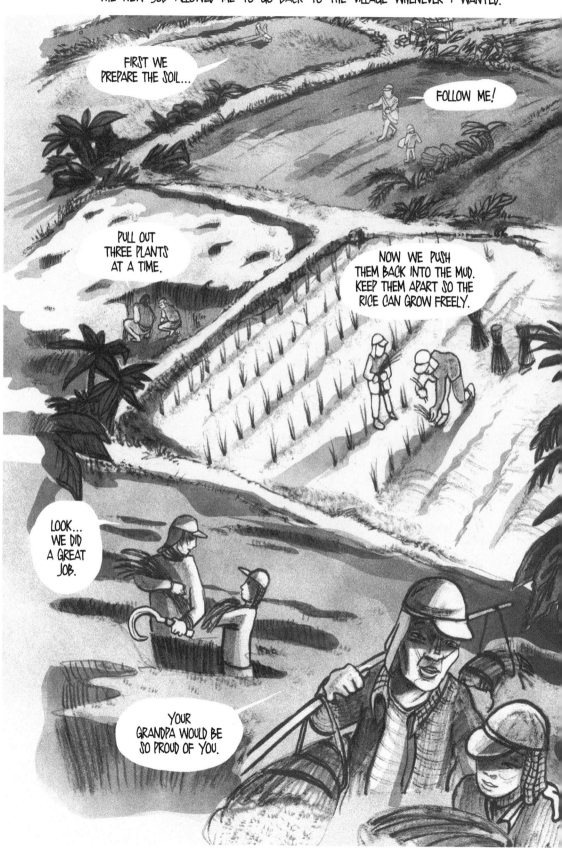

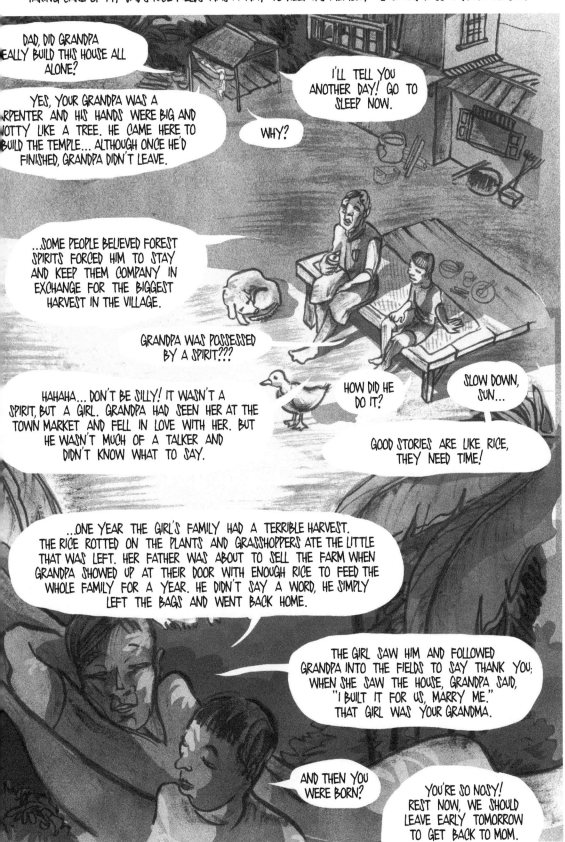

IN THE CITY, POLICE OFFICERS KEPT ASKING FOR MORE MONEY, BUT THAKSIN WAS HELPING US TO SEE THINGS DIFFERENTLY: WE WERE CITIZENS, AND OFFICERS SHOULD WORK FOR US, NOT THE OTHER WAY AROUND. SO, AFTER A FEW MONTHS OF QUIETLY PAYING, WE STARTED TO ORGANIZE.

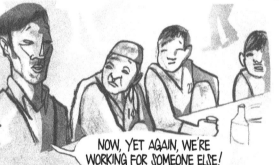

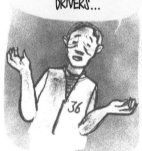

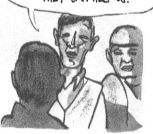

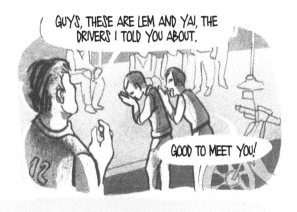

GUYS, THESE ARE LEM AND YAI, THE DRIVERS I TOLD YOU ABOUT.

GOOD TO MEET YOU!

HONG TOLD US ABOUT YOUR PROBLEMS WITH POLICE OFFICERS. UNFORTUNATELY, YOU'RE NOT THE ONLY ONES. IT'S TIME TO PUT AN END TO PEOPLE IN THIS CITY TREATING US LIKE ANIMALS! THAKSIN PROMISED TO REGISTER US AND GIVE US OFFICIAL VESTS...

BUT THERE'S NO TIME TO SIT BACK AND WAIT FOR THE GOVERNMENT TO DELIVER ON ITS PROMISES. IF WE WANT SOMETHING, WE'LL HAVE TO FIGHT FOR IT. STARTING TOMORROW WE'RE GOING TO ORGANIZE A DEMONSTRATION EACH WEEK IN FRONT OF THE POLICE STATIONS. WE WANT TO LET PEOPLE KNOW HOW WE ARE RUN AND WHO MAKES MONEY FROM OUR WORK. WE HOPE TO SEE A LOT OF YOU THERE! MY BROTHERS, WE'VE HAD TO FIGHT FOR EVERYTHING IN OUR LIVES. NOW WE MAY HAVE FOUND AN ALLY IN THAKSIN, BUT WE STILL NEED TO APPLY PRESSURE!!

SO, DID THEY COME TO THE STATION?

YEAH, TWO GUYS, MOTORTAXIS LIKE US. THEY'RE ORGANIZING SOME PROTESTS.

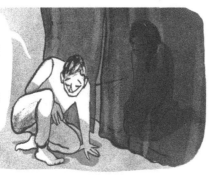

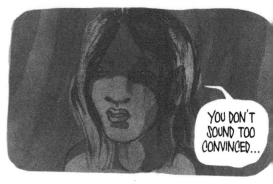

YOU DON'T SOUND TOO CONVINCED...

I DON'T KNOW, WE WORKED SO HARD TO BUILD THE LIFE WE HAVE NOW...

IT SEEMS CRAZY TO PUT IT AT RISK AGAIN...

NOK...

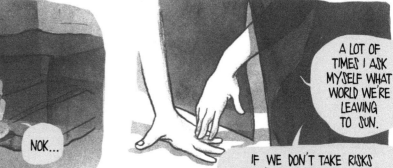

A LOT OF TIMES I ASK MYSELF WHAT WORLD WE'RE LEAVING TO SUN.

IF WE DON'T TAKE RISKS TO GIVE HIM A BETTER LIFE, WHO WILL?

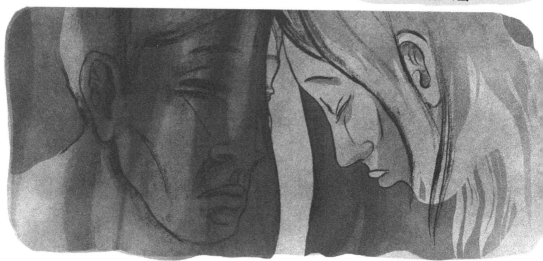

SO WE BEGAN. EACH WEEK, SOME OF US WOULD TAKE A BREAK FROM WORK AND JOIN THE PROTEST.

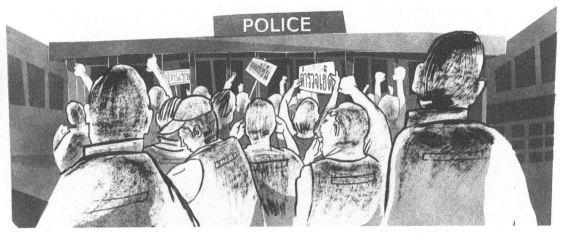

WE GOT TO KNOW NEW DRIVERS, REALIZED THAT WE WEREN'T ALONE,
AND WE LEARNED TO FIGHT TOGETHER AND TRUST EACH OTHER.

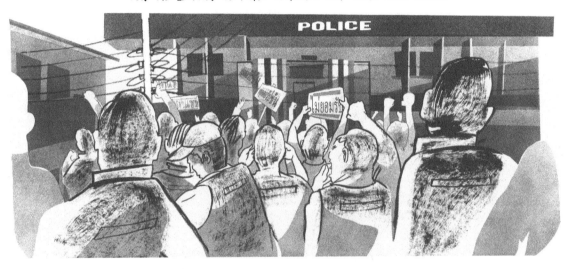

AFTER A COUPLE OF MONTHS, WE BECAME A FORCE TO BE RECKONED WITH.

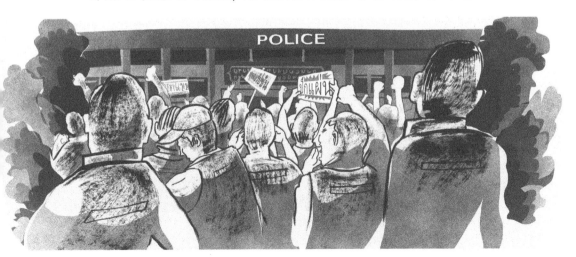

A GROUP OF US WERE EVEN INVITED TO MEET WITH THAKSIN. HONG WAS AMONG THEM.

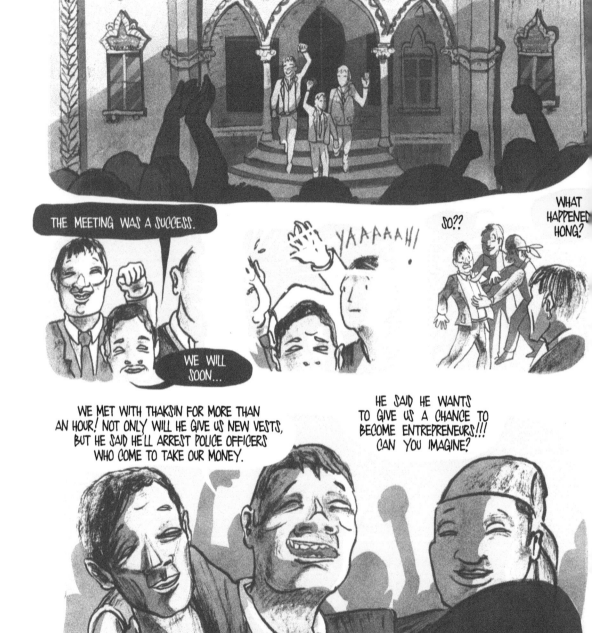

THE MEETING WAS A SUCCESS.

WE WILL SOON...

YAAAAAH!

SO??

WHAT HAPPENED HONG?

WE MET WITH THAKSIN FOR MORE THAN AN HOUR! NOT ONLY WILL HE GIVE US NEW VESTS, BUT HE SAID HE'LL ARREST POLICE OFFICERS WHO COME TO TAKE OUR MONEY.

HE SAID HE WANTS TO GIVE US A CHANCE TO BECOME ENTREPRENEURS!!! CAN YOU IMAGINE?

FOR THE FIRST TIME IN OUR LIVES, THE POLITICIANS WE SAW ON TV WERE NOT DISTANT TALKING HEADS. FINALLY, SOMEBODY HAD NOTICED THAT WE EXISTED.

AND IT WASN'T JUST WORDS. ON MAY 3, 2003, WE RECEIVED THE NEW UNIFORMS.

EVERY MORNING I PUT MINE ON AND FELT PROUD OF MYSELF...

MY FRIENDS, AND MY JOB.

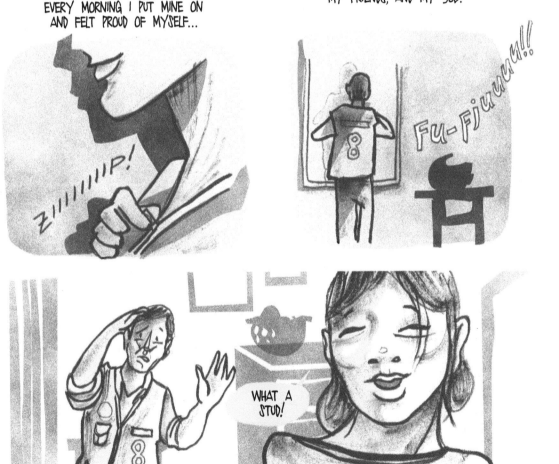

THOSE YEARS WERE EXHILARATING. WE FELT PART OF SOMETHING BIGGER THAN OURSELVES. BUT UNDERNEATH ALL OF THIS, EVERYDAY LIFE KEPT GOING ON.

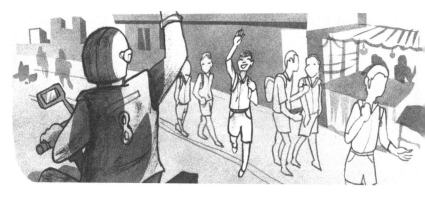

MOMMY!!! DAD BOUGHT ME A SLINGSHOT!!

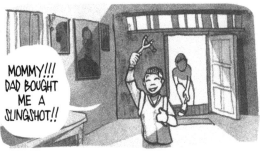

HOLD ON, YOUNG MAN!!! WHAT DID YOU FORGET?

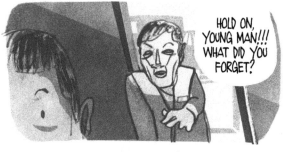

YOU KNOW THAT WHEN YOU ENTER THE HOUSE YOU HAVE TO TAKE OFF YOUR SHOES AND GREET THE KING!

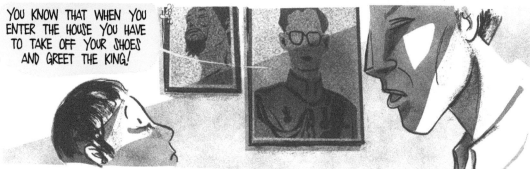

HE'S A GREAT MAN...

THE FATHER OF OUR NATION.

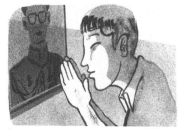

HE'S LIKE THE SKY. HE SEEMS DISTANT...

BUT HE IS ALWAYS THERE WHEN WE NEED HIM.

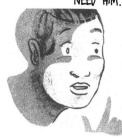

THE REAL QUESTION IS...

CAN HE USE A SLINGSHOT?

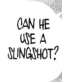

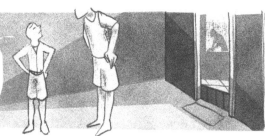

EVERY DAY SUN BECAME MORE LIKE HIS MOM.

IN THOSE YEARS, WE FELT SO CLOSE. WE COULD FACE ANYTHING, EVEN THE MOST DEVASTATING DISASTERS.

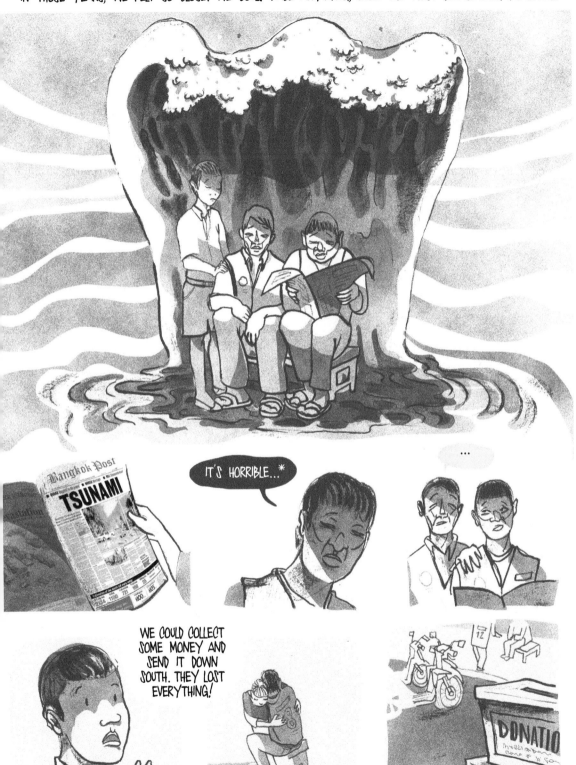

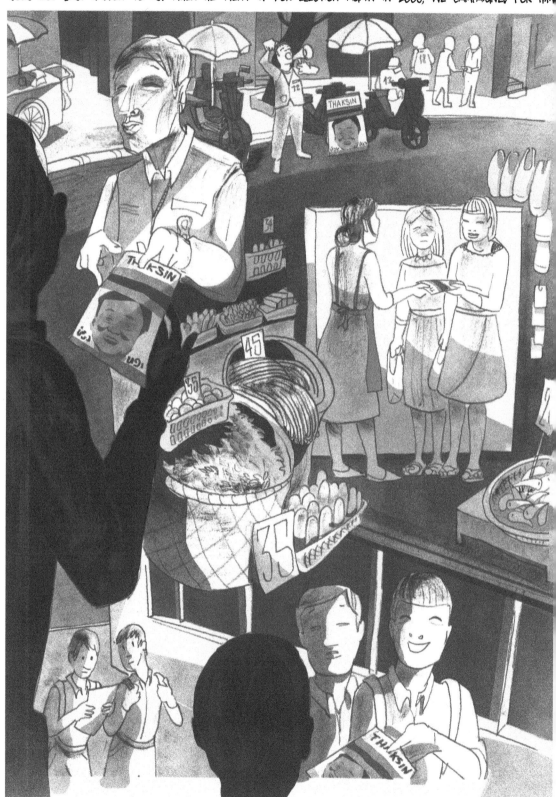

144

AND IT PAID OFF. ON MARCH 9, THAKSIN WAS RE-ELECTED, WITH AN EVEN LARGER MAJORITY.

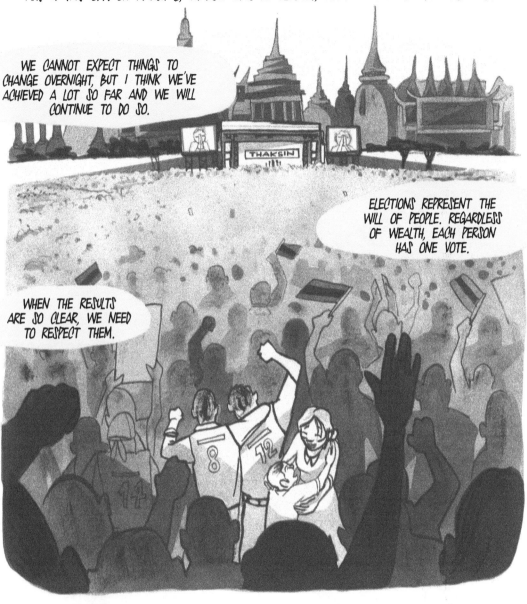

WE CANNOT EXPECT THINGS TO CHANGE OVERNIGHT, BUT I THINK WE'VE ACHIEVED A LOT SO FAR AND WE WILL CONTINUE TO DO SO.

ELECTIONS REPRESENT THE WILL OF PEOPLE. REGARDLESS OF WEALTH, EACH PERSON HAS ONE VOTE.

WHEN THE RESULTS ARE SO CLEAR, WE NEED TO RESPECT THEM.

NOBODY CAN PRETEND THAT THEIR OPINION IS WORTH MORE THAN THAT OF THE MAJORITY.

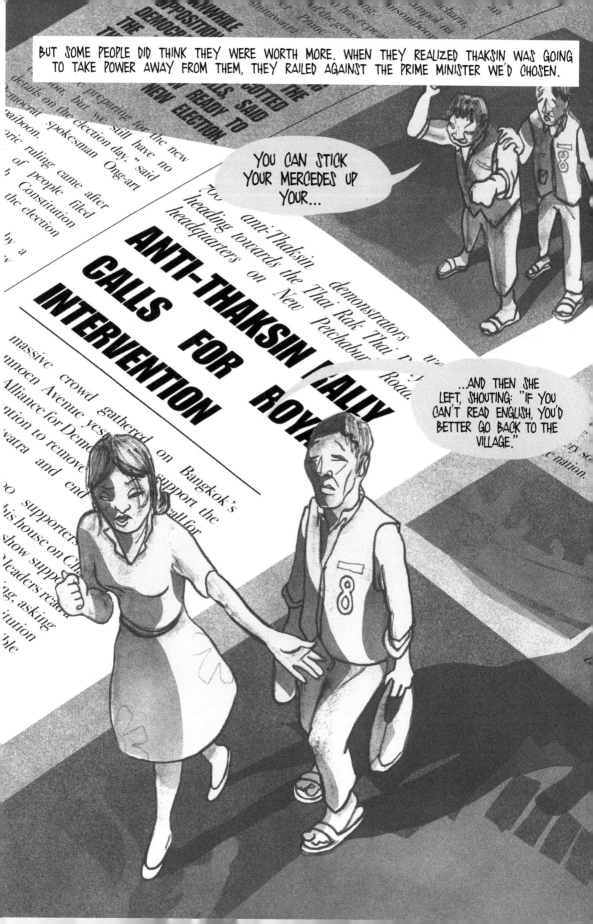

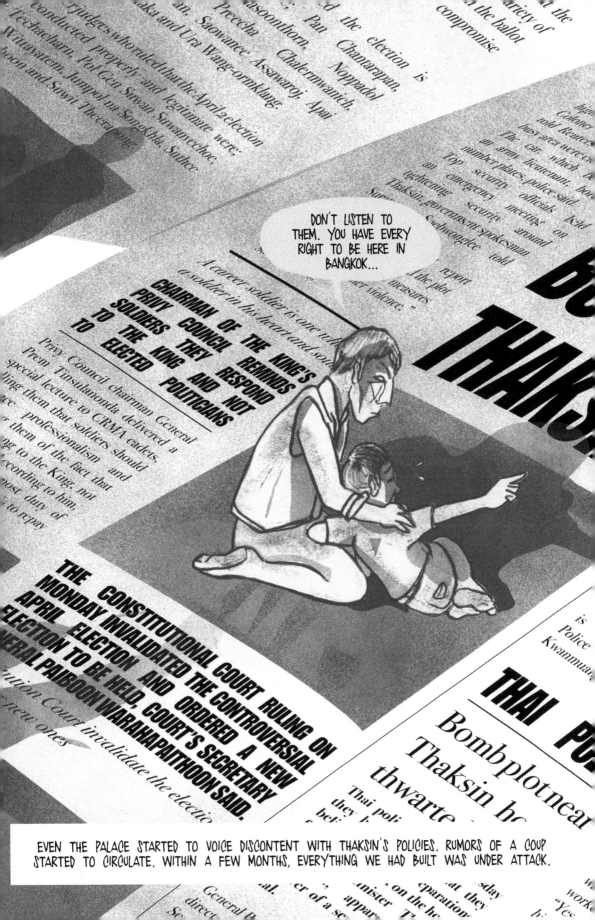

EVEN THE PALACE STARTED TO VOICE DISCONTENT WITH THAKSIN'S POLICIES. RUMORS OF A COUP STARTED TO CIRCULATE. WITHIN A FEW MONTHS, EVERYTHING WE HAD BUILT WAS UNDER ATTACK.

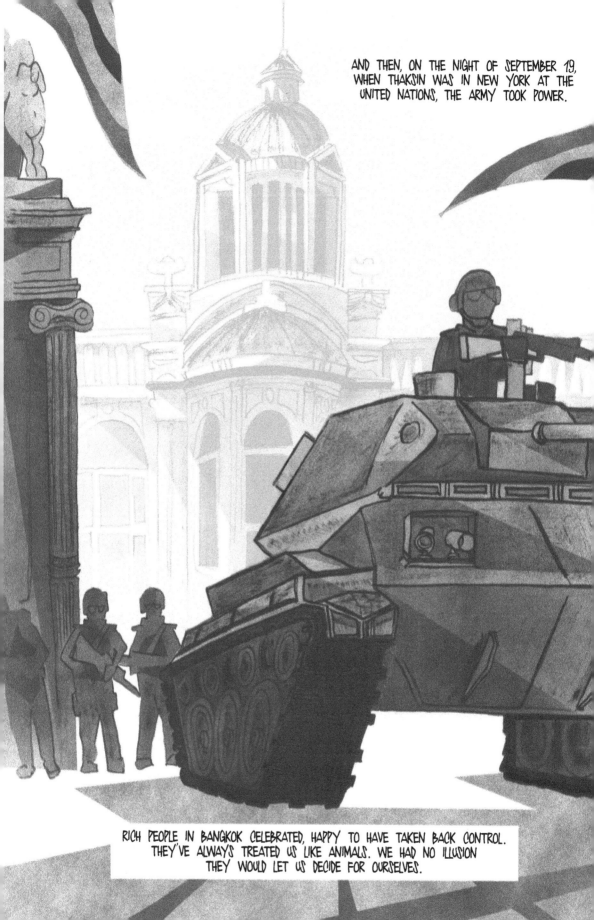

AND THEN, ON THE NIGHT OF SEPTEMBER 19, WHEN THAKSIN WAS IN NEW YORK AT THE UNITED NATIONS, THE ARMY TOOK POWER.

RICH PEOPLE IN BANGKOK CELEBRATED, HAPPY TO HAVE TAKEN BACK CONTROL. THEY'VE ALWAYS TREATED US LIKE ANIMALS. WE HAD NO ILLUSION THEY WOULD LET US DECIDE FOR OURSELVES.

BUT WHAT BROKE OUR HEARTS WAS SEEING THE KING, A MAN WE'D ALWAYS THOUGHT WAS ON OUR SIDE, GIVE THEM POWER.

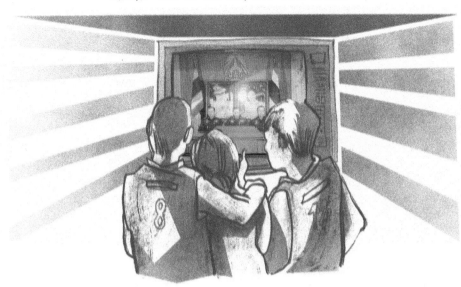

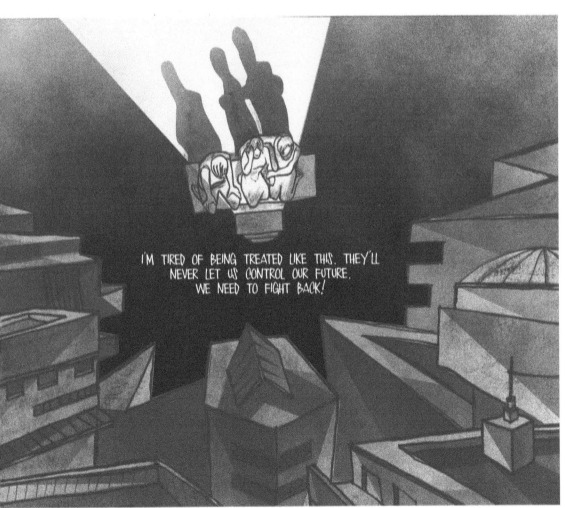

I'M TIRED OF BEING TREATED LIKE THIS. THEY'LL NEVER LET US CONTROL OUR FUTURE. WE NEED TO FIGHT BACK!

CHAPTER

5

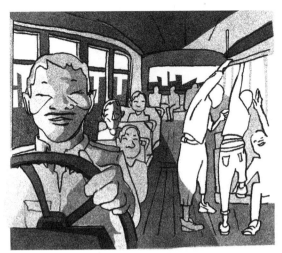
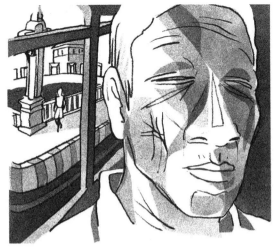

IT'S FUNNY TO THINK BACK TO THE FIRST TIME I CAME TO BANGKOK.

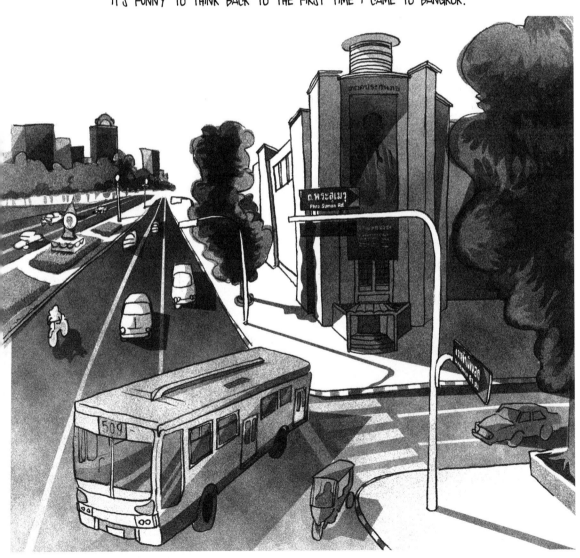

I WAS SO NAIVE AND EXCITED.

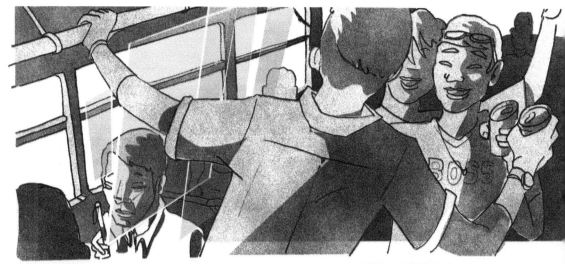

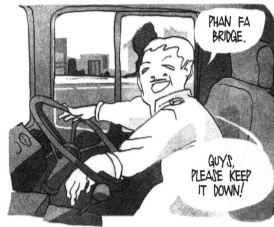

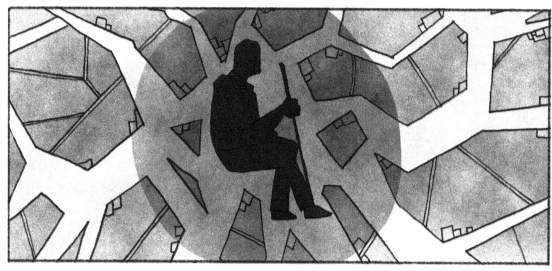

JUST BEING IN THE CITY MADE ME FEEL STRONGER.

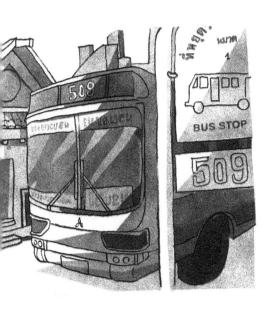
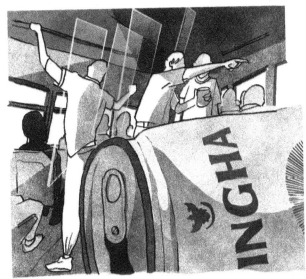

NO LONGER A SPECTATOR BUT THE PROTAGONIST OF A NEW ERA OF PROGRESS.

RAJADAMNERN STADIUM.

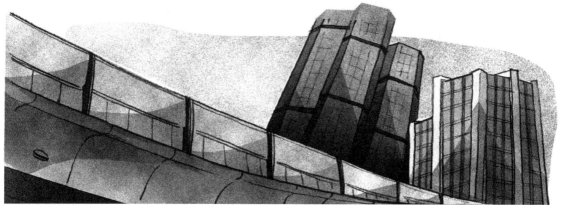

FOR A LONG TIME, I WAS BLINDED BY ITS SHINING LIGHTS,

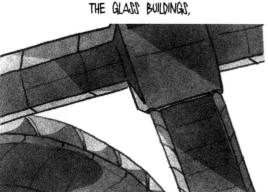

THE GLASS BUILDINGS,

AND COLORFUL SCREENS.

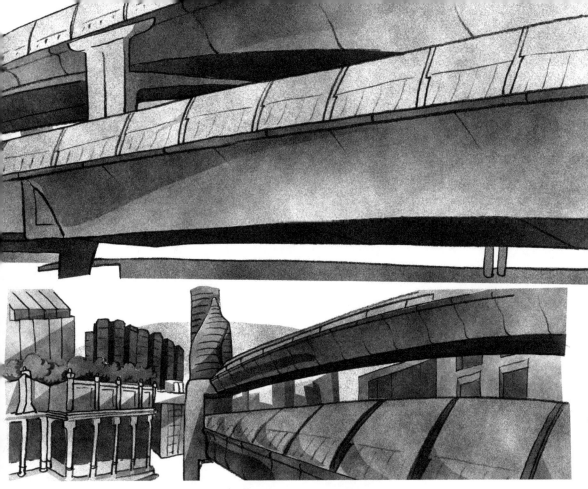

I HAD TO LOSE MY SIGHT TO SEE WHAT HID BEHIND THEM

AND UNDERSTAND THAT I WAS JUST A PAWN

IN A GAME LARGER THAN ME.

I WAS FORCED TO STOP AND LISTEN TO THE SOUNDS UNDERNEATH THE NOISE OF TRAFFIC, THE JINGLES OF ADVERTISEMENTS, AND THE CHEERING CROWDS.

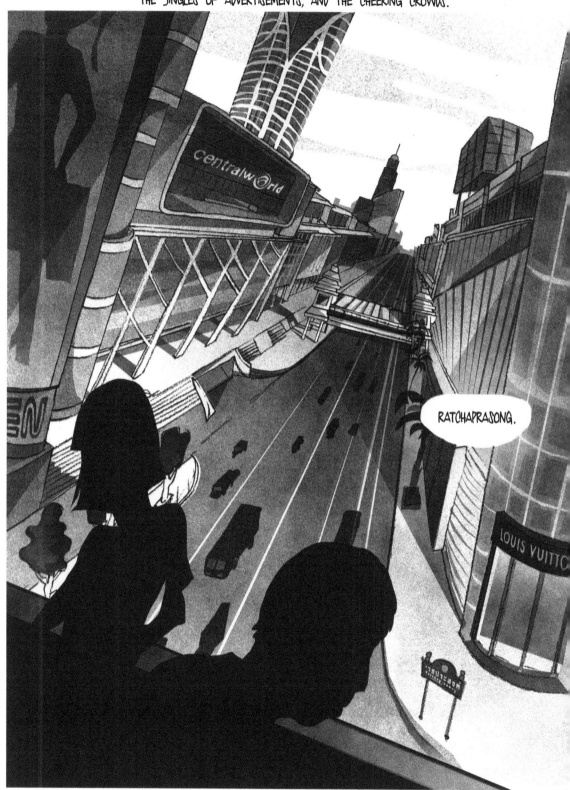

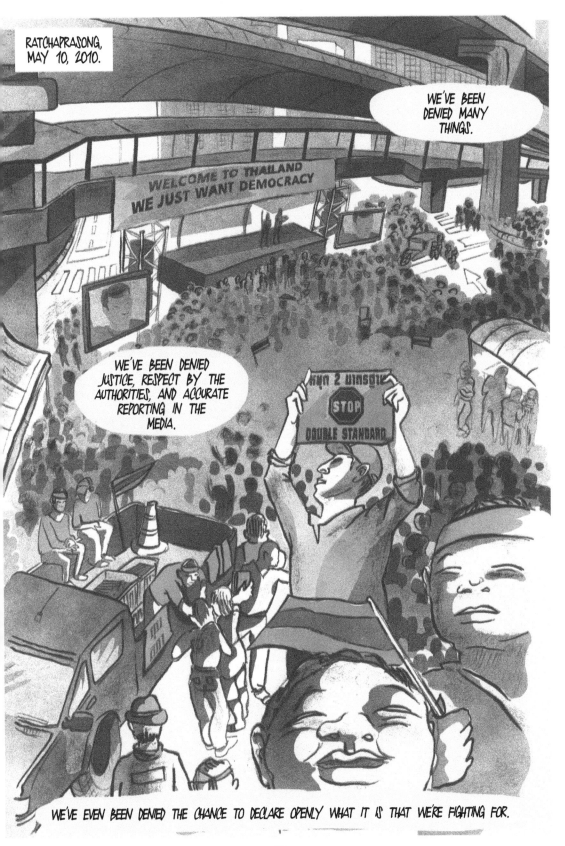

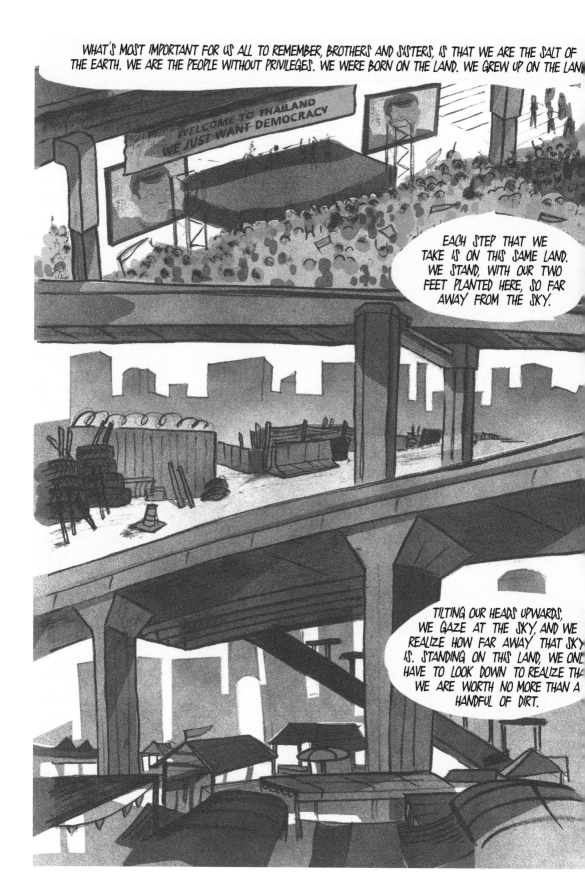

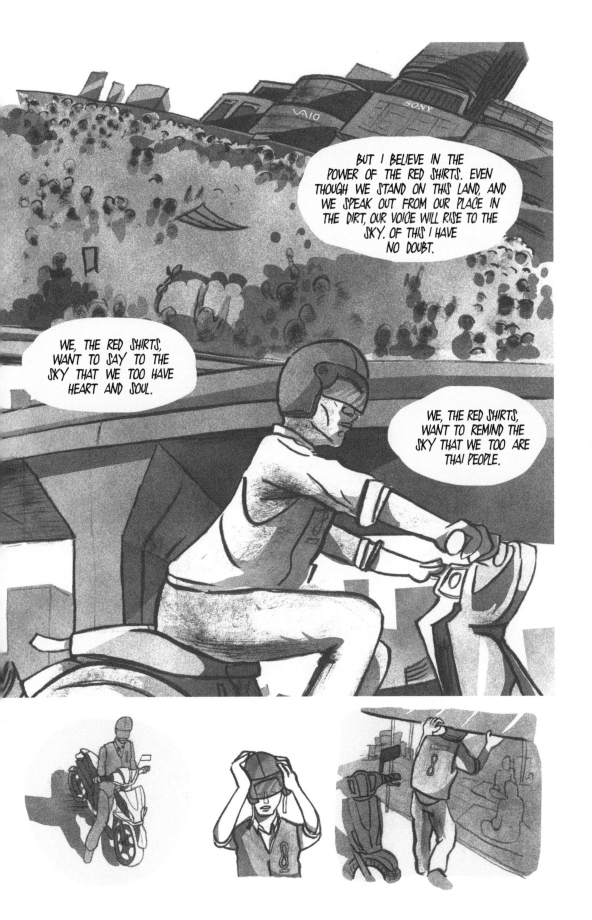

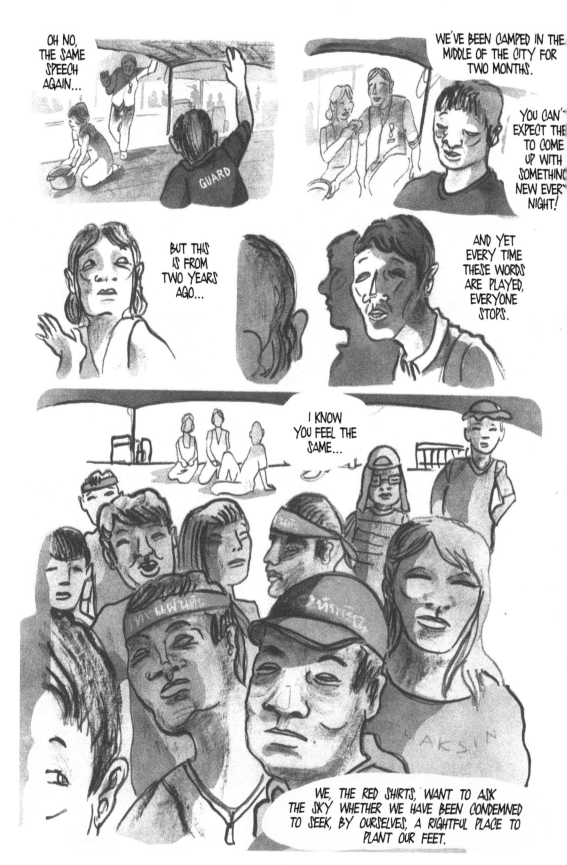

AFTER THE MILITARY COUP IN 2006, WE WEREN'T THE ONLY ONES WHO FELT THAT WE COULDN'T JUST WAIT AROUND FOR THE NEXT ELECTION.

AT FIRST, THERE WERE SMALL GROUPS PROTESTING, COMPOSED MOSTLY OF STUDENTS AND SOME LONELY ACTIVISTS. BUT IN 2009, WHEN A NEW UNELECTED GOVERNMENT TOOK POWER, THOUSANDS OF PEOPLE IN THE PROVINCES AND MIGRANT WORKERS IN THE CITY STARTED TO ORGANIZE A MASS MOVEMENT, THE RED SHIRTS.

WE BEGAN WITH SIT-INS AROUND THE COUNTRY. THEN, ON MARCH 14, 2010, WE DECIDED TO TAKE OVER THE CAPITAL. BANGKOK WAS INVADED BY HUNDREDS OF THOUSANDS OF RED SHIRTS. WE DEMANDED THAT THE ILLEGITIMATE GOVERNMENT RESIGN.

INITIALLY, WE OCCUPIED A LARGE AVENUE IN OLD TOWN. ON APRIL 10, THE ARMY TRIED TO DISPERSE US, BUT WE PUSHED THEM BACK: 25 PEOPLE DIED AND HUNDREDS WERE INJURED.

WE DECIDED TO MOVE TO THE RATCHAPRASONG INTERSECTION.

OLD TOWN

WE THOUGHT THE ARMY WOULD NEVER ATTACK THE AREA WHERE RICH PEOPLE GO TO SHOP. THERE, IN THE SHADOW OF SKYSCRAPERS AND SHOPPING MALLS, WE CREATED A VILLAGE.

THEY WERE USED TO LOOKING DOWN ON US. NOW IT WAS US STARING UP AT THEM.

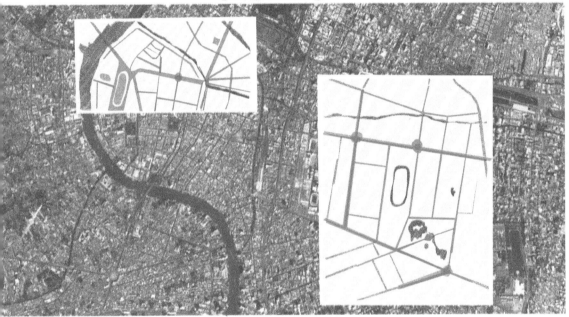

DURING THE DAY, THE PROTEST SITE WAS FILLED MOSTLY WITH OLDER PEOPLE AND UNEMPLOYED WOMEN, BUT AFTER THE WORKDAY ENDED, PEOPLE CAME IN FROM EVERY PART OF TOWN.

OUR DEFENSES WERE WELL ORGANIZED AND WE HAD SEALED OFF THE AREA WITH HANDMADE BARRICADES. YET THE MEMORY OF THE ARMY'S BULLETS WERE STILL WITH US.

RATCHAPRASONG

MANY MOTORCYCLE TAXI DRIVERS JOINED IN. SOME OF US PATROLLED THE BARRICADES, OTHERS MONITORED THE ARMY'S MOVEMENTS.

WE KNEW VERY WELL THAT MAKESHIFT DEFENSES WOULDN'T BE ENOUGH TO PROTECT US. BUT WE HOPED THAT OUR ABILITY TO MOVE EASILY THROUGH BANGKOK'S STREETS AND ALLEYS WOULD HELP US PREVENT, OR AT LEAST ANTICIPATE, ANOTHER ATTACK.

HONG, AS ALWAYS, WAS THE FIRST ONE TO JOIN, AND WHEN I COULD, I WAS THERE WITH HIM.

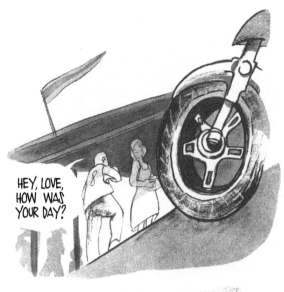

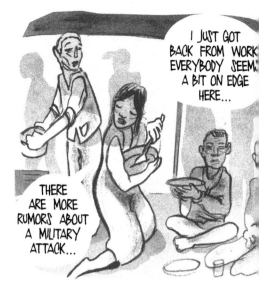

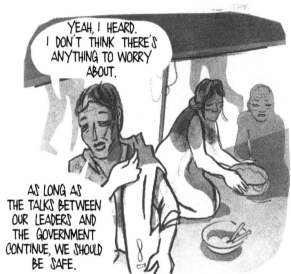

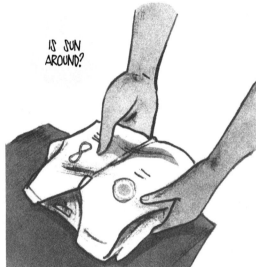

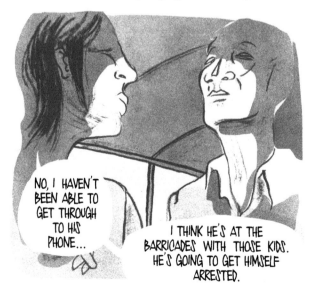

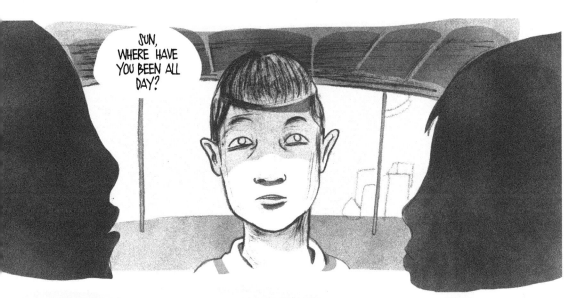
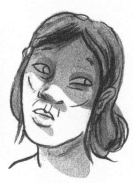

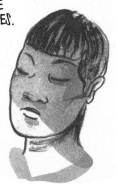
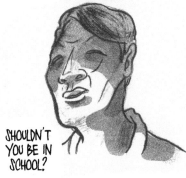
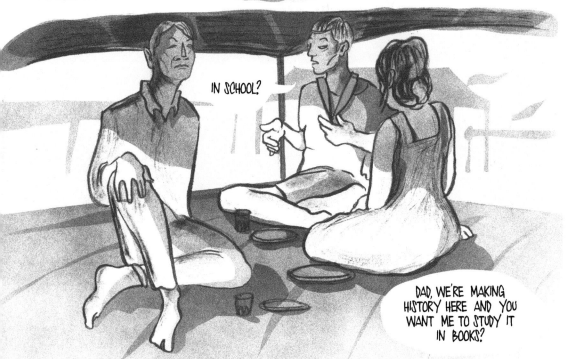

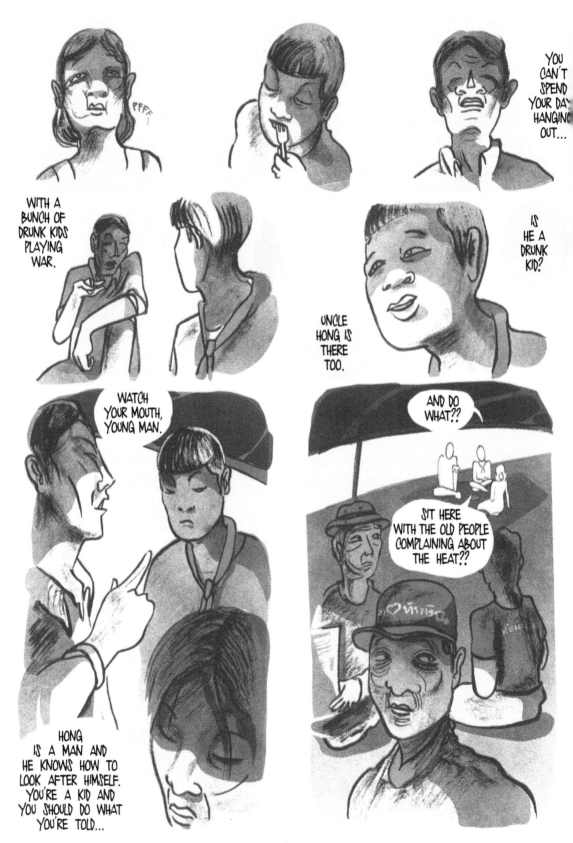

SHOW SOME RESPECT! IF IT WASN'T FOR THEM, THERE WOULD BE NO PROTEST.

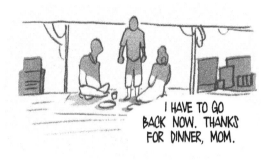

I HAVE TO GO BACK NOW. THANKS FOR DINNER, MOM.

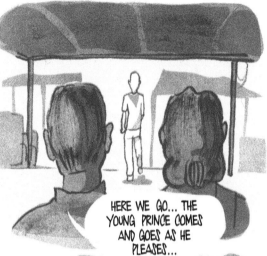

HERE WE GO... THE YOUNG PRINCE COMES AND GOES AS HE PLEASES...

AND KEEP YOUR FUCKING PHONE ON!!!

HE'S A TEENAGER, HE'S NOT SUPPOSED TO LISTEN TO US...

SOMETIMES HE DRIVES ME CRAZY!

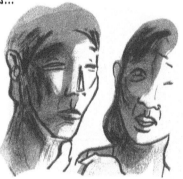

DON'T TAKE IT PERSONALLY...

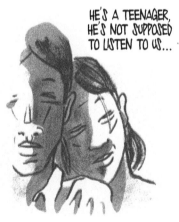

ASK HONG TO STEP IN, MAYBE HE CAN TALK SOME SENSE INTO HIM.

165

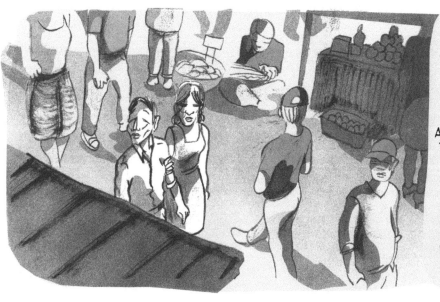

THOSE WERE STRANGE DAYS. RUMORS SPREAD AMONG THE PROTESTERS. ONE MOMENT IT SEEMED LIKE A MILITARY ATTACK WAS IMMINENT; THE NEXT WAS BACK TO A SLEEPY CALM. USUALLY GAI AND I WOKE UP AT DAWN, ATE SOMETHING, AND WENT TO WORK. SOMETIMES IN THE EVENING, WE STROLLED AROUND.

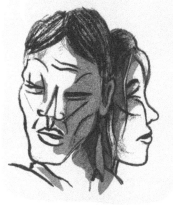

HOW DID WE END UP WITH SUCH A STUBBORN KID?

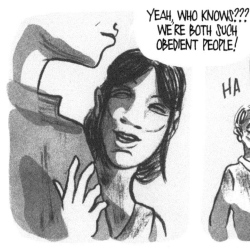

YEAH, WHO KNOWS??? WE'RE BOTH SUCH OBEDIENT PEOPLE!

HA HA! HA HA!

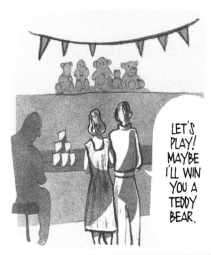

LET'S PLAY! MAYBE I'LL WIN YOU A TEDDY BEAR.

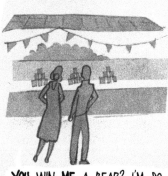

YOU WIN ME A BEAR? I'M SO MUCH BETTER THAN YOU AT THIS. WANNA BET?

IT FELT LIKE A VILLAGE FAIR, BACK IN THE DAYS BEFORE SUN WAS BORN.

BUT THEN WE WERE IMMEDIATELY REMINDED THAT WE WEREN'T THERE TO HAVE FUN.

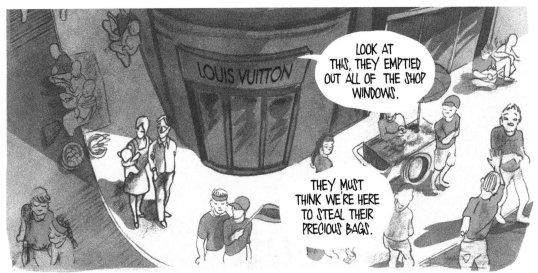

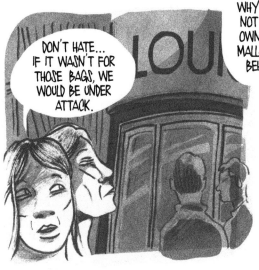

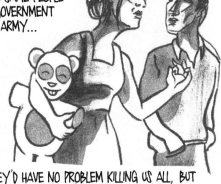

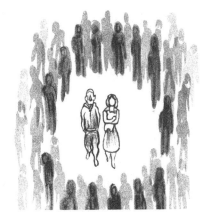

IT'S ALMOST FUNNY, THOUSANDS OF FARMERS IN THE MIDDLE OF THE CITY...

PROTECTED BY LOUIS VUITTON!!!

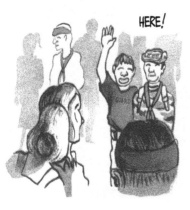

HERE!

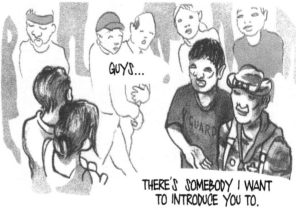

GUYS...

THERE'S SOMEBODY I WANT TO INTRODUCE YOU TO.

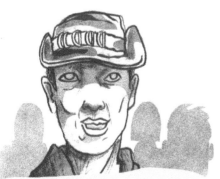

GENERAL SEH DAENG. THIS IS GAI AND NOK, SOME OF MY CLOSEST FRIENDS. WITHOUT THEM I WOULDN'T BE HERE.

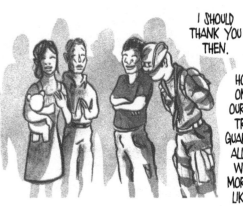

I SHOULD THANK YOU THEN.

HONG IS ONE OF OUR MOST TRUSTED GUARDS; WE ALL WISH WE HAD MORE MEN LIKE HIM.

GENERAL, WHAT AN HONOR. WE'RE REALLY GRATEFUL TO YOU FOR KEEPING US SAFE.

IT'S WOMEN LIKE YOU WHO ARE DOING MOST OF THE WORK, LOOKING AFTER OUR MEN AND ELDERS.

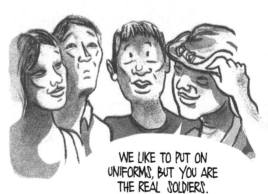

WE LIKE TO PUT ON UNIFORMS, BUT YOU ARE THE REAL SOLDIERS.

GENERAL, DO YOU THINK THE ARMY IS REALLY PLANNING ANOTHER ATTACK?

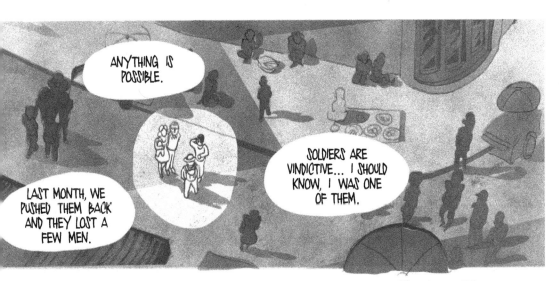

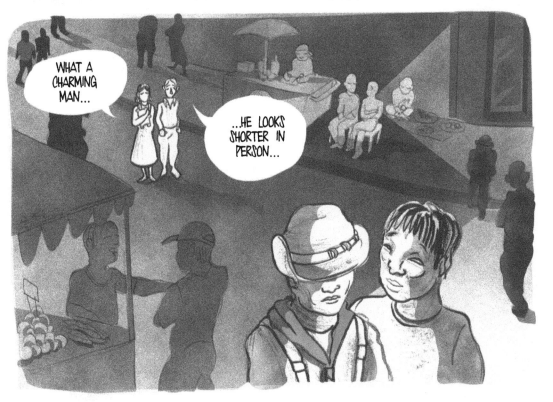

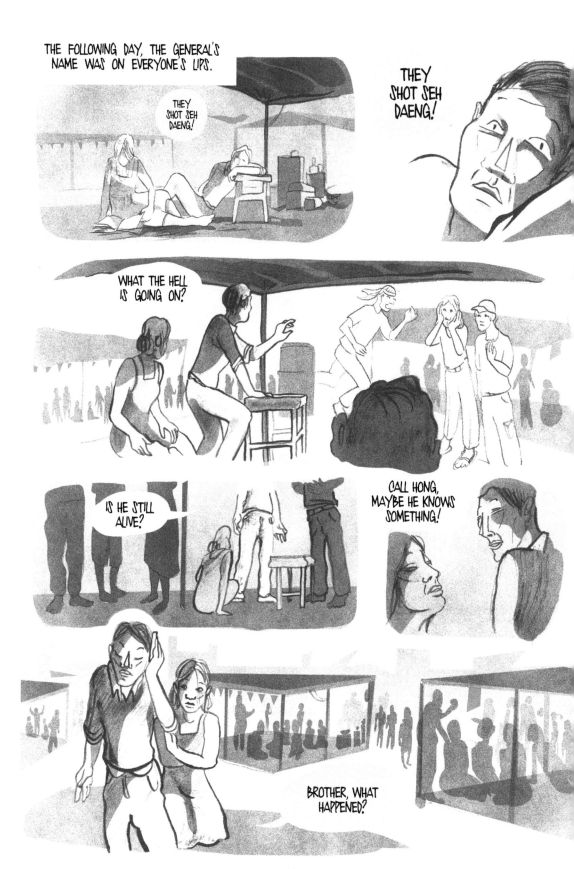

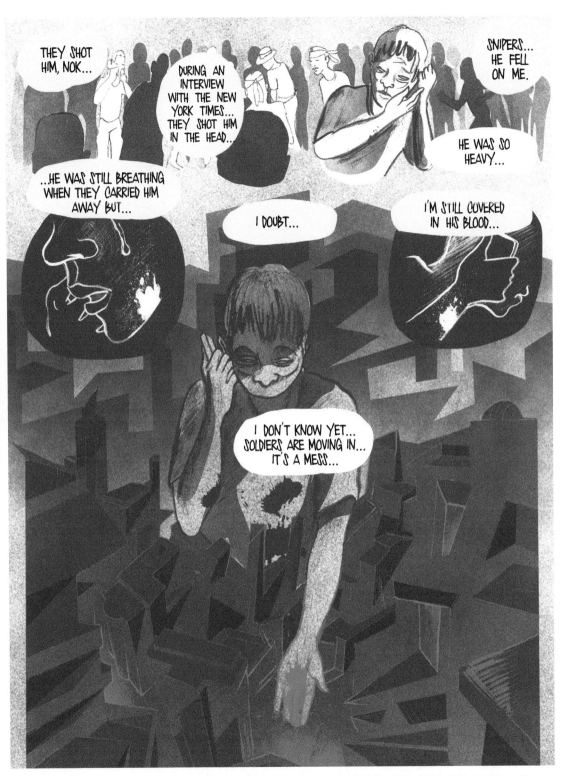

THAT NIGHT WAS TERRIFYING. INSIDE THE PROTEST AREA, EVERYTHING WAS CALM, BUT OUTSIDE, ALL HELL BROKE LOOSE. IN THE MIDDLE OF THE NIGHT, WE WERE WOKEN UP BY THE SOUND OF SHOTS AND EXPLOSIONS. INSIDE THE BARRICADES, NOBODY WAS ABLE TO FALL BACK TO SLEEP. WE WAITED FOR THE SUN TO COME UP AS THE SOUND OF BULLETS ECHOED IN THE STREETS, NOT FAR FROM US.

THE NEXT MORNING WE WERE AT WAR. GAI STAYED AT THE PROTEST. SUN AND I WENT TO THE BARRICADES.

THANKS FOR COMING TO HELP OUT.

ALL THE YOUNGER PEOPLE WILL STAY HERE TO PROTECT THE BARRICADES. ALL THE MOTORTAXIS, COME WITH ME.

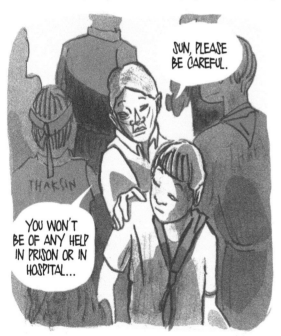

SUN, PLEASE BE CAREFUL.

YOU WON'T BE OF ANY HELP IN PRISON OR IN HOSPITAL...

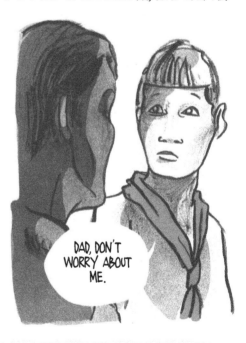

DAD, DON'T WORRY ABOUT ME.

LAST NIGHT, THE MILITARY INJURED HUNDREDS OF RED SHIRTS AND KILLED FIVE. UNFORTUNATELY, IT'S JUST THE BEGINNING. THEY CONTINUE TO ADVANCE AND SOON THEY'LL CLOSE DOWN THE WHOLE AREA. WE'RE OPENING TWO FRONTS: THE FIRST ONE, HERE, TO DEFEND THE PROTEST; THE SECOND ONE, BEHIND THE ARMY LINES, TO PREVENT THE SOLDIERS FROM ADVANCING OR RETREATING.

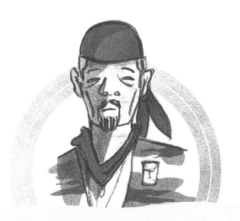

YOU HAVE A VERY IMPORTANT ROLE: TRANSPORT US FROM ONE FRONT TO ANOTHER SO WE CAN DIRECT THE FIGHTERS. EVEN IF THE ARMY CONTROLS THIS AREA, THE REST OF THE CITY WILL REMAIN ALMOST NORMAL. ALWAYS WEAR YOUR VESTS SO THAT THE MILITARY WILL NOT STOP YOU. ACT NORMALLY, AS IF WE'RE NORMAL PASSENGERS: NEVER SPEND TOO MUCH TIME IN ONE SPOT AND YOU SHOULDN'T HAVE ANY PROBLEMS. IF YOU HAVE FAMILY STAYING HERE, NOW IS YOUR CHANCE TO SAY GOODBYE. YOU PROBABLY WON'T BE ABLE TO SEE THEM FOR A WHILE. ALL CLEAR?

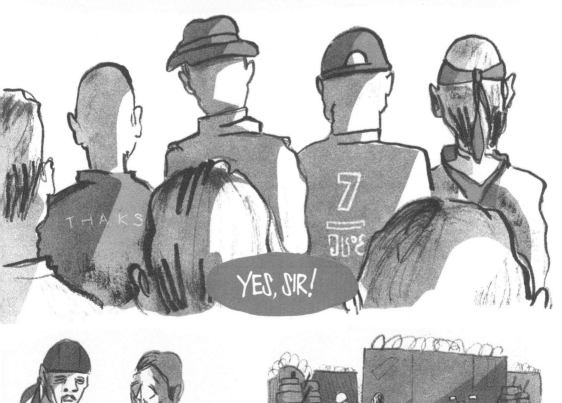

YES, SIR!

HONG TOLD ME I CAN TRUST YOU.

YOU COME WITH ME...

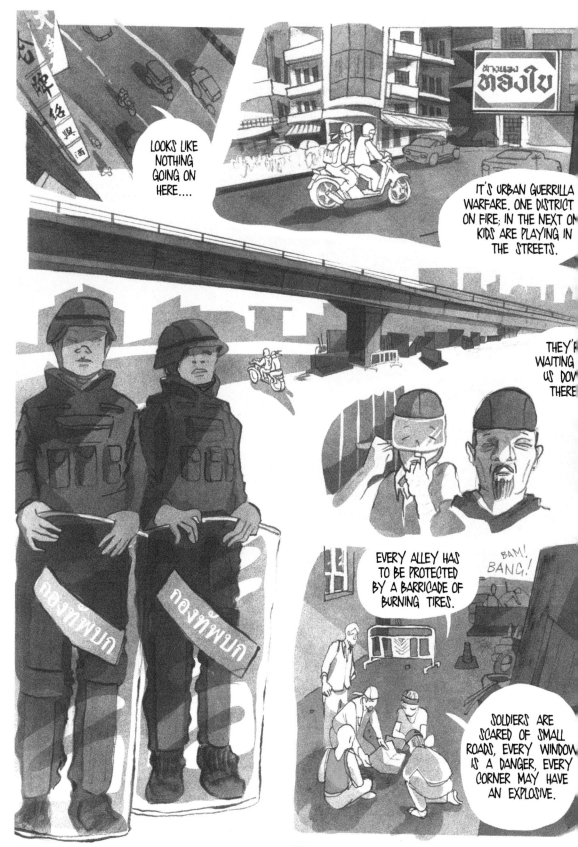

174

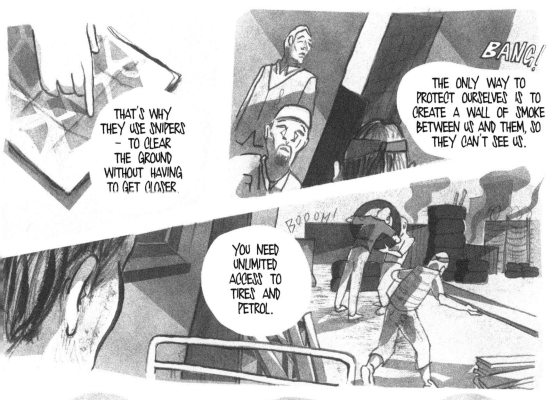

THAT'S WHY THEY USE SNIPERS - TO CLEAR THE GROUND WITHOUT HAVING TO GET CLOSER.

BANG!

THE ONLY WAY TO PROTECT OURSELVES IS TO CREATE A WALL OF SMOKE BETWEEN US AND THEM, SO THEY CAN'T SEE US.

BOOOM!

YOU NEED UNLIMITED ACCESS TO TIRES AND PETROL.

IS SUN WITH YOU?

...S CRAWLING ...TH SOLDIERS ...ERE, HONG. ...R MORE AND ...ORE PEOPLE ...RE JOINING ...S IN THE ...STREETS.

THANKS, BROTHER.

GOTTA GO NOW.

ONE OF THE MANY SAFE HOUSES WE HAVE AROUND THE CITY.

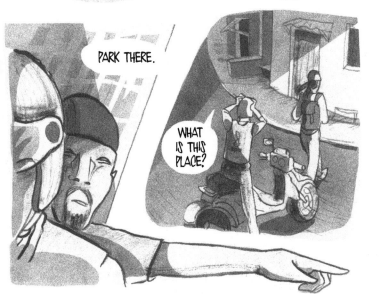

PARK THERE.

WHAT IS THIS PLACE?

WE'LL SPEND THE NIGHT HERE.

175

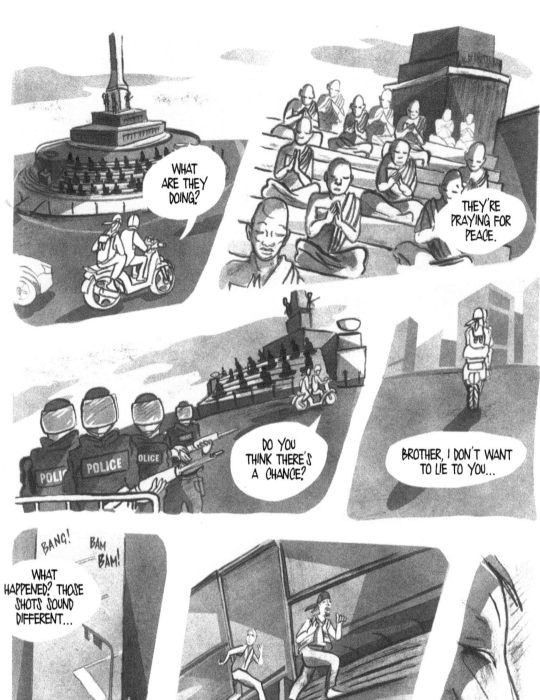

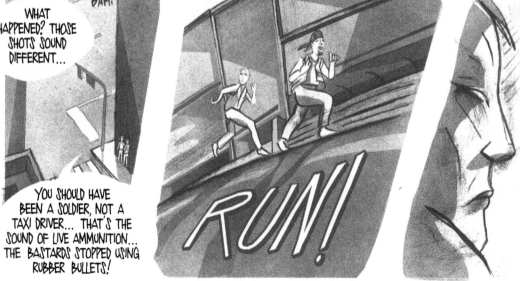

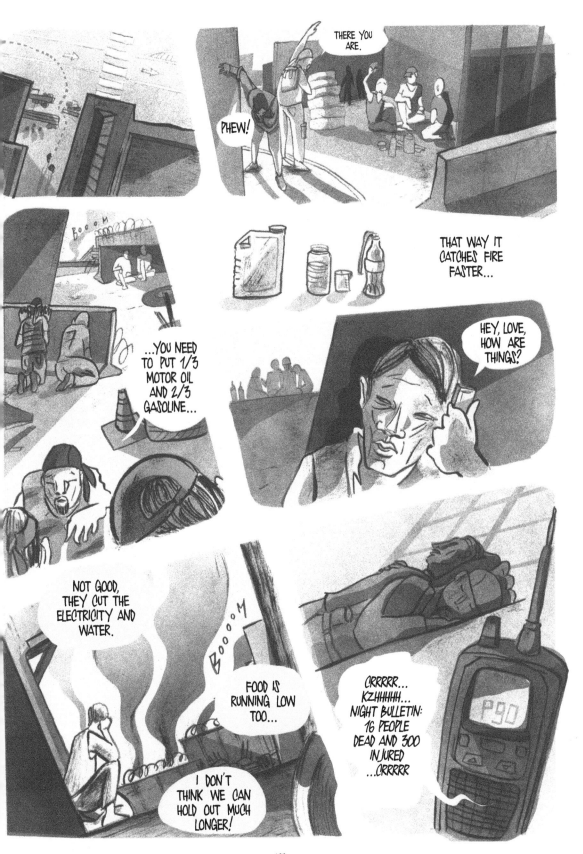

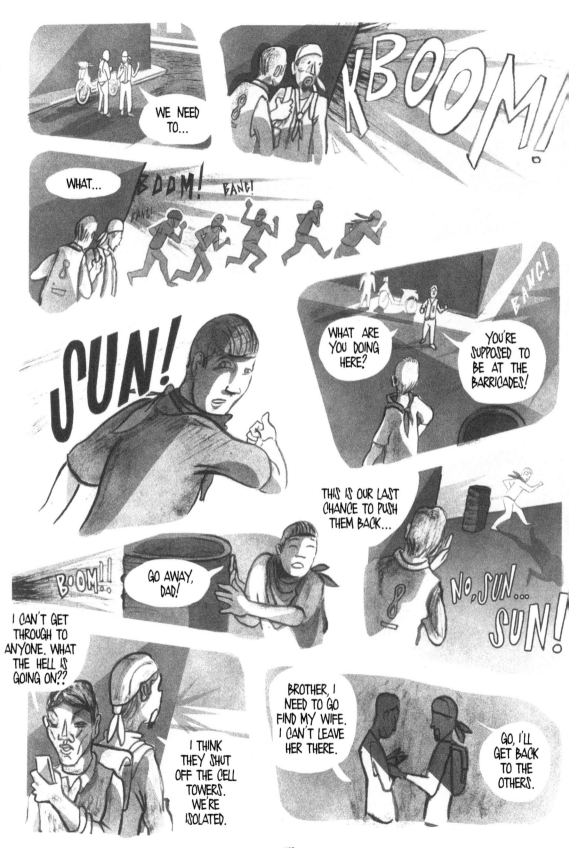

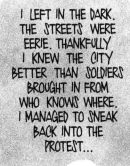

I LEFT IN THE DARK. THE STREETS WERE EERIE. THANKFULLY I KNEW THE CITY BETTER THAN SOLDIERS BROUGHT IN FROM WHO KNOWS WHERE. I MANAGED TO SNEAK BACK INTO THE PROTEST...

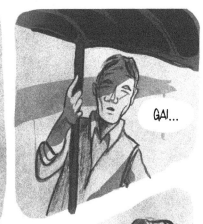

GAI...

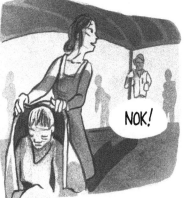

NOK!

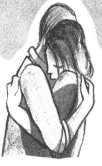

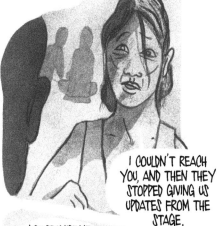

I WAS SCARED SOMETHING HAD HAPPENED TO YOU.

I COULDN'T REACH YOU, AND THEN THEY STOPPED GIVING US UPDATES FROM THE STAGE.

THE ARMY CONTROLS THE MAIN ROADS.

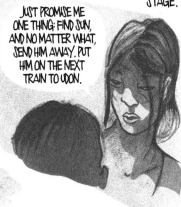

JUST PROMISE ME ONE THING: FIND SUN, AND NO MATTER WHAT, SEND HIM AWAY. PUT HIM ON THE NEXT TRAIN TO UDON.

THE SMALL ALLEYS ARE STILL OURS, BUT WE CAN'T ADVANCE.

PEOPLE ARE DYING OUT THERE...

GAI, WHAT ABOUT US?

WHAT CAN WE DO? WE'RE HERE FOR A REASON AND THERE ARE PEOPLE COUNTING ON US...

179

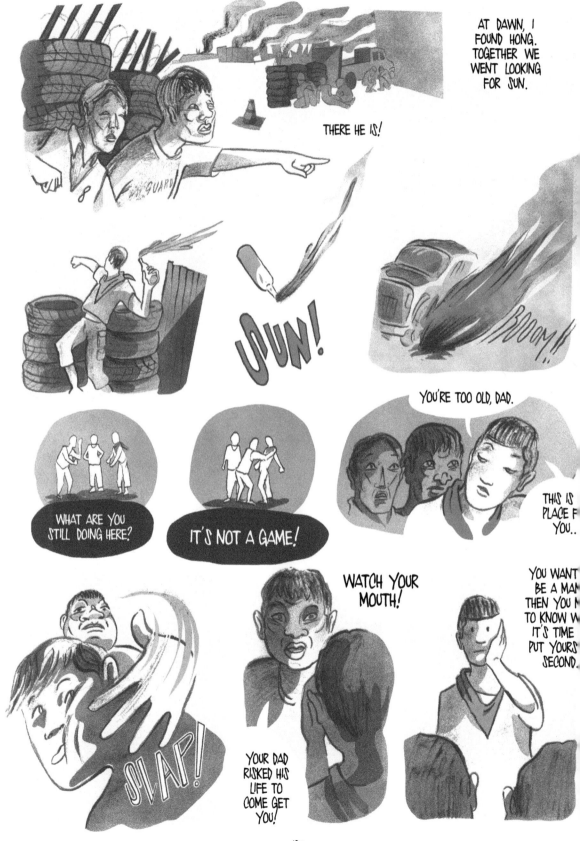

180

I DIDN'T THINK WE'D BE ABLE TO GET HIM TO LEAVE.

LOOK AROUND, HONG, NOTHING'S GOING ON HERE; IT FEELS LIKE WE COULD BE ON THE OTHER SIDE OF THE WORLD.

WHAT DO WE DO NOW?

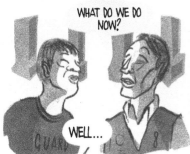

WELL...

I DOUBT WE'LL BE ABLE TO GET BACK TO THE PROTEST. I GUESS IT'S OUR TURN TO MAN THE BARRICADES.

ANOTHER DAY OF WORK, EH?

JUST ANOTHER NORMAL DAY AT WORK!

181

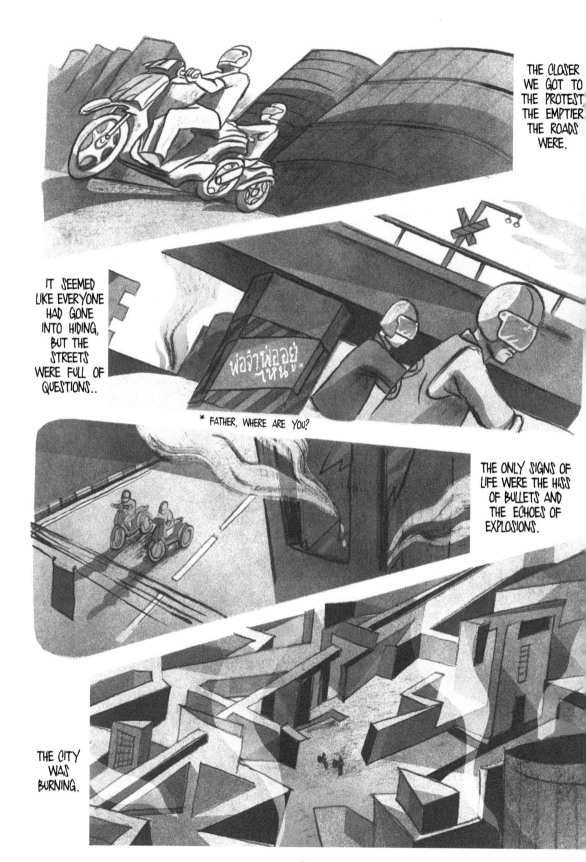

THE CLOSER WE GOT TO THE PROTEST, THE EMPTIER THE ROADS WERE.

IT SEEMED LIKE EVERYONE HAD GONE INTO HIDING, BUT THE STREETS WERE FULL OF QUESTIONS..

* FATHER, WHERE ARE YOU?

THE ONLY SIGNS OF LIFE WERE THE HISS OF BULLETS AND THE ECHOES OF EXPLOSIONS.

THE CITY WAS BURNING.

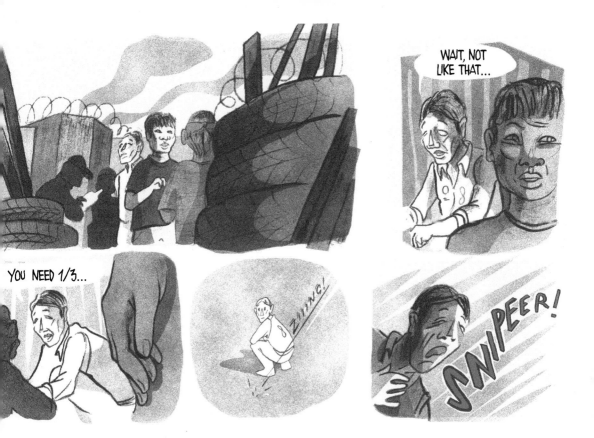

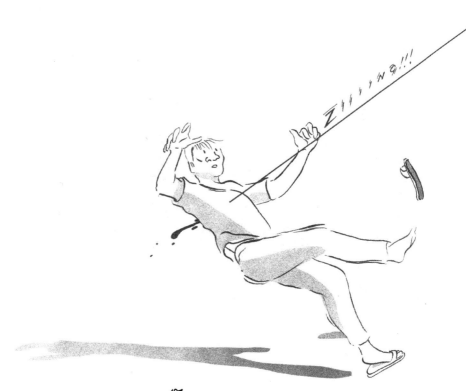

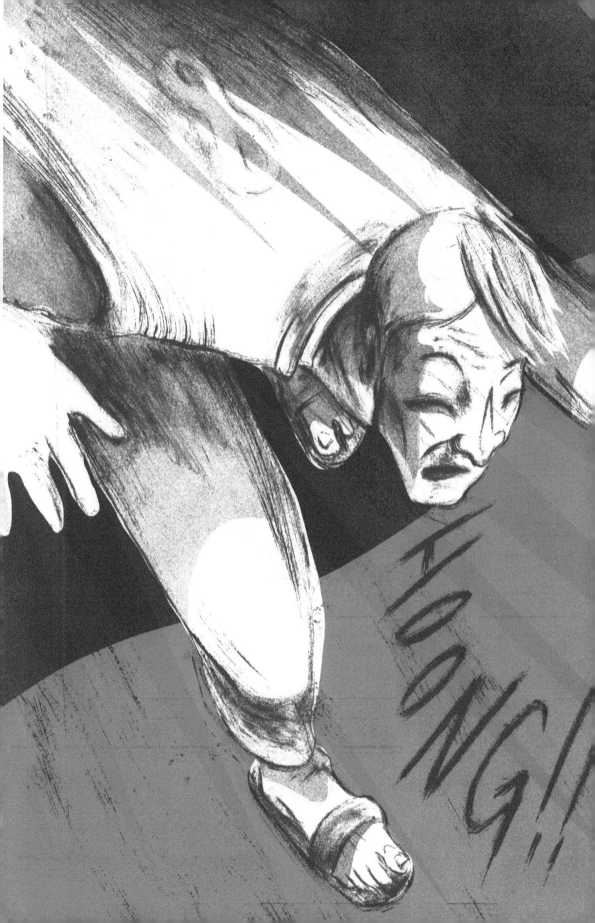

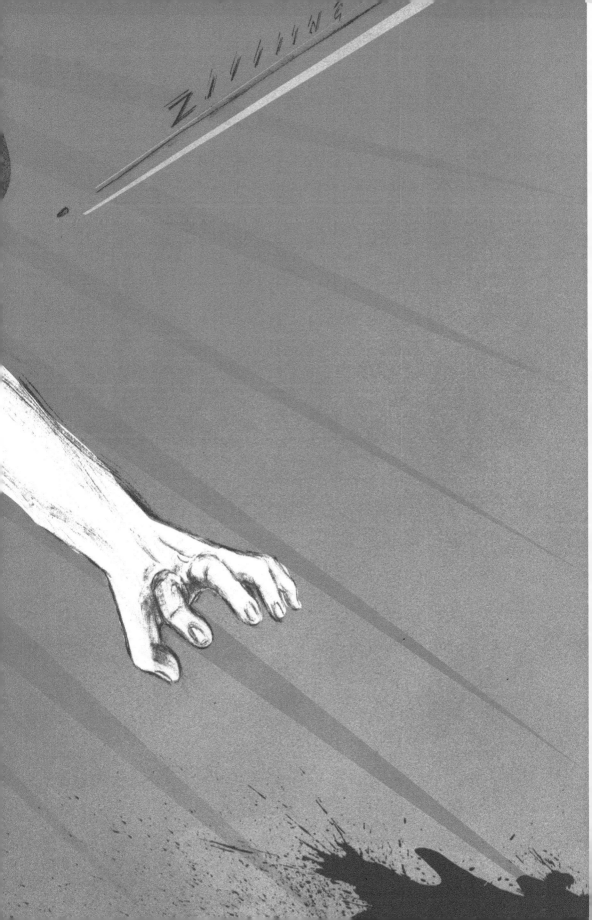

I CAN'T SEE ANYTHING.!!

HELP!

HELP!

WHERE ARE YOU TAKING ME?!

LET ME GO!

WHERE AM I?

PLEASE, TALK TO ME...

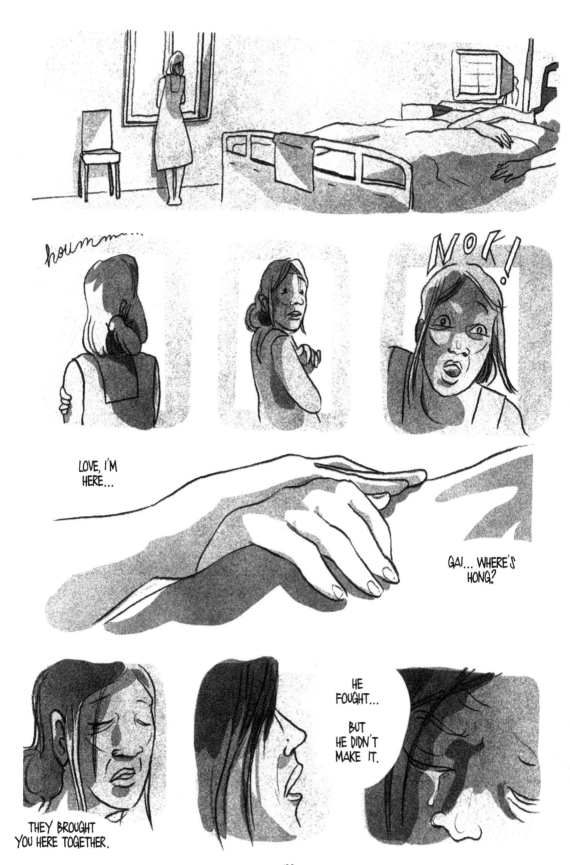

HE'S DEAD, NOK.
I'M SORRY...

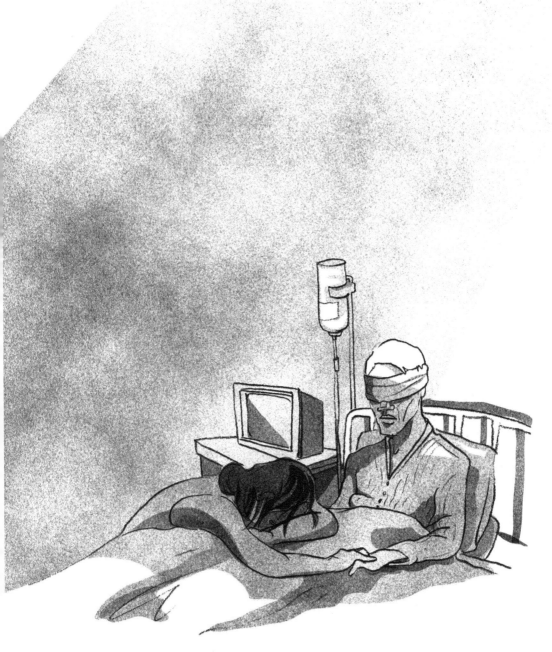

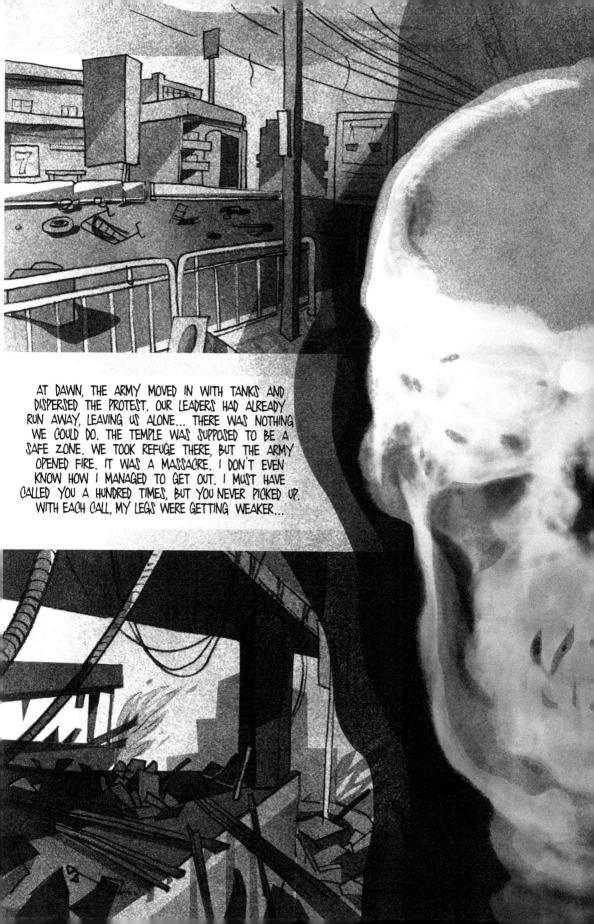

AT DAWN, THE ARMY MOVED IN WITH TANKS AND DISPERSED THE PROTEST. OUR LEADERS HAD ALREADY RUN AWAY, LEAVING US ALONE... THERE WAS NOTHING WE COULD DO. THE TEMPLE WAS SUPPOSED TO BE A SAFE ZONE. WE TOOK REFUGE THERE, BUT THE ARMY OPENED FIRE. IT WAS A MASSACRE. I DON'T EVEN KNOW HOW I MANAGED TO GET OUT. I MUST HAVE CALLED YOU A HUNDRED TIMES, BUT YOU NEVER PICKED UP. WITH EACH CALL, MY LEGS WERE GETTING WEAKER...

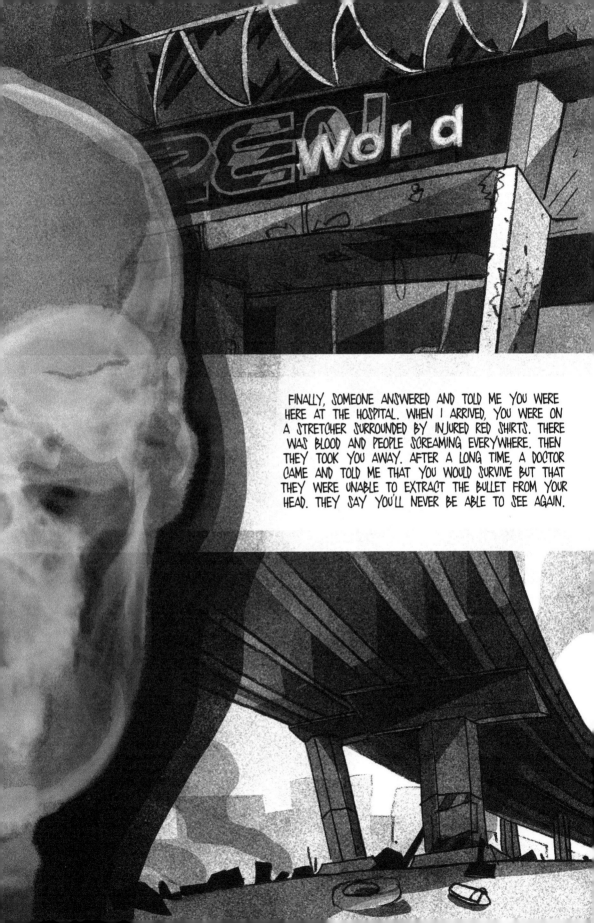

FINALLY, SOMEONE ANSWERED AND TOLD ME YOU WERE HERE AT THE HOSPITAL. WHEN I ARRIVED, YOU WERE ON A STRETCHER SURROUNDED BY INJURED RED SHIRTS. THERE WAS BLOOD AND PEOPLE SCREAMING EVERYWHERE. THEN THEY TOOK YOU AWAY. AFTER A LONG TIME, A DOCTOR CAME AND TOLD ME THAT YOU WOULD SURVIVE BUT THAT THEY WERE UNABLE TO EXTRACT THE BULLET FROM YOUR HEAD. THEY SAY YOU'LL NEVER BE ABLE TO SEE AGAIN.

AFTER A WEEK, WE LEFT THE HOSPITAL AND WENT BACK HOME. I HAD TO LEARN EVERYTHING OVER AGAIN: HOW TO MOVE, HOW TO EAT, HOW TO ACCEPT MY SITUATION.

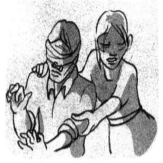

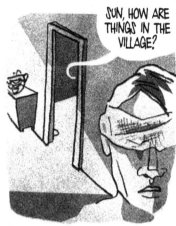
SUN, HOW ARE THINGS IN THE VILLAGE?

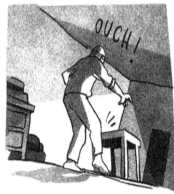

OUCH!

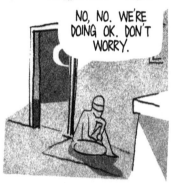
NO, NO. WE'RE DOING OK. DON'T WORRY.

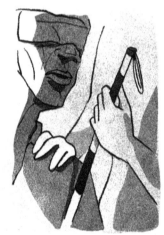

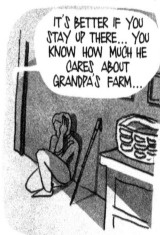
IT'S BETTER IF YOU STAY UP THERE... YOU KNOW HOW MUCH HE CARES ABOUT GRANDPA'S FARM...

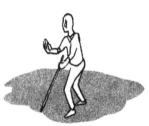

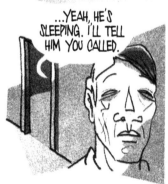
...YEAH, HE'S SLEEPING. I'LL TELL HIM YOU CALLED.

LITTLE WAS LEFT OF THE PROTEST. SOMETIMES OTHER RED SHIRTS INVITED US TO TELL OUR STORY. IT WASN'T MUCH, BUT IT MADE ME FEEL LIKE OUR SACRIFICES WERE NOT COMPLETELY FORGOTTEN.

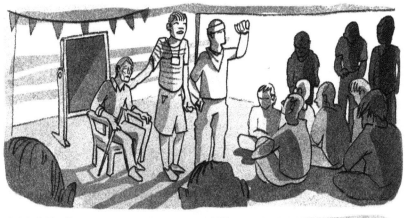

I'M SORRY I LOST MY SIGHT...

BUT I [FEE]L EVEN [M]ORE [S]ORRY FOR [TH]AILAND.

OUR WHOLE COUNTRY HAS BEEN LEFT IN THE DARK. THERE'S NO JUSTICE HERE.

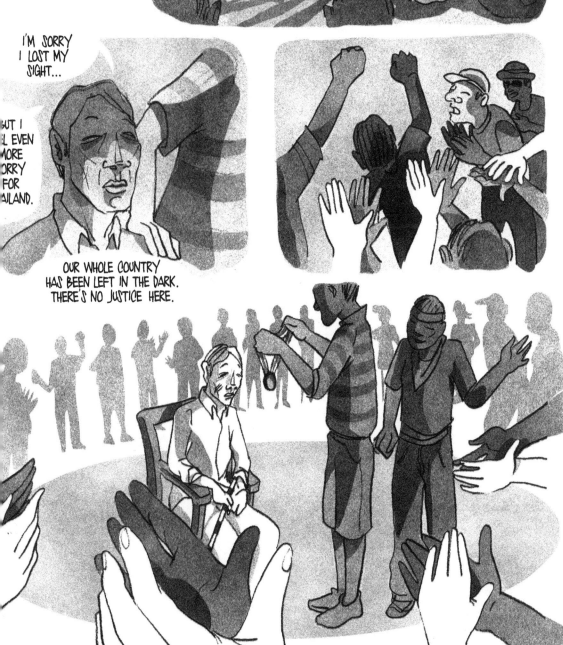

THE UNELECTED GOVERNMENT RESIGNED AND PROMISED NEW ELECTIONS. AT LEAST WE HAD ACHIEVED SOMETHING

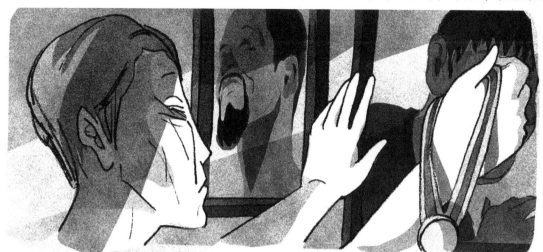

I STARTED SELLING LOTTERY TICKETS ON THE STREET CORNER, AS MANY BLIND PEOPLE IN BANGKOK DO. GAI WENT BACK TO THE SHOP.

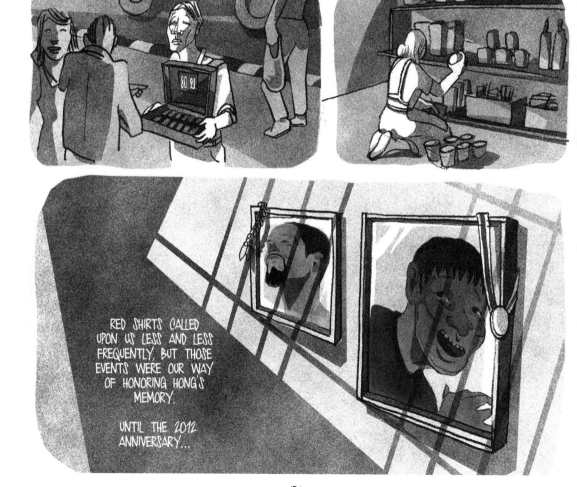

RED SHIRTS CALLED UPON US LESS AND LESS FREQUENTLY, BUT THOSE EVENTS WERE OUR WAY OF HONORING HONG'S MEMORY.

UNTIL THE 2012 ANNIVERSARY...

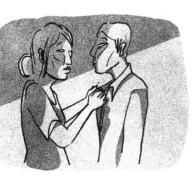

THAT MORNING, WE WENT BACK TO RATCHAPRASONG. AFTER THE USUAL REMEMBRANCE, THAKSIN APPEARED ON THE GIANT SCREEN. I COULD NOT SEE HIM, BUT HIS WORDS HIT ME HARDER THAN ANY IMAGE I HAD EVER SEEN.

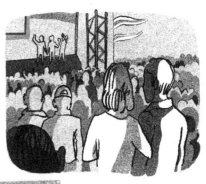

BROTHERS AND SISTERS, I WANT TO THANK YOU ALL FOR THE SUPPORT YOU HAVE GIVEN ME OVER THE PAST FEW YEARS. WE HAVE FOUGHT TOGETHER, WE HAVE REJOICED TOGETHER, AND WE HAVE CRIED TOGETHER.

TODAY, WE HAVE REACHED THE END OF OUR PATH. YOU PUSHED THE BOAT TO SHORE, AND FOR THIS I WILL ALWAYS BE GRATEFUL.

NOW, WITH THE UPCOMING ELECTIONS, THERE'S A MOUNTAIN TO CLIMB. I HAVE TO CONTINUE BY MYSELF.

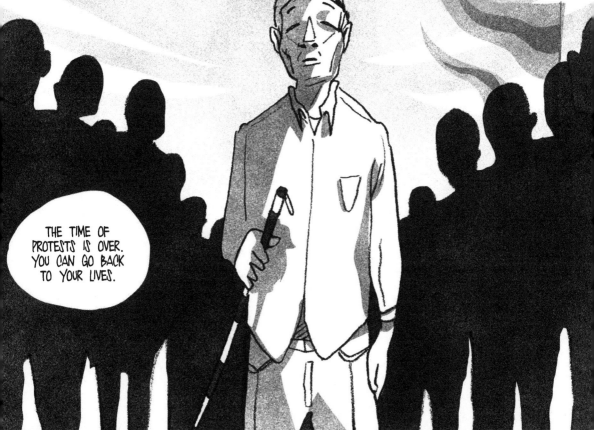

THE TIME OF PROTESTS IS OVER. YOU CAN GO BACK TO YOUR LIVES.

WHAT LIVES WERE WE SUPPOSED TO RETURN TO? THAKSIN WAS TRYING TO GET POWER BACK WITH THE ELECTIONS. BUT HE KNEW THAT TO WIN, THE PROTESTS WOULD HAVE TO COME TO AN END... THAT WE WOULD NEED TO STOP DEMANDING JUSTICE, FOR OURSELVES AND FOR OUR DEAD.

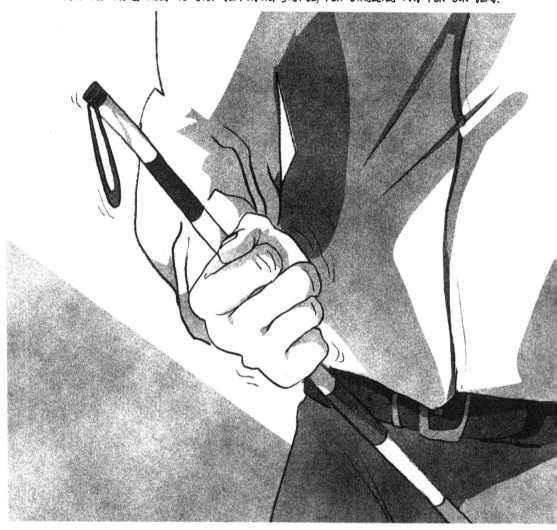

WE HAD RISKED EVERYTHING TO BECOME THE MASTERS OF OUR OWN DESTINY, BUT THAKSIN WAS USING US FOR HIS POLITICAL GAMES.

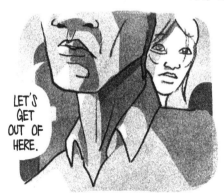

LET'S GET OUT OF HERE.

THE BULLET TOOK MY SIGHT. THAKSIN'S BETRAYAL SHATTERED MY WHOLE BEING.

I WAS PARALYZED, UNABLE TO PUT MYSELF BACK TOGETHER.

I'D BEEN A FARMER AND A MIGRANT. I'D BEEN
A CARPENTER AND A TAXI DRIVER. I HAD
TRUSTED THE ABBOT, THE KING, AND THAKSIN.
NOW WHAT WAS LEFT OF ME?

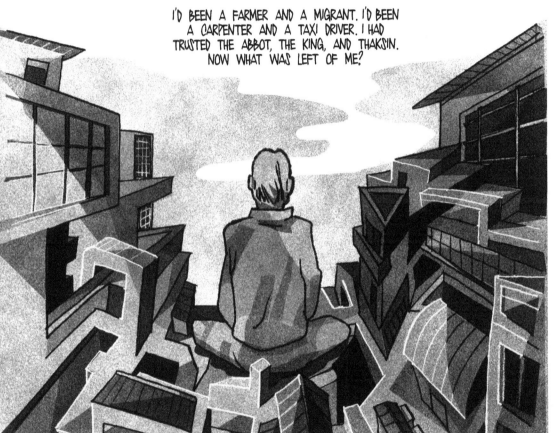

THIS QUESTION FOLLOWED ME IN THE DARKNESS.

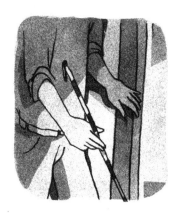 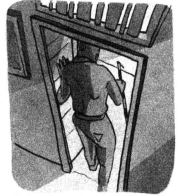 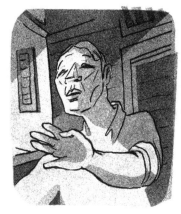

FOR MONTHS I ROAMED THROUGH MY MEMORIES AND THROUGH THE CITY...

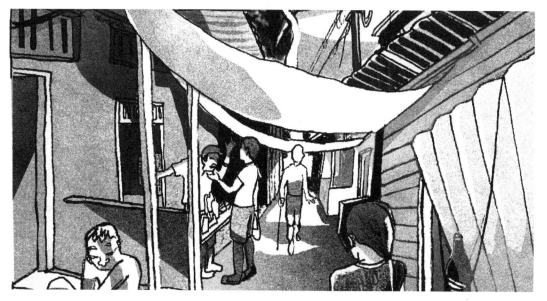

LOOKING FOR A DIRECTION.

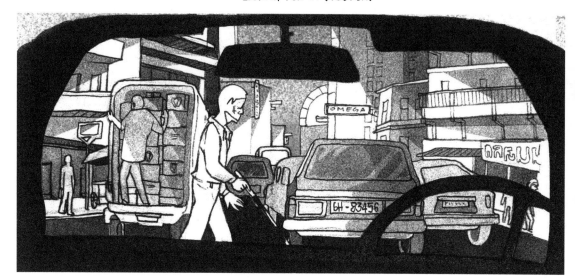

AT FIRST I WENT BACK TO THE TEACHINGS THAT HAD HELPED ME TO MAKE SENSE OF MY LIFE IN THE PAST.

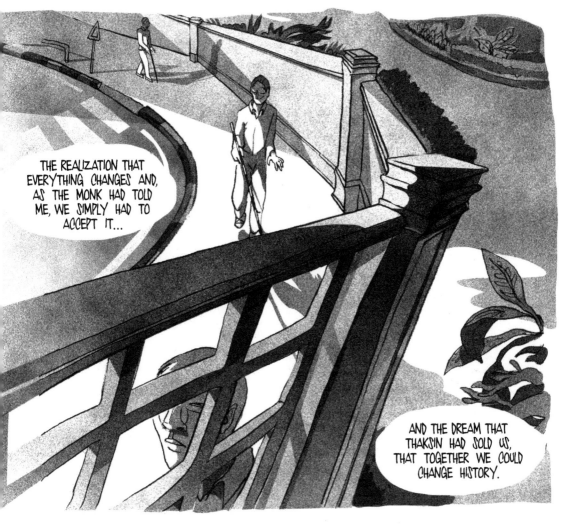

THE REALIZATION THAT EVERYTHING CHANGES AND, AS THE MONK HAD TOLD ME, WE SIMPLY HAD TO ACCEPT IT...

AND THE DREAM THAT THAKSIN HAD SOLD US, THAT TOGETHER WE COULD CHANGE HISTORY.

FOLLOWING THEM I HAD LOST MY BEST FRIEND...

MY SIGHT...

AND ANY FAITH IN OUR ABILITY TO CHANGE THINGS.

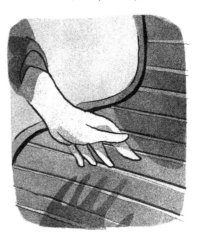

ALL THAT WAS LEFT WAS
THE EMPTY SPACE AROUND ME.

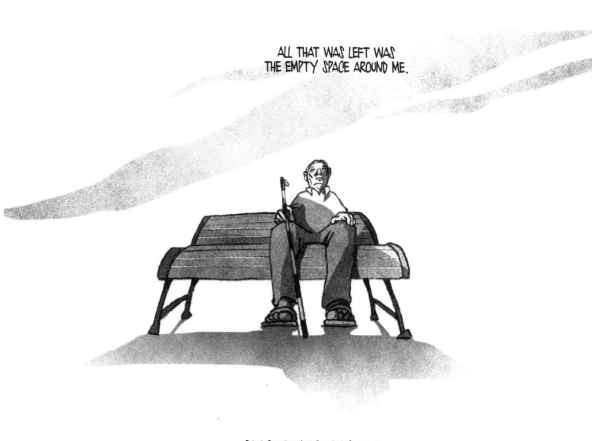

SO I STARTED LISTENING TO IT.

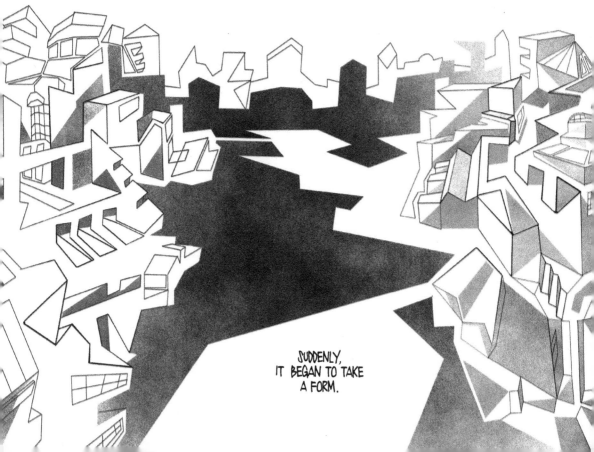

SUDDENLY,
IT BEGAN TO TAKE
A FORM.

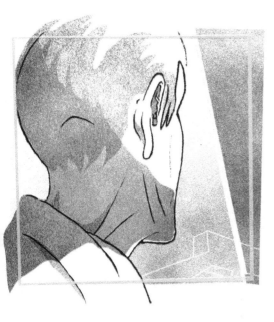
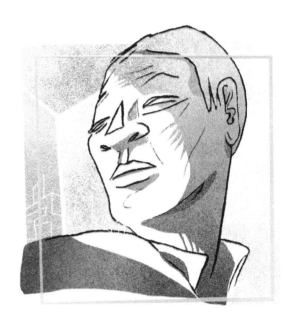
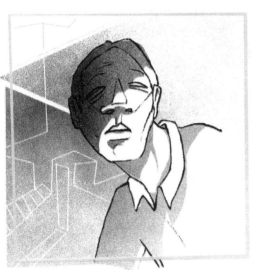
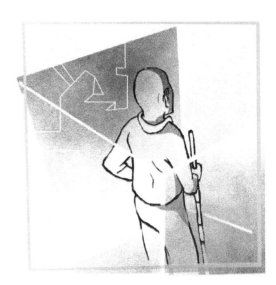

WHAT APPEARED IN FRONT OF ME WASN'T THE REALITY I HAD KNOWN, BUT SOMETHING
THAT DETERMINED ITS PACE AND FATE: AN OCTOPUS THAT SWALLOWED EVERYTHING,
INDIFFERENT TO OUR EXISTENCE.

NOW I REALIZED THAT OUR LIVES HAD BEEN A CONTINUOUS ATTEMPT TO TAME THAT BEAST, BUT IN SO DOING, WE SIMPLY GOT TANGLED IN ITS TENTACLES.

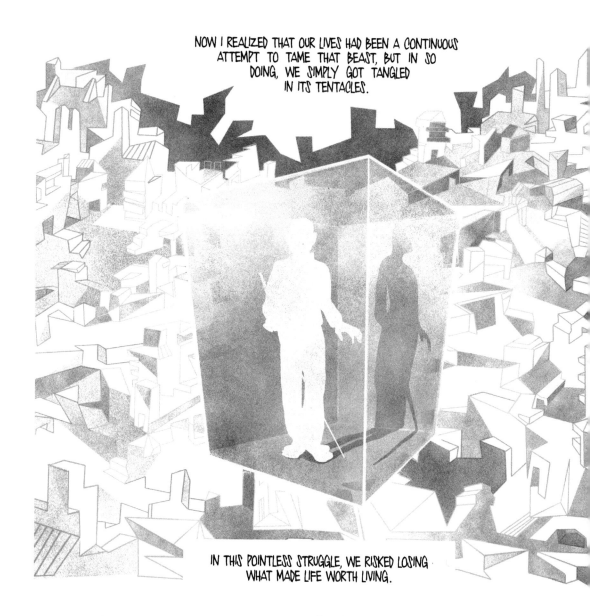

IN THIS POINTLESS STRUGGLE, WE RISKED LOSING WHAT MADE LIFE WORTH LIVING.

 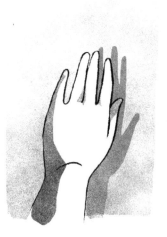 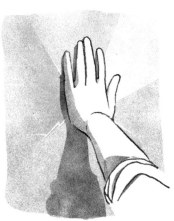

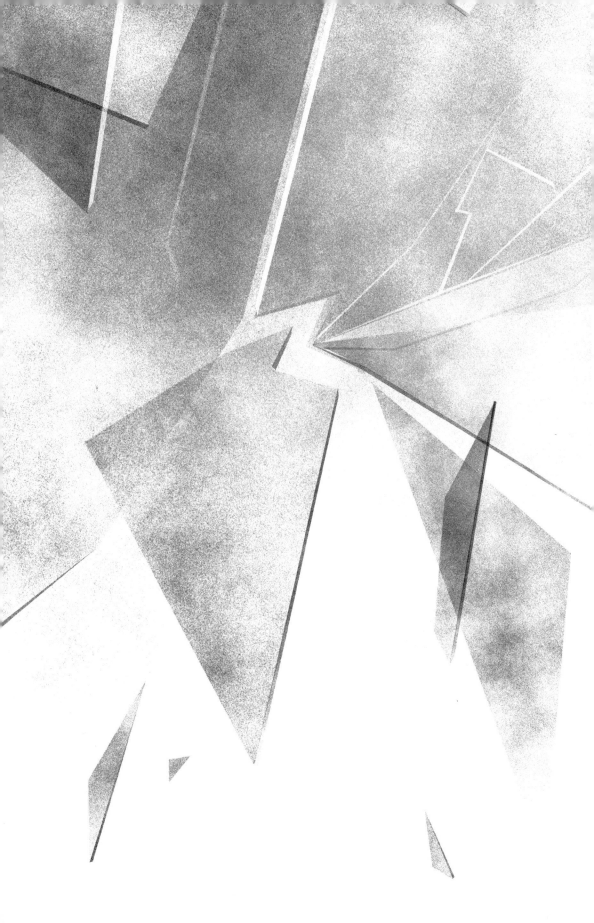

THE SMELL OF RICE READY TO BE HARVESTED.

THE SOUND OF HONG'S LAUGHTER.

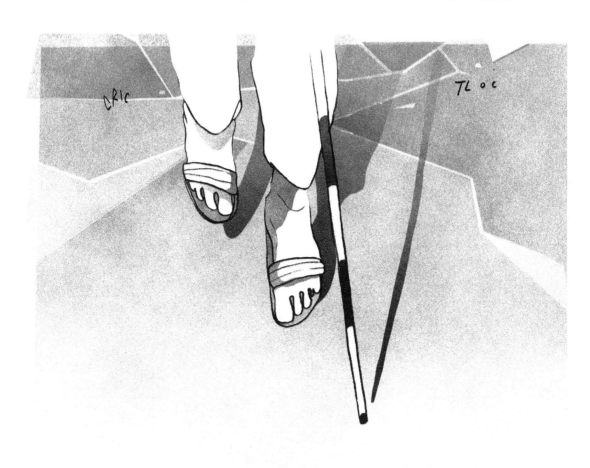

GAI'S GENTLE STRENGTH.

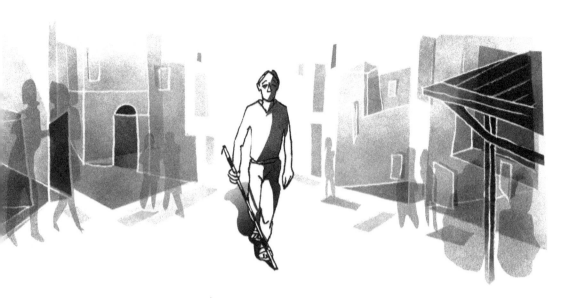

SUN'S UNPREDICTABLE FUTURE.

AND IT'S
TO THEM I NOW WANT
TO RETURN.

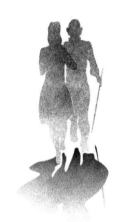

Special thanks to:

Andrea Anselmi, Luul Balestra, Elena Bartoli, Ilaria Benini, Diego Ceresa, Pavin Chachavalpongpun, Seksit Changthong, Chaloem Changtongmadun, Patricka Chulamokha, Stefano Coccia, Filippo Fabbiani, Roberto Fabbri, Daniel Feary, Marco Gatta, Antonella Lombardi, Giuseppina Luchetti, Anastasia Martino, Daniele Massaccesi, Orsola Mattioli, Giuseppe Mele, Jyothi Natarajan, Enrico Natalucci, Giuseppina Ortenzi, Lawrence Osborne, Francesco Paciaroni, Caterina Palpacelli, Angelica Paolorossi, Emilia Patrignani, Silvia Petrucci, Julie Potter, Lizzie Presser, Alessandro Ruggeri, Anjali Singh, Laura Sopranzetti, Paolo Sopranzetti, Renato Sopranzetti, Silvia Sopranzetti, Adun Sriraksa, Cecilia Trisciani, Nicolas Verstappen, All Souls College – University of Oxford, Cinema Mele – Pizzo Calabro, Center for Southeast Asian Studies – Kyoto University, the Thai Film Archive, the National Library of Thailand.

TIMELINE OF EVENTS

A select timeline of events in the lives of the graphic novel's characters in relation to events in Thai history:

November 26, 1982

Nok arrives in Bangkok for the first time.

In 1982, Thailand celebrates the bicentennial year of the reigning Chakri dynasty. The economy, due to a global recession, is stagnant, while the Communist insurrection in northern Thailand is declining amid mass defections and surrenders.

September 9, 1985

Nok is living with Hong in the Klong Toey slum in Bangkok and finally adjusting to life in the city.

On September 9, 1985, the Young Turks unsuccessfully attempt to topple the government of General Prem Tinsulanonda while he is abroad. Led by Colonel Manoonkrit Roopkachorn, the pre-dawn coup consists of several hundred men and 22 tanks. Within ten hours, government troops, led by General Chavalit Yongchaiyudh, quell the bloody rebellion. There are 59 injuries and five casualties, two of them foreign journalists. Over 40 active and former military officers are arrested.

May 18, 1992

Nok and Gai get married in their village.

Between May 17 and 20, 1992, a massive protest takes place in Bang-kok against the attempt of General Suchinda Kraprayoon to become prime minister, after he had taken power in a military coup in 1991 and promised to step down a year later. Up to 200,000 people demonstrate in central Bang-kok at the height of the protests. The military crackdown begins May 18 and results in 52 government-confirmed deaths, hundreds of injuries (includ-ing journalists), over 3,500 arrests, and hundreds of disappearances. Many of those arrested are alleged to have been tortured. On May 20, the violent clashes come to an end when King Bhumibol invites the audience of General Suchinda as well as Chamlong Srimuang, one of the leaders of the protest, and demands that they stop the confrontation and find a parliamentary solu-tion to the political impasse.

July 2, 1997

Nok loses his construction job in Koh Pha-Ngan. Rather than returning to his village, he remains there, falling deeper and deeper into his addiction.

On May 14 and 15, 1997, the Thai baht is hit by massive speculative at-tacks. While at first the government tries to sustain the value of the local currency, on July 2 the baht is left free to float, losing half of its value in a day. The country's booming economy comes to a halt. Companies that had borrowed heavily from international capital go into bankruptcy, and millions of Thai workers lose their jobs, especially in finance, real estate, factory pro-duction, and construction.

January 6, 2001

Nok, Hong, Gai, and Sun are living in Bangkok. The two friends work as motorcycle taxi drivers.

Thaksin Shinawatra is elected as prime minister of Thailand. His policies, dubbed Thaksinomics, promise to put an end to the economic downturn by protecting national capital and companies while expanding the welfare state to the lower classes in Thai society. Even if Thaksin represents a new class of billionaire politicians, many among the poor see him as a hero.

May 3, 2003

Nok and Hong receive new motorcycle taxi vests from the government, a sign of their recognition as legitimate workers and service providers in the city.

The government of Thaksin Shinawatra begins the "war on dark influ-ences" to fight local organized crime and members of the state bureaucracy

who extort money from workers in the informal economy. Following the theories of Hernando De Soto, this campaign aims to enfold informal economies as state-sanctioned and taxed activities. The vests become a source of pride for thousands of workers, who finally see themselves recognized by the government.

December 26, 2004

Sun proposes a fundraiser for the victims of the tsunami.

The 2004 Indian Ocean earthquake and tsunami occurs at 07:58:53 local time on December 26, with an epicenter off the west coast of northern Sumatra. The earthquake is caused by a rupture along the fault between the Burma Plate and the Indian Plate. The tsunami travels through the Andaman Sea and hits the southwest coast of Thailand, about 500 kilometers (310 miles) from the epicenter. Approximately 5,400 people are killed and another 3,100 are reported missing.

February 6, 2005

Nok, Gai, and Sun canvass for Thaksin to be re-elected, becoming part of his electoral machine.

Thaksin Shinawatra is elected for a second term as prime minister, the first in Thai history to complete a full term and be re-elected in a one-party majority.

September 19, 2006

Nok, Gai, and Hong watch the television coverage of the military junta taking power, with the declared support of King Bhumibol.

On September 19, 2006, while Prime Minister Thaksin is away in New York to address the United Nations General Assembly, the Royal Thai Army stages a coup d'état against him. The coup, the first non-constitutional change of government in 15 years, follows a yearlong political crisis involving Thaksin, his allies, and his political opponents, and it occurs less than a month before elections are scheduled to be held. General Prem Tinsulanonda, chairman of the Privy Council, is widely reported as masterminding the coup. The military cancel the scheduled October 15 elections, abrogate the 1997 constitution, dissolve parliament and the constitutional court, ban protests and all political activities, suppress and censor the media, declare martial law nationwide, and arrest cabinet members. This event eventually leads to the creation of the Red Shirt movement.

March 12–May 19, 2010

Nok, Hong, Sun, and Gai take part in the Red Shirt protests. Over the course of these days, their lives will be forever changed.

In the following three months, a series of political protests are organized, both in Bangkok and in smaller centers around the country. The United Front for Democracy Against Dictatorship (UDD) (also known as the Red Shirts) demands a democratic election and an end to economic and political inequality. The protests escalate into prolonged confrontations between protesters and the military; the soldiers eventually open fire, killing more than 90 civilians and injuring more than 2,100 people.

Initially, the protests are mobile caravans around the city. In early April, however, a main protest camp is set up around the Democracy Monument and the Red Shirts refuse to stop protesting until the government resigns. A state of emergency is declared in Bangkok on April 8, banning political assemblies of more than five persons. On April 10, troops unsuccessfully crack down on the Red Shirts camp, resulting in 24 deaths and more than 800 injuries. The Thai media calls the crackdown "cruel April." After the attacks, most of the Red Shirts move to the Ratchaprasong intersection, where they set up a second stage. On April 28, the military and protesters clash in northern Bangkok, wounding at least 16 protesters and killing one soldier. The UDD moves out of the Democracy Monument area and consolidates at Ratchaprasong. On May 3, Prime Minister Abhisit announces a reconciliation road map and elections on November 14. The road map is tentatively accepted by the UDD, but they later add further conditions and the government cancels negotiations.

By mid-May, the Ratchaprasong protest camp is surrounded by armored vehicles and snipers are positioned on tall buildings around the area. On the evening of May 13, General Khattiya Sawasdipol ("Seh Daeng"), security advisor to the protesters and leader of the armed "Ronin" guards, is shot in the head by a sniper's bullet while he is giving an interview to the press. Thereafter, the state of emergency is expanded to 17 provinces and the military begins a violent crackdown, dubbed by the Thai media as "savage May." An additional 41 civilians are killed (including one Italian journalist) and more than 250 injured. The government claims that the killed civilians were either armed terrorists or shot by terrorists and even insists that some civilians were shot by terrorists disguised in army uniforms. The military declares the area a "free-fire zone," in which anybody – be they protester, resident, tourist, or journalist – will be shot on sight, with medics banned from entering. On May 14, United Nations secretary general Ban Ki-moon encourages protesters and the government to reopen talks. On May 16, UDD leaders repeat that they are ready for additional talks as long as the military pulls back, but the government demands the unconditional dispersal of the protesters. The government rejects the Senate's call for a ceasefire and Senate-mediated negotiations. On May 17, Amnesty International calls for the military to stop

using live ammunition. In the early morning of May 19, armored vehicles lead the final assault into Ratchaprasong, killing at least five people. Soldiers are reported to have fired on medical staff who went to the aid of injured protesters. By 1:30 pm, UDD leaders surrender to police and tell protesters to give themselves up. Dozens of arson attacks break out nationwide on selected targets, including Central World, the largest shopping mall in the country, various banks, civic buildings, and government offices. A curfew is declared and troops are authorized to shoot on sight anyone inciting unrest. An undisclosed number of arrests and detentions take place and 51 protesters remain missing.

May 19, 2012

On the occasion of the two-year anniversary of the Red Shirt dispersal, thousands of people return to the Ratchaprasong intersection. Nok and Gai attend to commemorate Hong. Even though Thaksin's sister, Yingluck Shinawatra, was elected as prime minister the previous year, the Red Shirts continue to demand accountability and an independent investigation of the events of 2010. During this commemoration, Thaksin calls for an end to the street mobilizations and a return to parliamentary politics. This is a fatal blow to the Red Shirt movement, which fractures as some people accept his decision and others feel betrayed by it.

INTERVIEW WITH THE AUTHORS

What sparked this book?

The idea for this comic was born from Claudio's desire to bring the many stories he had collected during his ten years of research in Thailand to a public beyond academia. This desire became even more urgent after the country's 2014 coup, after which the military government actively started to erase the memories of the political events Claudio had studied in his research. As often happens with authoritarian regimes, controlling the past and its memory becomes a way of determining the present, as the many people who've taken to the street in a new wave of protests in Thailand since 2020 have shown. The first victims of the military takeover of 2014 were in fact the personal stories of thousands of common people who had fought and who continue to fight, not just to obtain political and social freedom but also to survive, amid the turmoil of political and historical events. Our intention was to do something, however small, to keep these stories alive and bring them to both a Thai and an international audience. Claudio had been doing research in Thailand, lived there, learned the language, and witnessed, over the course of those years, the biggest political mobilization in the country's history, the Red Shirt protest, during which 100 people were shot down by military forces and snipers. He had done all of this as an anthropologist, writing academic papers, books, giving conferences, and occasionally publishing op-eds in the press. In all of these efforts, what was most lost and buried in academic or news jargon were the stories of the amazing, courageous, and utterly human people he had met. This project is driven by those people, by an attempt to center them and their stories.

 With this in mind, Claudio started to discuss the project with Chiara, a longtime friend who, at the time, was working in publishing in London. Chiara's proposal was to use the medium of the graphic novel, due to both its growing popularity and its narrative potential and potency. Once we agreed on this, the

next challenge was to find an artist with a distinctive aesthetic style but also a willingness to be involved in a truly collective and participatory project. This meant, on one hand, questioning the usual division of labor in collaborative comics: breaking down the distinctions between writer, scriptwriter, editor, and visual artist. We also needed to find an illustrator who would be open to going beyond a stereotypical or fixed depiction of contemporary Thailand. This, however, proved challenging. After much discussion and knowing that the artist we chose would be addressing a mostly international public and introducing them to the sensory realities of Thailand, we decided to look for an artist who did not have previous contact with the country, someone with whom we could collectively build an "anthropological" sensibility toward the country. A common friend introduced us to Sara's work and showed us some of her sketches. While clearly the subject was very far away from the stories we wanted to tell, something in her drawings intrigued us. We sent her a set of pictures Claudio had taken during his research and asked her to give us her own interpretation. What came back was a set of striking black-and-white sketches with the rough yet not patronizing feeling we were looking for. Not only did her drawings convince us, but Sara immediately started to research Thai visual culture, interior design, and architectural style, proving we had found the right person.

How did you structure your work after that?

After completing preliminary sketches and research, we received a fellowship from Oxford University, where Claudio was completing his postdoc, to travel to Thailand. During our stay, Chiara and Sara entered Claudio's fieldwork with four objectives in mind.

First, we carried out the work of location scouting, typical of film productions. Starting from Bangkok, we traveled to the northeastern part of Thailand to visit a few countryside villages and then to Koh Pha-Ngan, an island in the Gulf of Thailand where many of Claudio's informants had worked. Our purpose was to expose ourselves as much as possible to Thai images, colors, shapes, smells, noises, sensations, feelings, and atmospheres and select the specific locations in which our story would take place, creating an initial visual archive. We had previously decided that our story would not be told using the classic "solo author" narrative structure, in which the foreign researcher/journalist/traveler becomes the main narrator and a "Virgil," guiding the reader through an unknown landscape and culture. Instead, we based every line of our dialogues on real interviews with the people Claudio had spent years talking to, creating composite characters who would condense in themselves a variety of voices. Therefore, since we wanted to tell the story from the point of view of a set of local characters, we could not limit ourselves to experiencing Thailand with our own eyes.

Consequently, the second component of our research was more properly ethnographic. The work of an anthropologist is that of attempting, if only for a

moment, to experience reality through the eyes of somebody else. This means approaching something that could, at first sight, appear exotic to an outsider and de-exoticizing it by showing it in context and making it familiar and everyday. Practically, we began this process by spending a few weeks interviewing and living in close contact with the persons whose stories we wanted to tell and with whom Claudio had developed friendships and collaborations over previous years. We ended up eating live shrimps on a floating boat in a remote village in the northeastern part of Thailand, spending long, boring afternoons at a motor-cycle taxi station in Bangkok, and hanging around the barracks of construction workers on a Thai island. In this phase, Claudio was conducting interviews and translating for Chiara and Sara, while they were archiving all the material we produced in this phase: recordings, sketches, travel diaries, photos, and videos.

Our decision to make our main character a blind person raised a number of challenges. To make a long story short, during our stay in Thailand, we decided to explore the experience of blindness, both generally and in the specific config-urations it takes in Bangkok. For the former aspect, we collected all the material we could find on the subject, mixing personal narratives with psychologists' and neuroscientists' work on it. In the context of Thailand, many blind persons end up selling lottery tickets on the streets. It became therefore important to spend as much time as we could with those vendors, following them in their daily journeys, discussing how they moved around a giant and unwelcoming city, and how they experience urban spaces, weather conditions, and transpor-tation systems, as well as their interactions with sighted people. This type of research required that we expose ourselves, even if only for a day, to those ex-periences. With this in mind, we retraced the path that the main character walks in our graphic novel blindfolded, archiving our sensations along the journey.

Finally, given that our story takes place over the course of 50 years, we needed to use our time in Thailand to collect as much historical material as we could, to be able to reconstruct how the country had changed visually over time. This proved a massive enterprise, but thankfully Claudio had started this work years back, during his fieldwork. Once we had selected the time range of our story, the locations, and the basic storyline, we started to collect as much visual evidence as we could on these elements. This meant creating a large archive of more than 5,000 very disparate items, from shoe models to house appliances, from build-ings to movie posters, from news clippings to songs. We organized this archive by year, starting from 1975 to the present, so that whenever we needed to draw a specific year, we could make sure that our representation would be faithful. What did this mean in practice? As an example, let's say we knew that our main character would be in Koh Pha-Ngan in the period from 1993 to 1998. What did the island look like in those years? Which buildings were there and which were not? What T-shirts and pants would construction workers have worn there? What songs would they have listened to? And on what type of radio? What about food wrapping? Scaffoldings? Based on such questions, we worked backward, trying to answer them and create a visual archive with those answers, relying

mostly on material from the National Library, the Thai Film Archive, private collections of local historians, and Thai online forums and Facebook groups.

Why did you choose a blind protagonist? It seems like a very risky choice for a graphic novel.

The decision was almost natural, actually. The blind man who inspired the older Nok is an incredible person. Claudio has known him for many years but was never able to write academically about him, probably because his personal story is simply too fascinating to butcher with an academic ax. It was him, first, who talked to Claudio about his blindness as a metaphor for the dark times that Thailand is living through. He is a person of tremendous sensitivity, able to think and interpret the dramatic events he lived as collective occurrences. Blind people in Thailand, as in many other places, are often seen as having acquired another type of sight, as able to see beyond, and the person behind Nok has been truly able to do so. We thought a lot about the right title to tell his story, and originally the title Claudio had in mind was based on a concept that the real person behind Nok always used to refer to the new sight he'd acquired: *Taa Sawaang*. This means, literally, "bright eyes," but it is used to refer to an awakening, both in the Buddhist sense of the term and in the sense of obtaining a clearer vision of the political reality of contemporary Thailand. Over the last years, opponents of the monarchy have started to use this term to refer to the moment they realized that the monarchy was not what they thought it was and did not have people's interests at heart. It is not uncommon, behind closed doors, for people to ask each other when they became *Taa Sawaang*. This was for us a very interesting semiotic and semantic node: blindness, new visions, and awakenings.

How did you manage to work together across the geographic distance?

That was the hardest part of this project. That's mainly why it took four years to get the first Italian edition out. We worked from very distant places: Claudio was based in Oxford, Chiara in Macerata, and Sara in Milan. Moreover, each of us worked on this as a side project. This meant that working times were stretched out and that getting together and having a consistent back and forth was challenging. Just to give you an example, the first chapter, which would determine the setup for the rest of the novel, took more than a year to complete. After that, we realized that we needed to have concentrated chunks of time in which to fence off the world and focus exclusively on the project. Therefore, we developed a system. At the beginning of each chapter, we would discuss the content in a set of endless Skype meetings. After that,

Claudio would work on the dialogues. Once those were drafted, another set of endless meetings would ensue. After we settled on the final form, Sara would start storyboarding. As you can guess, more meetings would follow. From there, the basic structure, content, and visual form of the chapter would be defined and Sara would transform the storyboard into a fully drawn chapter. At this stage, we tried to have a weeklong set of meetings in person, often thanks to the support of artistic residencies. These were some of the most intense, but also rewarding, periods of work, during which we would see the chapters take their final layout as we worked together on increasingly minute details, from particular words used to the shape of a leg.

How did you select the historical events to include in the graphic novel?

Attempting to narrate 50 years of Thai history in a comic book of 200 pages is a titanic enterprise, condemned to imperfection. At first, we created a giant timeline on a two-meter-long piece of paper, which remained on top of our desks until the book was finished. It was made of two lines: the upper one plotted the most significant events in the history of Thailand over the period we wanted to cover; the lower one had personal events related to the lives of the main characters. In a way, the former was a representation of History (with a capital H), the latter of some of the histories that occurred underneath it, sometimes in conjunction with it and other times completely autonomously. To reconstruct History, we based our selection on the works of Thai historians, and for the personal histories we relied on Claudio's interviews, creating composite characters. We were particularly interested in exploring how the first line – that of epoch-making events, rulers, and kings – intersected and intertwined with the everyday histories of migrants and workers, their families and villages. This is why the prominence of historical events changes over the course of the novel. Initially, our characters are barely involved, or even interested, in large social events. They sort of occur in the background of their lives, broadcast from an old radio or a TV set. As the protagonists grow and become actively involved in the country's economic and political transformations, those events become integral parts of their daily lives, something they discuss around a table and then, eventually, in which they become directly involved. Ultimately, this is a story of political and collective awakening as well as how the waves of historical changes lift, engulf, or crush ordinary people.

Speaking of ordinary people, are the characters real people?

The narrative revolves around a main character: Nok. Readers meet him as an old blind man who sells lottery tickets on the streets of Bangkok, and along

his path he has memories and flashbacks of different periods of his life. The older version of Nok is mostly based on a real person that Claudio has known for years. The young Nok in the flashbacks is a collage of different people with similar personal and political histories who share the same struggles and desires. Similarly, the other characters are composites based on a number of real people melded into each one. The decision to mix multiple people in one character was made for both narrative and legal reasons. The structure of the novel is already quite complex, and the subject is far from the everyday experience of most of our readers. However, we did not want to include lengthy pages of descriptions and context-setting that often appear in similar non-fiction graphic novels. A way to attain this was to condense multiple people into a single character, like Nok, so as to follow events through his experiences rather than through an all-knowing authorial voice. On top of that, we had a more practical and legal reason. We did not want to ignore the monarchy in the book; however, lèse-majesté law makes it extremely dangerous to critique the institution. Composite characters, therefore, are a way of protecting the anonymity of our informants, making them impossible to track down and recognize.

So is there an anti-monarchic current in the country, even if any opposition is formally illegal?

There is, and this is the great unspoken tension of contemporary Thailand. The former king, the one depicted in the comics, died in 2016 and throughout his life, he was profoundly loved by many. But like all the great historical characters, he had his highs and lows and even simply admitting this is a crime in Thailand. Lèse-majesté law punishes any critique of the monarch with three to fifteen years of detention. True or false, any critique would land people in jail. This is a central question in all of Claudio's work: What do love and adoration mean when they are enforced by law? Obviously, below this surface of legal consequences, the people we talked to in Thailand had a variety of feelings toward the monarchy and in this novel we did not want to shy away from them.

It is strange that when we think about Thailand or when people plan to travel there, the country is rarely associated with military coups, authoritarianism, or mass murder in political protests, even though all of these are central aspects of your book and the lives it presents. Why do you think that is the case?

This paradox that you point out is very central to the original idea behind this book. We wanted to present to an international audience another face

of Thailand, one a bit more complex than a tourist brochure. Some economists talk about the "Teflon effect" when analyzing contemporary Thailand, meaning that nothing gets stuck to the country. Military coups, mass protests, and violent repression can occur and yet the economy continues to remain stable and tourists arrive. International observers tend to associate Thailand with sandy beaches and smiling people, or at most with prostitution, but not with political unrest. This is not by chance: The Thai Ministry of Tourism is one of the most effective propaganda machines in the country, heavily funded, and the main producer of the idea of Thailand as a tropical paradise and the Land of Smiles. Trying to maintain the two conflicting elements of the country – the calm tourist Eden and the country often governed by repressive military dictatorships – is not an easy task. Yet it remains the ministry's main purpose. This is not to say that one is the real face of Thailand and the other a fake; things are a bit more complex. Entire families have made a living, put their kids through school, and/or gained access to health services through the tourist boom sponsored by the ministry. But at the same time, this growth has been rooted in exploitative practices. Nok's life is an example of such complex dualities. In the 1990s, the tourist industry allowed his family to prosper in the countryside, but it also devoured his body with unbearable work and amphetamines amid the construction of the vacationers' paradise.

What difficulties did you find in presenting and re-presenting both faces of Thailand?

Our objective was always to find a balance between the two. From a narrative point of view, we wanted to tell the story of a country largely unknown, or superficially known, to our readers. We therefore tried to let the country speak in its own voice. This meant allowing the dialogues between our characters to lead the readers, using local media (whether newspapers, radio, or TV) to narrate historical events and minimizing an omniscient external voice. This way, we thought, we could preserve the complexities and ambiguities of everyday lives in the midst of historical transformation without needing to impress a moral commentary on them. From a graphic point of view, instead, the main challenge was to re-create local atmospheres and scenes without relying on the orientalist stereotypes that often dominate the Western gaze and associate Thailand with mysticism, Buddhism, pristine nature, or criminality, stressing the distance between "us" and "them." Finally, from a linguistic point of view, we risked almost the opposite – that of making the language too familiar and "English," erasing some of the linguistic and semantic peculiarities typical of Thai. On this front, we decided to translate local terms while preserving the semantic universe to which they relate.

Speaking of languages, colors do a lot of communicative work in your novel. How did you choose them?

Colors play a pivotal role in this book, both in the present portrayals and in the flashbacks. In the former, bright colors oppose the black and white to visually narrate the protagonist's blindness. In the flashbacks, instead, we chose specific colors for each chapter, the result of the impressions that our residency in Thailand left on Sara. And yet colors never play a descriptive function; they operate as psychological levers. Each chapter tells a phase of Nok's story and the color we selected helped us to make his inner world more incisive and evident. For instance, the cold colors of the city make it rigid and repulsive, while the deep red of the countryside soil gives it a sense of warmth while winking to the Red Shirt movement. Generally speaking, the colors structure the story as a visual palindrome to stress the circularity of the narrative. In the flashbacks, in fact, we start with viewing a city depicted with cold colors and we end up, right at the end of the book, with the same palette. This suggests a continuity in the feeling of Bangkok but also a dimension of change, represented by the color red, the color of protest. Green and red, instead, connect the second and fourth chapters, in which personal relationships play a central role, whether between Nok and his father, Gai and Nok, or with the newborn. The central chapter, on the other hand, has a different color structure – the acid tone of the island. This palette is not repeated, as it represents the turning point of the story and the main character's development. In this sense, colors become the symbols of the change of time and the storyline, particularly the diachronic dimension of the narrative. On the contrary, the black-and-white sections not only represent blindness but also have the synchronic function of depicting the here and now of Nok's new life.

After being published in Italian, the book came out in the Thai edition in 2019 with the title *Taa Sawaang*. What were the main challenges of bringing this text to a Thai audience and how was it received?

Being able to get this book out in Thailand for a local audience was an incredible opportunity, made possible by Nuntawan Chanprasert, the editor at Reading Italy, a small press that publishes Italian literature in Thai translation. Because of the content of the graphic novel and its title in Thai, deciding to publish it was extremely brave on her part. The level of repression continues to be high in the country and a book that narrates these sensitive histories to a larger audience could easily lead her into trouble. So, on one hand, there were legal worries regarding the publication. These generated a very long discussion on the thin line that we had to walk between not being left open to lèse-majesté charges – which could land us, but especially her, into jail – and

preserving the narrative and political significance of the book. The solution we finally adopted in Thai was to cover three particularly sensitive sentences with a black line, a strategy used by progressive Thai filmmakers to pass state censorship while indexing its presence and effects.

From another angle, we were personally terrified by the idea of being read by a local audience. After all, we are three foreigners telling the story of contemporary Thailand to a Thai public who had personally lived through it. This fear similarly drove our reflections on orientalism, cultural appropriation, and the politics of representation throughout our production process. Nuntawan had read the book in Italian and she was adamant about the importance of bringing it to a Thai audience; this gave us some degree of confidence. Nonetheless, when we knew the book would be launched at a Bangkok book fair, we waited with trepidation.

The result was really unexpected and overwhelming. Since its first days, the graphic novel has done very well, and we'd started to see discussions and engagements with it on blogs and Facebook groups, then reviews from literary journals and newspapers, and finally endorsements from renowned artists, intellectuals, and political activists. We could not believe our eyes. The book entered the bestseller lists of many bookstores and e-commerce websites in the country, stayed there for weeks, and it has since been reprinted three times. This was incredibly humbling – both to see that Thai readers were responding positively to the book and to see a graphic novel, a format very unusual in Thailand, on those lists. Even more unexpected, in the summer of 2020, the book received the "Notable Book Award," a prize given by a group of 60 Thai publishers to the volume they think local readers should read. This made us hopeful not just that we had done a good job but also that our book could play a role in bridging comics – traditionally associated with "funny" and youthful themes in the country – and academic and political research. That said, part of the book's success has surely to do with its timing. As the book was hitting the shelves in Thailand, a new generation of political activists was taking the streets, opposing the current military government, and breaking a decades-long taboo against openly criticizing the monarchy. What we had tried to do in the book resonated, we think, with some of their strategies, both in terms of mixing everyday languages and media with serious political discussion and of reclaiming histories of popular struggle as constitutive of the present. On the other hand, some of our concerns about censorship paled in comparison with the bravery of Thai activists, who opened a Pandora's box that this book only began to point out.

READING GUIDE

The Story

1 How does Nok become blind?
2 Why do you think Nok decided to move to Bangkok? What is he looking for there?
3 Why does old Nok want to leave the city?
4 How does becoming blind affect Nok's perception of and relationship with Bangkok?
5 What is the role of Nok's father in the book?
6 Why do you think Gai is reluctant to go out with Nok at first? What does this say about the relationship between city and countryside?
7 Why does Nok decide to leave the village?
8 How does the 1997 economic crisis enter the story? What are its causes and how does it affect the lives of the characters?
9 What brings Nok back to Gai after he was on the island?
10 What does Thaksin represent for our protagonists?
11 What is the relationship between police officers and workers in the informal sector? What role does this play in the motorcycle taxi drivers' politicization?
12 What are the reasons behind the characters' mobilization with the Red Shirts? What are they fighting for?
13 This story could be seen as a long analysis of the transfer and transformation of forms of knowledge over multiple generations. Can you identify phases in which this happens? How do generational differences affect the story?

On Migration

1 What role do desires and expectations play in the lives of the main characters? How does Nok's dream of migration change over the course of his life?
2 How do personal relationships influence and shape the experiences of the protagonists? In particular, what roles to family, love, and friendship play in their lives?
3 Migration often implies a de-localized relationship between family members. How does the relationship between Nok, Gai, and Sun change over time? What are the roles of gender and generational dynamics in these changes?
4 What role does technology (radio, TV, phones) play in the lives of the migrants depicted in the book?
5 What forms of exclusion, inequality, stigmatization, discrimination, and marginalization do Nok and his family experience in Bangkok over the course of the story?
6 The lives of the characters are heavily shaped by work and its demands. How much and in what ways does work influence people's lives, including your own? What does this say about contemporary capitalism?

On Tourism

1 The tourist industry plays a central role both in Thailand and in the lives of Nok and Hong. What are the larger structural forces that organize this industry? How do they affect the characters' lives? What about those of Gai and Sun?
2 In the book, you rarely see tourists but you encounter the workers behind the resorts. What is their role and how does it relate to your previous perceptions of Thailand?
3 What is the role of drugs in Nok's life? Moreover, how do they relate to economic development in the Thailand of the 1990s? What about in contemporary capitalism?
4 How are we to understand our own practices as tourists? Does the book frame tourism as a positive or negative force? Do such phenomena need to be one or the other?

On Mobilization

1 What are the Red Shirts' demands? Can you relate them to other known social movements?
2 Why do the motorcycle taxi drivers become so central to the Red Shirts' revolt?

3 How does political consciousness emerge during the story for our characters? How do Nok, Hong, Gai, and Sun differ in their political participation and reflections?

4 What do you think makes Nok and Gai leave the Red Shirt movement?

5 This is a story of political awakening but also disillusionment. What is the relationship between these two orientations to collective action in the book? Can you think of examples from your experience of the roles of these two emotions in political movements?

On Historical Events

1 How do historical events enter the lives of the main characters? Can you see a change over the chapters? If so, how?

2 Key moments in the country's history and that of the characters sometimes coincide; other times they contradict each other. Can you identify two moments in which they are in tension and two in which they go together?

3 There are a few images of the King of Thailand throughout the book. Can you locate them and explain what role they play in the story?

4 How do the characters think they can make a difference in the course of the events? Does this change over time?

5 Does History (with a capital H) always "win" over the small histories?

Narrative Devices

1 Why do you think the book is called *The King of Bangkok*?

2 What is the function of the prologue?

3 What are the symbols used over the story and what do you think they mean?

4 In your opinion, what does the symbolism of the octopus mean? And the amulet?

5 How did the authors choose to represent blindness?

6 What do you think is the function of colors in each chapter?

7 What is the relationship between realistic storytelling and the imaginative representations in the book?

8 What role do natural elements play in the journey of blind Nok (wind, rain, sound, etc.)?

9 Nok's father is identified with rural life. What do you think is the function of this relationship?

10 What is the role of flashbacks in the story? Why do you think the authors decided to use this narrative device?

11 Can you see a relationship between the three characteristics of life according to the Thai monk and the chapters of the book?

Visual Reading

1 What do the colors tell us about time?
2 Why are some turning points depicted only through visual content rather than written form?
3 What are the visual differences in the representation of urban and natural landscapes?
4 The book is filled with images that operate as metaphors. Can you identify two of them and explain their role in the storytelling?
5 Choose a page and try to separate texts from visual content. Where is the nonverbal meaning of the images?

Ethnography in Graphic Form

1 The authors decided not to include themselves in the story. Why do you think they did this? How does it affect the narrative?
2 What do you think this medium can achieve that would not be possible through other forms of ethnography? What about its limitations?
3 What do you think about the partial fictionalization of ethnography? Aren't anthropologists supposed to collect data and represent their findings as accurately as possible?
4 What do you think are some of the ethical issues involved in the production of a graphic novel as an ethnography?

Beyond *The King of Bangkok*

1 What are some of the stereotypes about Thailand you previously had that were challenged by this story?
2 We live in times of political unrest and mobilization. What do you think this story has to say about collective action? Are there any elements that you found in the book that can be applied to your own context?
3 How does the graphic story speak to your own experiences of migration, travel, and mobility?
4 Did you at any point identify with one of the characters? Why and how?

FURTHER READINGS

On Thailand

Apichart, Kriengkrai. 2008. *101 Thai Forms*, Art4D.

Apichatpong, Weerasethakul. 2010. *Uncle Boonmee Who Can Recall His Past Lives* (film).

Baker, Chris, and Pasuk Phongpaichit. 2014. *A History of Thailand*. Cambridge: Cambridge University Press.

Cornwel-Smith, Philip. 2005. *Very Thai: Everyday Popular Culture*. Bangkok: River Books.

Glassman, Jim. 2010. "'The provinces elect governments, Bangkok overthrows them': Urbanity, Class and Post-Democracy in Thailand." *Urban Studies* 47, no. 6: 1301–23.

Haberkorn, Tyrell. 2011. *Revolution Interrupted: Farmers, Students, Law, and Violence in Northern Thailand*. Madison: University of Wisconsin Press.

Keyes, Charles. 2014. *Finding Their Voice: Northeastern Villagers and the Thai State*. Chiang Mai: Silkworm Books.

Kurathong, Nirawan. 2010. "A Brief History of Thai Comics and Graphic Novels." *Bangkok: LET'S Comic*.

Manit, Sriwanichpoom. 1997. *Pink Man Begins* (photographic series).

Mills, Mary Beth. 1999. *Thai Women in the Global Labor Force: Consuming Desires, Contested Selves*. New Brunswick: Rutgers University Press.

Pen-Ek, Ratanaruang. 2001. *Monrak Transistor* (film).

Prabda, Yoon. 2007. *Imagined Landscapes*. Bangkok: Typhoon Books.

Sopranzetti, Claudio. 2018. *Owners of the Map: Motorcycle Taxi Drivers, Mobility, and Politics in Bangkok*. Berkeley: University of California Press.

Verstappen, Nicolas. 2017. *Thai Comics in the Twenty-first Century: Identity and Diversity of a New Generation of Thai Cartoonists*. Faculty of Communication Arts, Chulalongkorn University.

Winichakul, Thongchai. 1997. *Siam Mapped: A History of the Geo-body of a Nation*. Honolulu: University of Hawai'i Press.

Essays

Bakhtin, Mikhail. 2013. *Problems of Dostoevsky's Poetics*. Minneapolis: University of Minnesota Press.

Basso, Keith H. 1996. *Wisdom Sits in Places: Landscape and Language among the Western Apache*. Albuquerque: UNM Press.

Calvino, Italo. 1988. *Six Memos for the Next Millennium*. Belknap: Harvard University Press.

Canetti, Elias. 1977. *The Tongue Set Free*. New York: Farrar, Straus and Giroux.

Falcinelli, Riccardo. 2017. *Cromorama*. Turin: Einaudi.

Gibson, Dave, and Tim Pilcher. 2016. *How Comics Work*. New York: Quarto Publishing Group–Wellfleet Press.

Harvey, David. 2001. *Spaces of Capital: Towards a Critical Geography*. London: Routledge.

Jakobson, Roman. 1959. "On linguistic aspects of translation." *On Translation* 3: 30–39.

Lefebvre, Henri. 1991. *Critique of Everyday Life*, 3 Vols. New York: Verso.

Li, Tania Murray. 2007. *The Will to Improve: Governmentality, Development, and the Practice of Politics*. Durham: Duke University Press.

Said, Edward W. 1978. *Orientalism*. New York Pantheon Books, 1978.

Scott, James C. 2010. *The Art of Not Being Governed: An Anarchist History of Upland Southeast Asia*. Singapore: Nus Press.

Wolff, Kurt. 1991. *Kurt Wolff: A Portrait in Essays and Letters*. Chicago: University of Chicago Press.

Novels

Blissett, Luther. 2003. *Q*. London: William Heinemann.

Eco, Umberto. 2007. *Foucault's Pendulum*. New York: Houghton Mifflin Harcourt.

Kristóf, Ágota. 1986. *Trilogie des jumeaux*. éd. Livraphone.

Maraini, Dacia. 1990. *La lunga vita di Marianna Ucrìa*. New York: Rizzoli.

Osborn, Lawrence. 2009. *Bangkok Days*. New York: North Point Press.

Sklovskij, Viktor. 2017. *Marco Polo*. Macerata: Quodlibet.

Williams, John Edward. 1965. *Stoner*. New York: Viking Press.

Comics

Briggs, Raymond. 2016. *Ethel and Ernest*. London: Jonathan Cape.

Fior, Manuele. 2016. *5,000 km Per Second*. College Park: Fantagraphics Books.

GIPI. 2020. *One Story*. College Park: Fantagraphics Books.

Lewis, John, and Andrew Aydin. 2016. *March*, 3 Vols. Marietta: Top Shelf Productions.

Liew, Sonny. 2016. *The Art of Charlie Chan Hock Chye*. New York: Pantheon Books.

McGuire, Richard. 2014. *Here*. New York: Pantheon Books.

Miller, Frank, Roger McKenzie, and John Romita Jr. 2014. *Daredevil: The Man without Fear*. Vol. 1. Marvel Entertainment.

Miller, Frank, and David Mazucchelli. 2014. *Daredevil: Born Again*. Vol. 1. Marvel Entertainment.

Nanni, Giacomo. 2018. *Atto di Dio*. Milano: Rizzoli Lizard.

McCloud, Scott. 1994. *Understanding Comics: The Invisible Art*. New York: Harper Collins & Kitchen Sink Press.

Sousanis, Nick. 2015. *Unflattening*. Belknap: Harvard University Press.

Tamaki, Mariko, and Jillian Mariko. 2014. *This One Summer*. New York: First Second Books.

Tadao Tsuge. 2016. *La mia vita in barca* (つげ忠男). Bologna: Coconino Press.

Thi Bui. 2017. *The Best We Could Do: An Illustrated Memoir*. New York: Abrams.

This groundbreaking series realizes ethnographic and anthropological re-search in graphic form. The series speaks to a growing interest in comics as a powerful narrative medium and to the desire for a more creative and pub-lic anthropology that engages with contemporary issues. Books in the series are scholarly informed works that combine text and image in ways that are conceptually sophisticated yet accessible to broader audiences. These books are open-ended, aesthetically rich, and encourage conversations that build greater cross-cultural understanding.

Series Editors: Sherine Hamdy (University of California, Irvine) and Marc Parenteau (comics artist)

Series Advisory Board: Juliet McMullin (University of California, River-side), Stacy Pigg (Simon Fraser University), Fiona Smyth (OCAD Univer-sity), Nick Sousanis (San Francisco State University)